THE TURN TO
Ethics

CULTURE WORK

A book series from the
Humanities Center
at Harvard

Marjorie Garber, Editor
Rebecca L. Walkowitz, Associate Editor

Media Spectacles
Marjorie Garber, Jann Matlock, and
Rebecca L. Walkowitz, Editors

Secret Agents
The Rosenberg Case, McCarthyism, and Fifties America
Marjorie Garber and Rebecca L. Walkowitz, Editors

The Seductions of Biography
Mary Rhiel and David Suchoff, Editors

Field Work
Sites in Literary and Cultural Studies
Marjorie Garber, Paul Franklin, and Rebecca L. Walkowitz,
Editors

One Nation under God?
Religion and American Culture
Marjorie Garber and Rebecca L. Walkowitz, Editors

Psychoanalysis, Historicism, and Early Modern Culture
Carla Mazzio and Douglas Trevor, Editors

THE TURN TO
Ethics

Edited by
**Marjorie Garber, Beatrice Hanssen,
and Rebecca L. Walkowitz**

ROUTLEDGE
New York and London

Published in 2000 by
Routledge
29 West 35th Street
New York, NY 10001

Published in Great Britain by
Routledge
11 New Fetter Lane
London EC4P 4EE

Routledge is an imprint of the Taylor & Francis Group.

Printed in the United States of America on acid-free paper.
Design and typography: Cynthia Dunne

10 9 8 7 6 5 4 3 2 1

Library of Congress Cataloging-in-Publication Data
 The turn to ethics / edited by Marjorie Garber, Beatrice Hanssen, and
Rebecca L. Walkowitz.
 p. cm
 Proceedings of a conference.
 Includes bibliographical references.
 ISBN 0-415-92225-9 (hb) — ISBN 0-415-92226-7 (pb)
 1. Ethics—congresses. I. Garber, Marjorie B. II. Hanssen, Beatrice. III.
Walkowitz, Rebecca L., 1970–
BJ19 .T87 2000
170—dc21 99-053685

Contents

Introduction:
The Turn to Ethics

Marjorie Garber, Beatrice Hanssen, and Rebecca L. Walkowitz

What kind of a turn is the turn to ethics? A Right turn? A Left turn? A wrong turn? A U-turn? Whose turn? Whose turn is it to turn to ethics? And why? Why now?

In the popular imagination, in the world of technology and scientific innovation, and in the contemporary political arena, in every newspaper and newsmagazine, phrases like "ethical responsibility" (and "ethical lapse") appear with startling frequency. Whether it's the sex scandal in the White House, the debate about human cloning, or the question of campaign funding reform, we have become inured to the idea that "ethics"

is a kind of moral orthopedics.

Often "ethics" seems to be situational and remedial, called into being by a local and immediate crisis. In a large library or bookstore, one can find hundreds of volumes titled *The Ethics of X or Y*: the ethics of abortion, accounting, ambiguity, apartheid, animal experimentation, and (our favorite) "asking" (subtitle: "dilemmas in higher education fundraising")—and these are only some of the a's. The b's include bankruptcy, "boxing and manly sports," and business; the c's, capitalism, chivalry, and citizenship; the d's, divorce, deconstruction, and democracy, and so on all the way to the end of the alphabet, the ethics of "work and wealth," of world religions, and of "withdrawal of life support systems."

"Ethics" is not only a praxis, but also a principle, and the essays in this volume ask how situated examples have reconfigured general theories. Ethics, contributors suggest, is a process of formulation and self-questioning that continually rearticulates boundaries, norms, selves, and "others." From Aristotle and Kant to Nietzsche and Hegel to Habermas and Foucault to Derrida and Lacan and Levinas to many of the essayists collected here, the concept of ethics and the ethical has been reconceptualized, reformulated, and repositioned. There was a time, not so many years ago, as Geoffrey Harpham reminds us, when "ethics" was regarded in the realm of literary study as a "master discourse" that presumed a universal humanism and an ideal, autonomous, and sovereign subject.[1] To critics working in the domains of feminism, deconstruction, psychoanalysis, semiotics, and Marxism, this discourse became a target of critique: the critique of humanism was the exposé of ethics.

Things have changed. Ethics is back in literary studies, as it is in philosophy and political theory, and indeed the very critiques of universal man and the autonomous human subject that had initially produced a resistance to ethics have now generated a

crossover among these various disciplines that sees and does ethics "otherwise." The decentering of the subject has brought about a recentering of the ethical.

In their contributions to this volume, philosophers, political theorists, literary critics, and a physician bring the particularities of their own disciplinary training and interests to a vital complex of questions, with surprisingly fresh and challenging results. Many express concerns that the turn to ethics is a turn away from politics and toward moralism and "self-righteousness." All ultimately conclude that such concerns, rather than leading away from ethics, have helped to reinvigorate the intellectual field in the present moment.

The first several essays begin by thinking through the tension between the poststructuralist critique of ethics and the ethical critique of poststructuralism. Lawrence Buell situates this tension within literary studies: while some scholars—often those with disciplinary homes outside departments of literature—have looked to novels, poems, and plays for moral content and values, others, often situated within literature departments, have turned to "the dream of philosophy as a form of writing." The philosopher Emmanuel Levinas, Buell suggests, offers one model for literary-ethical inquiry by bringing poststructuralist thought into dialogue with traditional questions of justice and relationship. Buell invites a consideration of whether or not the critic's "ethical life-world of obligations" is, or ought to be, part of the question of literary ethics. Indeed, it is with the critic's obligations that Judith Butler introduces her discussion of Levinas and Nietzsche. Butler is interested in how both Levinas and Nietzsche have been implicated in the ethical crises of contemporary cultural and intellectual history. Working through Nietzsche's suspicion of ethics and Levinas's ethical demands, Butler imagines a role for ethics after poststructuralism.

Just as Nietzsche, a forceful critic of the ethical tradition in

philosophy, enables Butler to reformulate ethics for political critique, so literary critic John Guillory, concerned that ethical inquiry has occluded political engagement, turns to Michel Foucault. In a provocative dicussion of lay and professional reading, Guillory describes the practice of reading as an ethical "care of the self." Moving to psychoanalysis, Barbara Johnson brings D. W. Winnicott to Immanuel Kant, and rehabilitates the concept of "using people" as a surprisingly ethical practice. Like Butler and Guillory, Johnson challenges some of the central presuppositions of what constitutes "ethical behavior."

The next group of essays measure the relation between principles of ethics and their practice in the world. Pediatrician and author Perri Klass describes some particular crises that confront doctors dealing with premature infants. Because it is now possible to resuscitate and ventilate the smallest of newborns, Klass explains, both doctors and parents must live with the results of technological successes and failures. In these crises, Klass asserts, doctors face ethical dilemmas with little time for ethical contemplation.

In the field of politics, as in the field of medicine, some contributors argue, local situations often conflict with theoretical aspirations, so that it is not always clear whether ethical positions can exist independent of specific contexts. Thus Chantal Mouffe, a political philosopher, contends that moralism, under the sign of ethics, all too often replaces politics. She finds that the notion of "deliberative democracy" ignores or excludes the intrinsic antagonism that is a political reality and must be faced.

Addressing questions of recognition and social justice, philosopher Nancy Fraser proposes a social theory of "perspectival dualism," in which the justice of any social practice must be judged by its attention to both economic and cultural circumstances. She offers welfare, prostitution, pornography, and no-fault divorce as examples of complex ethical issues that

would benefit from an integrated approach uniting redistribution and recognition. Critical theorist Beatrice Hanssen asks what we mean when we speak of "recognizing the other"? Who is "the other," and how does that designation create ethical dilemmas and opportunities? To gauge these opportunities, Hanssen examines the particular case of multiculturalism in international context. Reading Frantz Fanon together with Hegel, Habermas, and Charles Taylor, she posits multiculturalism as "multi-ethics," offering a mediating position between Habermas and antifoundationalist poststructuralism.

The final essays ask how contemporary theories of culture are changing theories of ethics. For Homi Bhabha, ethics must be reconsidered within the "landscape of cultural difference." This is not so much a contextualization of ethics within multicultural societies, Bhabha suggests, as a restructuring of ethics within the framework of cultural diversity. He proposes a new view of the contested category of "choice," maintaining that it not only exemplifies liberal selfhood but in fact alters the very way in which selfhood, within cultures, is constructed and understood. Doris Sommer, a specialist in Latin American literature and culture, cautions readers against any easy assumption of intimacy with and understanding of "ethnically marked" texts. Rhetorical moves, she asserts, may make for opacities and "surprises" that keep "presumptively unmarked readers" at a distance. An ethical practice of reading, for Sommer, would require an awareness of the cultural particularism of literature. Engaging a similar question of the particular and the universal, Rebecca L. Walkowitz contends that theorists of ethical reading assume that texts possess a cultural difference that is both consistent and definitive. Literary ethics, Walkowitz observes, often presupposes a theory of distinctive, coherent cultures that literature is given to exemplify. She argues, however, that practices and contexts of reading regularly unsettle the locations of texts,

readers, and cultures, and that today's ethics of reading will need to take these disruptions seriously.

The idea for this volume was first suggested by Beatrice Hanssen, whom the other two editors (and the contributors) would like to thank. The editors are grateful as well to Barbara Akiba, Allan M. Brandt, Mary Halpenny, David Horn, Sol Kim, Lesley Lundeen, Karen Paik, Mun-Hou Lo, Elaine Scarry, and Mindy Smart.

NOTE

1. Geoffrey Galt Harpham, "Ethics," *Critical Terms for Literary Study* (Baltimore: Johns Hopkins University Press, 1995), 387.

THE TURN TO
Ethics

What We Talk About When We Talk About Ethics

Lawrence Buell

*i*n literary studies today, the ethical turn seems a groundswell of still uncertain magnitude and even more uncertain focus—a prospect offering grounds for both excitement and caution.

To take the magnitude part first, clearly something is afoot when a half dozen conferences and journal symposia are created around ethics and the literary in the space of a single year; when the Lentricchia-McLaughlin compendium of *Critical Terms for Literary Study* omits ethics in 1990 but includes it in 1995.[1] Exactly how strong a trendline exists? *PMLA* received forty-six submissions for its special 1999 ethics issue—about

the same as for the issues on evidence and on teaching, but far fewer than for those on ethnicity or postcolonialism or African-American studies. My MLA database search for 1981–1997 ethics-related literature scholarship yielded 1339 entries: twice that of deconstruction and epistemology, 30 percent more than hermeneutics, but one-third that of aesthetics, one-quarter of poetics, one-fifteenth of narrative, and one-thirtieth of theory. Yet one-thirtieth of theory is perhaps not such an inconsequential fraction after all.

So much for statistics. Now to ruminate on the more elusive why and what of the matter.

Several interlocking influences must be taken into account if one is to begin to give a satisfactory answer to the question of "Why ethics now?"—Why ethics talk should lately have flourished in literary studies. First, to a considerable extent, it always has, although its chief traditional subgenres (the evaluation of aesthetic merit and the reading of literary texts as moral reflection) were thrown into disarray by the coeval perturbations of the theory revolution and canonical revisionism of the 1970s. Second, ethics talk, of certain kinds anyhow, has been relegitimated during the past dozen years by currents within high theory itself: by Foucault's revaluation of the category of the self, conceiving of care of the self as an ethical project; by the argument on behalf of deconstructive critical practice as itself an ethic; and by the emergence of Emmanuel Levinas as a post-poststructuralist model for literary-ethical inquiry.[2] Third, the turn by philosophers toward the literary as a preferred mode of ethical reflection, such as moral philosophy à la Martha Nussbaum and Richard Eldridge and postepistemological pragmatism à la Richard Rorty.[3] Fourth, the ethics-in-the-professions movement, which in medicine and law and other fields has turned to literature as exemplum and/or model.

Much more could be said about background, but this is enough to suggest that the ethical turn is pluriform, not singu-

lar, and that it is not ascribable to any one catalytic event, be it the so-called fall of de Man, or the threat to Marxism posed by the Soviet unravelling, or to cultural politics by moral majoritarianism.[4]

Hence too the rationale for the first of four dimensions of the contemporary ethics-and-literature conversations that I want to single out for remark here:

1. *Ethics as earnest noise.* The origins of the newer literature and ethics work being disparate and sometimes mutually antagonistic, confusion is predictable, all the more so as "ethics" (whatever we mean by it) becomes increasingly fashionable, thereby tempting one to make a mantra of it, tempting more and more parties to lay claim. There is something that feels extremely heartening and reassuring about placing ethics, with its implication of right conduct, at the center of one's intellectual enterprise—as a pursuit, ethics may well appear far more high-minded than epistemology or ideology or politics. But by the same token, one may easily also feel—especially in those moments when the sense of exhilaration at engaging in the noble pursuit of ethics recoils to haunt one with the demand for a keener, more scrupulous self-criticism about the rigor and consistency of one's critical practice—the result may be a considerable sense of queasiness over how freely that signifier ("ethics") can slide around and metamorphose into something other or less than it seems to denote at first.

A bald recitation of the titles of some of the first twenty items unearthed in my MLA search begins to give a flavor of the as-yet insufficiently acknowledged cacophony:

- "Robert Coover's *The Public Burning* and the Ethics of Historical Understanding"

- "Misogyny, Homosexuality, and the Ethics of Passivity in First World War Poetry"

- "Moral Identity and the Good in the Thought of Iris Murdoch"

- "The Ethics of Suspicion in Augustine and Foucault"

- "Of Law and Forgetting: Literature, Ethics, and Legal Judgment"

- "Ethical Roles for the Writing Teacher"

The protean ductility exemplified by this short list of heterogenous projects is a phenomenon hardly unique to the late twentieth century. It dates back at least to the mid-nineteenth century, when the emerging culture of professionalism simultaneously began to produce both ethics specialists and "ethics of" discourse, built upon the notion of an ethics specific to this or that given field. The concept of a medical ethics, a legal ethics, a business ethics all seem to take root during the nineteenth century, as also does something sometimes called "literary ethics."

To my knowledge, the first attempt to define an ethics of the "literary" by a major literary figure occurs in a speech of 1838 by Ralph Waldo Emerson called "Literary Ethics," delivered to the assembled literary societies of Dartmouth College.[5] Unfortunately, like many such firsts, "Literary Ethics" makes a quite underwhelming read today. It is little more than a dumbed-down version of the more famous "American Scholar," sprinkled with telltale images about the wilderness state of the American hinterland that likely reflected Bostonian presuppositions about the condition in which Emerson fancies he's found his hinterland auditors. What's nonetheless strikingly anticipatory about Emerson's speech in present context is that he doesn't so much *define* "ethics" as hold it up as an umbrella term for diffuse reflection on the intellectual resources, the subject matter, and the personal regimen proper to the paradigmatic "scholar" or man of letters. Appeal to "ethics" makes possible a strategic blurring of standard boundaries: between life and work, persons and

texts, poesis and academic exercise—as a consequence of which the notion of "ethics" becomes user-friendly to both mainstream and counterhegemonic listeners: both a critique of overspecialized pedantry through its emphasis on how much wider or deeper true scholarship is than that *and* a way of making even workers in the conventional academic vineyard feel not rejected but endowed with a lofty mission—if they do their jobs right.

Emerson does have an identifiable preferred theoretical matrix for doing ethics, namely, a version of Foucauldian care of the self, but it gets stretched and ambiguated during the course of his semiautonomous reflections on writing, reading, the academy, the state of contemporary American literature and citizenship. Likewise, today, in literature and ethics talk a strong "ethics is this, ethics is that" emphasis may well open up into a more eclectic approach than at first seems likely. J. Hillis Miller did not shrink from invoking "the law of the ethics of reading" in his book of that title, and to define that law as the scrupulous practice of deconstructionist attention to fissures within the text ("rigorous unreliability," in Barbara Johnson's phrase);[6]—as contrasted with (say) how Wayne Booth identifies ethics of reading especially with the vision of literature as moral reflection.[7] Yet in practice Miller certainly does not decline to enter into this latter, more traditional mode of ethical reading, as in the studies comprising his sequel, *Versions of Pygmalion*,[8] while Booth for his part acknowledges that certain texts, if not most, border on the unreadable owing to internally inconsistent rhetorics.[9] Indeed, the famous passage in de Man's *Allegory of Reading* in which he characterizes ethicity as the symptom of "a linguistic confusion" (central to Miller's formulation of the law of reading ethics) does not flatly restrict the scope of ethics only to that. It acknowledges using "ethics" in an especially stipulated sense, and that the "confusion" at issue arises from dissonance between "two distinct *value* systems" within the text: a statement that, like portions of the essay leading up to it, at least

begins to reopen a vista onto ethics that comprehends ethical values other than discourse codes.[10]

All this is not to claim that all literature and ethics talk boils down to the same thing, only that it is a scene of overlapping epicenters whose peripheries overlap.

2. *Ethics as Relationship*. Clearly literature and ethics have to do, among other possible things, with relationships between texts and readers—but what? At one end of one continuum sits the via negativa of rigorous undecidability, at the other Booth's revival of the neo-Victorian via positiva of reading mediated by the image of the book as companion and friend. Philosophers, such as Richard Rorty and Martha Nussbaum, who turn to what they consider fiction's more supple and full-blooded ethical mimesis as a corrective or counter to formal reasoning seem to resonate more with the latter view, while the vision of reading as an ethics of difficulty has by and large been maintained more by literary professionals. It is worth a great deal more examination than I am able to provide in this short paper that contemporary literary theory overall has so far been so much more responsive to the dream of philosophy as a form of writing than the dream of literature *as* moral philosophy. The explanation that the latter is less attractive because less critically sophisticated does not quite seem to suffice. After all, when Clifford Geertz took anthropology on its literary turn, we responded enthusiastically even though his model of ethnography as reading was based on an already obsolescent new critical formalism. Likewise, when Hayden White gave us history as discourse, we cheered him on even though his model of metahistory was based on Northrop Frye's obsolete archetypalism.[11] But when Rorty and Nussbaum try to give us literature as ethical reflection, we are more reluctant to be pulled back to what looks suspiciously like old-fashioned values thematics: the "pre-modern strategy" of making "aesthetic sensibility ultimately subservient to the goal of moral improvement."[12] Perhaps the key difference between this and the

previous two cases is not so much the specter of rampant moralism as such as it is longstanding reluctance on the part of many if not most literary scholars to allow the central disciplinary referent or value to be located in anything but language.

Conceivably the situation may change when literary theory more fully assimilates Levinas, whose long-range influence on literary studies remains to be seen. From a distance, Levinas can seem the perfect abettor of the ethical turn away from both poststructuralism and Marxism: trumping Derrida with the claim of ethics' priority to epistemology, and preempting political criticism by identifying ethicity with acknowledgment of the other. But it takes some fancy footwork to get past his platonistic distrust for art as substitution of image for object. To the extent that one can plausibly redeem Levinas from himself and for literary-ethical theory via the notion of language as ethical expression, as a kind of "saying" unfolded in *Otherwise than Being*,[13] one must sooner or later grant what literary theory has been most reluctant to: a model of artistic representation as surrogate personhood, whether of authorial agent or fictive utterer or evocative text. A Levinasian ethics of criticism would presumably need to fuse a revised version of a deconstructionist vision of the impossibility of reading with a revised version of Booth's book as friend: the other for whom we feel responsibility prior to any awareness of it.[14] I for one would hope to see such an ethics of reading worked out. But one could not succeed without finding plausible ways of rescuing Levinas from himself in other respects also: for example, from his undifferentiated and indeed deliberately underimaged image of the other and his adherence to the model of ethical relation as an affair between two persons, reducing "justice" to the status of a socially necessary but ethically secondary apparatus.[15]

3. *Ethics as imperative.* In addition to relationality, "ethics" connotes authoritative, shared operating principles, either as key objective or as central metaphor. In the first vein (principles

as key objective), Habermasian so-called communicative ethics is the obvious case: seeking to set conditions that would enable and regulate rational interchange within a discourse community. In the latter vein (principles as metaphor), Geoffrey Harpham takes the position that ethical inquiry in literary studies does not point toward "an ultimately coherent set of concepts, rules, or principles," but does imply "a factor of 'imperativity' immanent in, but not confined to, the practices of language, analysis, narrative, and creation."[16] As the rhetoric of multiple options suggests, however, to define that imperativity factor is much harder than to declare allegiance to it—and the same is true for the Habermasians.

Harpham himself is I think at his best when applying his vision of ethics to formal structures like narrative plot, which he elegantly defines as "a principle of formal necessity that governs the movement towards the union of *is* and *ought*."[17] That is by no means imperativity's only possible locus, however. Just to take one other example, Martha Nussbaum's view of the ethicity of the worlds that novels imagine—which she characterizes as a dialogue between rule and perception—constitutes a mapping of narrative mimesis equivalent to Harpham's mapping of plot teleology, though the domain of reference is entirely different. What these otherwise divergent ethical critics share in common seems to be the goal of establishing the salience of an "ought-ness" in the text without hypostasizing either what "oughtness" is or fixing the text in a single position with regard to the conjuncture or disjuncture of "ought" and "is." Indeed, both quite clearly attach value to fiction's refusal to stabilize that relation.

As I strive, no doubt quixotically, to understand what might be the chief sources of this intense critical interest in imperativity, Levinas again looms up as a symptomatic and resonant figure. No recent philosopher drawn upon by literary theory is more gripped by the urgency of the ought, perhaps because at first sight his conception of it might appear to meet the seemingly

impossible criterion for a postmodern absolute: morality without ground, obligation prior to all theory, all self-consciousness, and "justified by no prior commitment" but arising merely out of an "anarchy" created by existential proximity to the other.[18] Here again, however, it remains to be seen whether Levinas's gift will turn out to be like the monkey's paw in the old tale, which granted wishes in such macabre ways that you wished you hadn't wished them. In offering the gift of ethicity, Levinas demands nothing less than an unconditional dismantling of one's protective defenses against the claims of the other. Prima facie, this seems more fit to be a gospel for the privileged or the oppressor (vide Luke's parables of the Prodigal Son, Dives, and Lazarus). It is hard to imagine the possibility of a resisting reader in Levinas's system, or even a relation of reciprocal equality between reader and text considered as surrogate person. Even if one accepts that "Peace with the other is first of all my business," will one consent to "the passivity of an undeclinable assignation"?[19]

4. *Ethics as professional conduct.* Although doubtless the rise of literature and ethics talk is somehow connected with the rise in disciplinary self-consciousness that has produced documents like the MLA's 1992 "Statement of Professional Ethics,"[20] in most of the theoretical and critical work the connection is harder to spot than it is in an ethics-in-the-professions–driven intervention like *Poethics* by Richard Weisberg, for whom literary representations of legal ethics are directly related to the work of teaching lawyers how lawyers do and ought to feel, reason, communicate, treat people, and so forth.[21] In the field of literary studies itself, although literary texts have been and will surely continue to be taught—at least up through the college level—with frequent reference to how they illuminate the conduct of life, so far as literary scholarship is concerned, the most searching work that has taken institutional controls and pedagogical contexts into account in the context of value considerations—that which focuses on canonicity and the evolution of

standards of aesthetic judgment—has generally not tended to use "ethics" as a central term of reference.[22] To be sure, some of the figures self-consciously associated with the ethical turn, like Miller and Booth, show sensitive awareness of doing what they do with texts in a professional context. But ironically this has been held against them as often as it has been held up as a point of praise: Miller, for example, has been criticized—unfairly I think—for a narrowly professorial conception of the ethics of reading and Booth for schoolmasterishness. Most literary specialists have not rushed to accept that literature and ethics ought to be discussed with constant reference to the life-world of the discussant: the ethical life-world of obligations to students and colleagues and institution and society. I am not sure that to do so is always a necessary thing or even a good thing, but I am sure that it *would* be a good thing if the question of whether it *is* a good thing were more explicitly discussed. Indeed, it may be that one of the best things that the ethical turn in literary studies can accomplish would be to keep us from getting so easily distracted from thinking about how what teacher-scholars do as professionals does and does not relate to what we are and what we wish to be as persons. That, incidentally, was something that the canonical originator of literary ethics, Ralph Waldo Emerson, was able to do quite astutely indeed, even when not at the peak of his form. For this, if for no other reason, "Literary Ethics" deserves rereading today.[23]

NOTES

1. Geoffrey Galt Harpham, "Ethics," in Harpham, *Critical Terms for Literary Study* (Baltimore: Johns Hopkins University Press, 1995), 387–405.

2. See particularly Michel Foucault, *Ethics: Subjectivity and Truth,* ed. Paul Rabinow (New York: New Press, 1994); Martin Jay, "The Morals of Genealogy: Or Is There a Poststructuralist Ethics?" in Jay, *Force Fields: Between Intellectual History and Cultural Critique* (London: Routledge, 1993); Robert Bernasconi and Simon Critchley, ed., *Rereading Levinas* (London: Athlone, 1991);

Critchley, *The Ethics of Deconstruction: Derrida and Levinas* (Oxford: Blackwell, 1992); and Robert Eaglestone, *Ethical Criticism: Reading After Levinas* (Edinburgh: Edinburgh University Press, 1997).

3. Martha Nussbaum, *Love's Knowledge: Essays on Philosophy and Literature* (New York: Oxford University Press, 1990); Richard Eldridge, *On Moral Personhood: Philosophy, Literature, Criticism, and Self-Understanding* (Chicago: University of Chicago Press, 1989); Richard Rorty, *Contingency, Irony, and Solidarity* (Cambridge: Cambridge University Press, 1989), chapters 7–8.

4. Referring to the case of de Man, Geoffrey Harpham expresses the temptation to assign specific causes to the literature-and-ethics revival (and frequently overzealous indulgence of that temptation) when he states with wittily self-conscious extravagance that, "On or about December 1, 1987, the nature of literary theory changed" ("Ethics," *Critical Terms for Literary Study*, 389).

5. Ralph Waldo Emerson, "Literary Ethics," in Emerson, *Nature, Addresses, and Lectures*, ed. Robert E. Spiller and Alfred Ferguson (Cambridge, Mass.: Harvard University Press, 1971), 95–116.

6. J. Hillis Miller, *The Ethics of Reading* (New York: Columbia University Press, 1987), 127 and 3–4, 43–44 and passim, during the course of which Miller affirms that "deconstruction is nothing more or less than good reading" (10); Johnson, *A World of Difference*, 17. For Miller, what especially makes this type of reading "ethical" (as opposed to "political") is the element of the reader's personal commitment to the endeavor at the highest level of seriousness, including the acceptance of responsibility for her/his reading.

7. Wayne Booth, *The Company We Keep: An Ethics of Criticism* (Chicago: University of Chicago Press, 1988).

8. J. Hillis Miller, *Versions of Pygmalion* (Cambridge, Mass.: Harvard University Press, 1990).

9. Booth's treatment of *Huckleberry Finn* in *Company*, 457–78 and passim, especially shows this.

10. Paul de Man, "Allegory (Julie)," in de Man, *Allegories of Reading* (New Haven, Conn.: Yale University Press, 1979), 206. My emphasis. The two systems in question are (1) congruence between "polarities of truth and falsehood that move parallel with the text they generate," and (2) when the polarities are at cross-purposes. Also, in what follows, "ethics" re-montages into "the moral": the preface and main text of *Julie* "are ethical not only in this wider sense. They are also moralistic in a very practical way that frequently borders on the ridiculous but that is nonetheless a necessary part of what is most consistent in Rousseau's thought" (206).

11. Clifford Geertz, "Thick Description: Toward an Interpretative Theory of Culture," in Geertz, *The Interpretation of Cultures* (New York: Basic, 1973), 3–30, as well as other essays in this same collection; Hayden White, *Metahistory* (Baltimore: Johns Hopkins University Press, 1973).

12. Herbert Grabes, "Ethics, Aesthetics, and Alterity," in *Ethics and Aesthetics: The Moral Turn of Postmodernism*, ed. Gerhard Hoffman and Alfred Hornung (Heidelberg: UniversitätsverlagC., Winter 1996), 17—with special reference to Rorty. Cf. Nussbaum's astringency toward literary theory on precisely the ground of its moral reflection deficit (*Love's Knowledge*, 169–71), and the seconding of such complaints by conservative literary critics of "the anti-humanistic stance of much post-structuralism" (Kenneth Asher, "Ethics and Literature," *ALSC Newsletter*, 2. ii–iii [Spring/Summer 1996]: 1). Yet on the intellectual left, one also sees a tendency in the 1990s for ethical mimesis to emerge as a more overt and central concern in critical work committed to foregrounding issues of social justice for oppressed peoples; e.g., in Doris Sommer's contribution to the present symposium and Satya P. Mohanty, *Literary Theory and the Claims of History* (Ithaca, N.Y.: Cornell University Press, 1997), especially chapters 6–7.

13. Featherstone, *Ethical Criticism*, 154–70, makes a brave argument along these lines (including the claim that Levinas's own exfoliation of his major terms/concepts can be considered a kind of poesis). It remains, however, that the dominant position Levinas takes when theorizing language in *Otherwise than Being* is to "signify" on the (post)structuralist tradition by appropriating "signification" as a metaphor for the concept of standing-for-the-other at the heart of his conception of ethical sensibility and by appropriating "saying" and "said" as metaphors of different modalities of ethical expressivity.

14. In Booth, the book as friend is an obsolete metaphor that needs to be relearned in order to restore plenitude to the reading relationship and offset the one-sidedness of a hermeneutics of suspicion. Levinas's relational ethic also aims to be an ethic of reconciliation, but he places great emphasis on the disruptive experience, positively a sense of persecution, that accompanies the onset of the sense of accountability. However, had Booth so chosen, he could certainly have stressed how the unsocialized reader (the student coping with a difficult assignment, for instance) may experience books as persecutors, while Levinas, conversely, could certainly have stressed the potentially joyous dimension of the turn toward the other.

15. For Levinas's conception of how "justice" is necessitated by the introduction of a "third party," see especially his *Otherwise than Being* (1974), trans. Alphonso Lingis (Dordrecht: Kluwer, 1991), 157–62. I suspect that a compelling theory of social justice can be extrapolated from this foundation, but Levinas himself

did not do that work; his ethics as articulated remains intensely interpersonally focused.

16. Harpham, *Getting It Right: Language, Literature, and Ethics* (Chicago: University of Chicago Press, 1992), 5.

17. Ibid., 183.

18. Levinas, *Otherwise than Being*, 112. Cf. Zygmunt Bauman, *Postmodern Ethics* (Oxford: Blackwell, 1988), 69–78, and Jacques Derrida, "Violence and Metaphysics": "Levinas does not seek to propose laws or moral rules, does not seek to determine a morality, but rather the essence of the ethical relation" ("Violence and Metaphysics," *Writing and Difference*, 111).

19. Levinas, *Otherwise than Being*, 117.

20. *Profession 1992.*

21. E.g., Richard Weisberg, *Poethics* (New York: Columbia University Press, 1992), 35. Weisberg revealingly declares about stories of racial oppression that "lawyers must once again read these stories" so that through "attention to legal communication and the plight of those who are 'other' . . . the ethical component of law" may be revitalized.

22. I am thinking of such studies as Barbara Herrnstein Smith, *Contingencies of Value* (Cambridge, Mass.: Harvard University Press, 1988); Paul Lauter, *Canons and Contexts* (New York: Oxford University Press, 1993); and John Guillory, *Cultural Capital* (Chicago: University of Chicago Press, 1993). A recent exception that may be a straw in the wind is Martin Jay, *Literature and the Culture Wars* (Madison: University of Wisconsin Press, 1996), which treats "ethics" extensively vis-à-vis the pedagogical challenge of negotiating cultural identity issues in the classroom ("the gap between personal and cultural identity creates the space where ethics must take place" [143]), where previous work of like kind might have been more likely to classify such negotiations as "politics." See John Guillory's reflections, elsewhere in this collection, on the turn to ethics as a turn from politics.

23. For their comments on this paper, which have helped me greatly in its revision, my sincere thanks to Doris Sommer, Sianne Ngai, and James Dawes.

Ethical Ambivalence

Judith Butler

i do not have much to say about why there is a return to ethics, if there is one, in recent years, except to say that I have for the most part resisted this return, and that what I have to offer is something like a map of this resistance and its partial overcoming which I hope will be useful for more than biographical purposes. I've worried that the return to ethics has constituted an escape from politics, and I've also worried that it has meant a certain heightening of moralism and this has made me cry out, as Nietzsche cried out about Hegel, "Bad air! Bad air!" I suppose that looking for a space in which to breathe is not the highest ethical aspiration, but it is there, etymologically embedded in aspiration itself, and

does seem to constitute something of a precondition for any viable, that is, livable, ethical reflection.

I began my philosophical career within the context of a Jewish education, one that took the ethical dilemmas posed by the mass extermination of the Jews during World War II, including members of my own family, to set the scene for the thinking of ethicality as such. The question endlessly posed, implicitly and explicitly, is what you would have done in those circumstances, whether you would have kept the alliance, whether you would have broken the alliance, whether you would have stayed brave and fierce and agreed to die, whether you would have become cowardly, sold out, tried to live, and betrayed others in the process. The questions posed were rather stark, and it seemed as if they were posed not merely about a hypothetical past action, but of present and future actions as well: Will you live in the mode of that alliance? Will you live in the mode of that betrayal, and will you be desecrating the dead by your actions, will you be killing them again? No, worse, you are, by your present action, effectively killing them again. It was unclear whether any sort of significant action could be dislodged from this framework, and whether any action could be dissociated from the ethical itself: the effect on action was generally paralysis or guilt with occasional moments of hallucinatory heroism.

We know this particular form of ethical thinking from Woody Allen films, the humor of Richard Lewis, and others. And, despite its gravity, or rather because of it, I can barely restrain myself from driving the logic into the sometimes hilarious extremes it achieves in the U.S. context (Did you brush your teeth? Are you betraying the Jews?) but I will try not to—and not only from fear of enacting that desecration again. It was with reluctance that I agreed to read Nietzsche, and generally disdained him through most of my undergraduate years at Yale until a friend of mine brought me to Paul de Man's class on *Beyond Good and Evil* and I found myself at once compelled and

repelled. As I read further I saw in Nietzsche a profound critique of the psychic violence performed by impossible and relentless ethical demands, the kind that takes whatever force of life-affirmation that might be available and turns it back upon itself, spawning from that negative reflexivity the panoply of psychic phenomena called "bad conscience," "guilt," and even "the soul." I read Nietzsche's *On the Genealogy of Morals* with difficulty, since what I wanted most from it was his critique of slave morality, and what I hated most in it was his persistent association of slave morality with the Jews and Judaism. It was as if the moment of the text that offered me some release from the hyperethical framework that I derived from a postwar Jewish education was the very one that threatened to implicate me in an alliance with an anti-Semitic text. The bind seemed almost airtight: to go against the hyperethicality of Judaism, I could go with Nietzsche, but to go with Nietzsche meant to go against Judaism, and this was unacceptable. If only he had left the anti-Semitic remarks aside, if only we could read him in such a way that those remarks really didn't matter!

I read since the age of fourteen a series of Jewish thinkers and writers, and if I am to be honest, I probably know more about them than I know about anything written in queer theory today. They included Maimonides, Spinoza, Buber, Benjamin, Arendt, and Scholem, and especially the work and letters of Kafka, whose ethical dilemmas impressed me as no less than sublime. But I clearly turned away from pursuing Jewish studies formally for fear, no doubt, that somewhere in those texts the crushing force of the unappeasable law would be upon me again. And I was drawn toward those kinds of readings that suspended the law, exposed its illegibility, its internal limits and contradictions, and even found Jewish authorization for those kinds of readings. I was also compelled to show that this kind of reading did not paralyze ethical or political action, to show that the law might be critically interrogated and mobilized at once.

Sometime in the last ten years I read some Levinas and found upon my first reading a hyperbolic instance of this superegoic law. I read, for instance, about the demand that is imposed upon me by the face of the Other, a demand that is "before all language and mimicry," a face that is *not* a representation, a demand that is *not* open to interpretation. "I am as it were ordered from the outside, traumatically commanded, without interiorizing by representation and concepts the authority that commands me, without asking myself: what then is he to me? where does he get his right to command?" (87).[1] What would it mean to obey such a demand, to acquiesce to such a demand when no critical evaluation of the demand could be made? Would such an acquiescence be any more or less uncritical and unthinking than an acquiescence to an ungrounded authoritarian law? How would one distinguish between a fascist demand and one which somehow affirms the ethical bonds between humans that Levinas understands as constitutive of the ethical subject?[2]

For the Levinas of *Otherwise than Being,* the reverse question seems to be paramount: Given that we reflect ethically on the principles and norms that guide our relations to others, are we not, prior to any such reflection, already in relation to others such that that reflection becomes possible—an ethical relation that is, as it were, prior to all reflection? For Levinas, the Other is not always or exclusively elsewhere; it makes its demand on me, but it is also of me: it is the constitutive relation of this subject to the ethical, one that both constitutes and divides the subject from the start. For Levinas, this splitting of the subject, foundationally, by the Other establishes this nonunitary subject as the basis for ethical responsibility.

This subject is, moreover, from the start split by the wound of the Other (not simply the wounds that the Other performs, but a wound that the Other somehow is, prior to any action). The task of this fundamentally wounded subject is to take responsibility

for the very other who, in Levinas's terms, "persecutes" that self. That Other delivers the command to take responsibility for the persecution that the Other inflicts. In effect, I do not take responsibility for the Other who wounds me after the wound has appeared. My openness to the Other is what allows for the wound and what also at the same time commands that I take responsibility for that Other.

When I first encountered this position, I ran in the opposite direction, understanding it as a valorization of self-sacrifice that would make excellent material for a Nietzschean psychological critique. This was clearly the will turned back upon itself, the reflexive rerouting of the *conatus* against its own strength, possibility for affirmation, and desire, a position that quite literally called into question self-preservation as the basis for ethical reflection. As an exercise, I would ask my students to take the above lines from Levinas and compare them with Nietzsche's from *On the Genealogy of Morals*: "Hostility, cruelty, joy in persecuting, in attacking, in change, in destruction—all turned against the possessors of such instincts: *that* is the origin of the 'bad conscience.' The man who, from lack of external enemies and resistances and forcibly confined to the oppressive narrowness and punctiliousness of custom, impatiently lacerated, persecuted, gnawed at, assaulted, and maltreated himself: . . . this deprived creature, racked with homesickness for the wild, who had to turn himself into an adventure, a torture chamber, an uncertain and dangerous wilderness—this fool, this yearning and desperate prisoner became the inventor of the 'bad conscience'" (85).[3]

Thus, it was with some wryness that I became aware of the sudden and enthusiastic turn to Levinas among the deconstructively minded after the Paul de Man affair broke into the public press. If the popular conclusion drawn from de Man's wartime writings was that something in that mode of deconstruction

leads to Nazi sympathizing, then perhaps there is a way to show that deconstruction is on the side of the Jews, that it can be made to serve an ethical demand that would put deconstruction on the side of responsibility, resistance, and antifascist ethics. My sense was that it made no sense to rush to a slave morality to avert the charge of fascism, and that there had to be some other way to navigate these alternatives besides heaping reaction formation upon reaction formation.

I don't know whether I have arrived at an alternative, or whether that is what I propose to offer you in the final pages of this paper. But I have come to think that the opposition that I saw between Levinas and Nietzsche was, perhaps, not quite as stark as I thought. I was going to write about the consonant meanings of "yielding" in Levinas, and "undergoing" in Nietzsche, but I am only able to clear the ground for a future reflection on the topic. I would like to point to two moments, instead, in which the subordinated becomes identified with the subordinator and where this identification is not simply an identification with the oppressor, but appears to be a paradoxical basis for a different order of commonality that puts the distinction between subordinator and subordinated into a useful crisis.

In the first essay of *On the Genealogy of Morals*, Nietzsche introduces the noble to us as someone with the capacity to forget; the noble has "no memory for insults" and his forgetfulness is clearly the condition of his capacity to exercise his will. (As he elaborates in the second essay, forgetfulness makes room for new experience, nourishes the "nobler" faculties, and keeps us from being preoccupied with what has happened to us [58–59]). The slave and the man of ressentiment, we are told, remember every insult perfectly, and develop a clear memory in the service of vengefulness.

Nietzsche then starts the second essay by introducing the animal who is bred with the right to make promises, and this ani-

mal turns out to be the noble in new form. What is paradoxical, and Nietzsche marks this, is that to make a promise means to have a memory, indeed, to have a continuous memory that lasts through time. If I say that I promise at one time, then my promise fails to remain a promise if, at another time, I forget what it is I have said. A promise is the sustained memory of an utterance, a memory that becomes instilled in the will, so that I not only say what it is I promise to do, but I also do precisely what I said I would do. The temporality of the utterance must, in the case of the promise, exceed the time and occasion of its enunciation. The linguistic deed of promising is "discharged" into the nonlinguistic deed precisely by virtue of this memory that becomes the resolution of the will.

Thus, this animal who requires forgetting also breeds in itself a capacity *to make and sustain a memory.* Forgetfulness is thus "abrogated"—Nietzsche's term—in those cases in which the need to sustain a memory of a promise emerges. He will tell us that within slave morality, a mnemonics of the will is prepared, that a memory is *burned* into the will, and that this burning is not only violent, but bloody (thus, Nietzsche's famous quip that Kant's categorical imperative is steeped in blood). The way in which this memory is burned in the will, however, is precisely through a reflexive venting of the will against itself. In other words, morality for the one within slave morality requires a self-inflicted violence. But is this actually different from the kind of memory of the will that the noble crafts for himself?

At the moment in which the noble seeks to have a memory, a continuous memory through time, is the noble acting like those who belong to the sphere of ressentiment? Can the noble keep his promise without *remembering an injury,* even if the injury that he remembers is one that he inflicts on himself?

The result of this self-infliction is a continuous and trustworthy will:

... between the original "I will," "I shall do this" and the actual discharge of the will, its *act,* a world of strange new things, circumstances, even acts of will may be interposed without breaking this long chain of will (58).[4]

The will of the promising animal is one that is extended through time, figured as "a long chain of will," suggesting that there are different interlocking links of the will which remain unbroken by new things and circumstances or other acts of will. Whatever it is I promise, I do. And I renew that promise in different circumstances, and keep that promise *despite all circumstances.*

Of course, the figure of a chain with discontinuous links is an odd one to stand for this putatively "continuous" will. Indeed, pages later, Nietzsche reinvokes the figure of the chain to support a contradictory conclusion. Writing of the law, he argues that it makes no sense to determine the function of the law in terms of the origins of the law, the original reasons why the law was made, the original purposes it sought to serve (77). As a social convention, the meanings and purposes of law change through time, they come to take on purposes that were never intended for them, and they no longer serve the original purposes for which they were devised. Nietzsche writes,

the cause of the origin of a thing and its eventual utility, its actual employment and place in a system of purposes, lie worlds apart; whatever exists, having somehow come into being, is again and again reinterpreted to new ends, taken over, transformed, and redirected by some power superior to it; all events in the organic world are a subduing, a *becoming master,* and all subduing and becoming master involves a fresh interpretation, an adaptation through which any previous "meaning" and "purpose" are necessarily obscured . . . (77).[5]

What happens if we return to the question of the status of the promise, if we understand the promise as one of the conventions that Nietzsche mentions above? Can it be said that the cause and origin of a promise lie worlds apart, if promising is understood as a custom, and its eventual utility, its actual employment and place in a system of purposes are in no necessary way linked to the act of promising itself? What does promising become if it is understood as one way to exercise a superior power, in Nietzsche's view, to reinterpret the promise to new ends, take it over, transform and redirect it? Or are we to conclude that promising as a customary act cannot exercise or manifest this superior power?

According to the above quotation, it seems that the "masterful" and "noble" thing to do is precisely to *revise* the meaning and purpose of a thing, an organ, or a custom according to new circumstances. And this power to reinterpret a convention to new ends not only requires becoming forgetful about the past, but characterizes the noble exercise of will.

The quotation continues:

> the entire history of a "thing," an organ, a custom can in this way be a continuous *sign-chain* [Zeichenkette] of ever new interpretations and adaptations [suggesting an adaptation to new circumstances] whose causes do not even have to be related to one another but, on the contrary, in some cases succeed and alternate with one another in a purely chance fashion (77).

This second use of the "chain" (*Kette*) seems to reverse the first, figuring the will as a chain of signs, a long sign-chain of the will, that indicates its uneven history. When the text makes this shift, the will, still called noble, not only adapts to new circumstances, but endows its customary utterances, including promises, with new meaning, divorcing it from its original and animating

intention. Indeed, therefore, to be a noble is precisely *not* to keep one's promise regardless of circumstance.

But here Nietzsche wants the noble to elude the self-terrorizing practice of the slave at the same time that he elevates the promise as the right and entitlement of the noble. What remains unclear, however, is whether the promise can be kept without some measure of self-terrorization. Nietzsche proposes that "something of the terror that formerly attended all promises, pledges, and vows on earth is still effective" (61). If the noble's promise does not elude that terror, is it a result of a certain self-terrorization, a terrorization of the will? And if so, is the conscience that is said to belong to the noble any different from the conscience that is said to belong to the slave? Can the noble, in other words, forget his terror and still sustain his promise?

The promise in Nietzsche seems to arise, then, from a necessary self-affliction, a terrorizing which was originally directed against the other which now preserves the Other, one might say in a Kleinian vein, precisely through a certain kind of sustainable damage to the self. Levinas's explanation clearly differs insofar as the wound is not to be understood as the reflexive form that aggression toward the Other takes, but constitutes something of the primary violence that marks our vulnerable, passive, and necessary relation to that Other. Indeed, for Levinas, the "I" is split from the start precisely by this yielding to the Other which is its primary mode of being and its irreducible relationality. Nietzsche's noble at first appears as an individuated figure, distinct from the slave, but are these figures actually distinct from one another? Indeed, does the one figure interrupt the other in much the same way that the Levinasian subject is fundamentally interrupted by its Other? Is Nietzsche's wounded relation to the promise which is, after all, invariably a promise to the Other any different from Levinas's wounded relation to alterity?

Just as, for Nietzsche, the injury to and by the other is "burned in the will" so Levinas writes that, "The Other is in me and in the midst of my very identification" (125). The Levinasian subject, we might say, also bears no grudges, assumes responsibility without ressentiment: "In suffering *by* the fault of the Other dawns suffering *for* the fault of Others." Indeed, this self is "accused by the Other to the point of persecution" and this very persecution implies a responsibility for the persecutor (126). Thus, to be persecuted and to be accused for this subject are that for which one takes responsibility: " . . . the position of the subject . . . is . . . a substitution by a hostage expiating for the violence of the persecution itself" (127). Importantly, there is no self prior to its persecution by the Other. It is that persecution that establishes the Other at the heart of the self, and establishes that "heart" as an ethical relation of responsibility. To claim the self-identity of the subject is thus an act of irresponsibility, an effort to close off one's fundamental vulnerability to the Other, the primary accusation that the Other bears. This is "an accusation I cannot answer, but for which I cannot decline responsibility. [*Accusation, en ce sens persécutrice, à laquelle le persécuté ne peut pas répondre—ou plus exactement—accusation à laquelle je ne peux répondre—mais dont je ne peux décliner la responsibilité*]" (127).[6] This primary responsibility for the persecutor establishes the basis for ethical responsibility.

Levinas dedicated *Otherwise than Being* "to the memory of those who were closest among the six million assassinated by the National Socialists, and of the millions and millions of all confessions and all nations, victims of the same hatred of the other [*la même haine de l'autre homme*], the same anti-Semitism." And just when it appears that Levinas has installed the Jew as the paradigm of all victimization, he warns on the next page against Zionist persecution, citing the precautionary words of Pascal: "'That is my place in the sun.' That is how the usurpation of the whole world began [*Voilà le commencement et*

l'image de l'usurpation de toute la terre]." And if it were not enough that the Jew figured here is *both* victim and persecutor, Levinas cites from Ezekiel the direct address of a God who bears the same double status, requiring violence and repentance at once: "if a righteous man turn from his righteousness . . . his blood will I require at your hands," and then, "pass through the city—through Jerusalem—and set a mark upon the foreheads of the men who sigh and cry for all the abominations that are done in the midst of it." But then, of course, God commits an abomination himself, instructing another man to follow the man he just instructed: "pass through the city after him and slay without mercy or pity. Old men, young men and maidens, little children and women—strike them all dead! But touch no one on whom is the mark. And begin at my sanctuary!" Thus, God endeavors to save from destruction those who bemoan the abominations, but he commits an abomination precisely in the act of providing salvation. Thus, God cannot condemn abomination without that condemnation becoming an abomination itself. Even with God, good and evil are less than distinct.

The subject who might seek to become righteous according to the ways of such a God will be one who is not only accused and persecuted from the start, but one who is also accusing and persecuting. In this view, there is no innocence, only the navigations of ambivalence, since it seems to be impossible to be persecuted without at once being or becoming the persecutor as well. What remains to be considered is how this scene of ethical inversion nevertheless leads to a responsibility that is, by definition it seems, constantly confounded by self-preservation and its attendant aggressions. If there is no becoming ethical save through a certain violence, then how are we to gauge the value of such an ethics? Is it the only mode for ethics, and what becomes of an ethics of nonviolence? And how often does the violence of ethics, seen most clearly when in the act of righteous denunciation,[7] pose the question of the value of the ethical rela-

tion itself? Certain kinds of values, such as generosity and forgiveness, may only be possible through a suspension of this mode of ethicality and, indeed, by calling into question the value of ethics itself.

Levinas recognizes that it is not always possible to live or love well under such conditions. He refers to this primary ethical relation to alterity as "breathless," as if the Other is what is breathed in and preserved within the hollow of the self, as if this very preservation puts the life of the ethical subject at risk. I don't know whether air that is not exhaled comes close to becoming "bad air," but certainly the ethical bearing in this instance degrades the biological conditions of life. Given that the Levinasian subject also rehearses an "insomniac vigilance" in relation to the Other, it may still be necessary to continue to call for "good air" and to find a place for the value of self-preservation, if one wants, for instance, to breathe and to sleep.

NOTES

1. This and subsequent quotations from Emmanuel Levinas are from *Otherwise than Being or Beyond Essence,* trans. Alphonso Lingis (Boston: Kluwer, 1978).

2. The ethical relation is that of a passivity beyond passivity, one that escapes from the binary opposition of passive and active; it is an "effacement," a "bad conscience," a primordial exposure to the Other, to the face of the Other, to the demand that is made by the face of the Other. "To have to respond to [the Other's] right to be—not by reference to the abstraction of some anonymous law, some juridical entity, but in fear of the Other. My 'in the world' [alluding to Heidegger], my 'place in the sun,' my at homeness, have they not been the usurpation of the places belonging to the other man already oppressed and starved by me?"("Bad Conscience and the Inexorable" in *Face to Face with Levinas,* ed. Richard A . Cohen [Albany: State University of New York Press, 1986], 38).

3. This and subsequent quotations from Friedrich Nietzsche are from *On the Genealogy of Morals,* trans. Walter Kaufmann (New York: Random House, 1967). In German: "Die Feindschaft, die Grausamkeit, die Lust an der Verfolgung, am Überfall, am Wechsel, an der Zerstörung—alles das gegen die Inhaber solcher Instinkte sich wendend: *das ist* der Ursprung des 'schlechten Gewissens'" (*Friedrich Nietzsche, Zweiter Band* [München: Carl Hanser Verlag, 1966], 799).

4. In German: "so das zwischen das urprungliche 'ich will,' 'ich werde' tun' und die eigentliche Entladung des Willens, seinen *Akt*, unbedenklich eine Welt von neuen fremden Dingen, Umständen, selbst Willensakten dazwischengelegt werden darf, ohne dass diese lange Kette des Willens spring" (800).

5. In German: ". . . die Ursache der Entstehung eines Dinges und dessen schliessliche Nützlichkeit, dessen tatsächliche Verwendung und Einordnung in ein System von Zwecken *toto coelo* auseinander liegen; das etwas Vorhandenes, irgendwie Zustande/Gekommenes immer wieder von einer ihm überlegnen Macht auf neue Absichten ausgelegt, neu in Beschlag genommen, zu einem neuen Nutzen umgebildet und umgerichtet wird; dass alles Geschehen in der organischen Welt ein Überwältigen, Herr-werden und dass wiederum alles Überwältigen und Herr-werden ein Neu-Interpretieren, ein Zurechtmachen ist, bei dem der bisherige 'Sinn' und 'Zweck' notwendig verdunkelt oder ganz ausgelöst werden muss" (817–18).

6. The original French is quoted from *Autrement qu'être ou au delà de l'essence*, 2nd ed. (The Hague: M. Nijhoff, 1978), 202.

7. See various acts of moral denunciation of late delivered against critical theorists working with the resources of the continental philosophical tradition.

The Ethical Practice of Modernity
The Example of Reading

John Guillory

*t*he renewal of interest in questions of the "ethical" in recent years testifies to the enduring nature of certain philosophical problems. If there has even been a "turn to ethics" in a number of disciplines, this event raises the question of what one turns *from* in order to arrive at the ethical. I would like to suggest that the inevitable answer to this question, at the present moment, is the *political*. The turn to ethics is a turn away from the political. Let us admit that to advocate such a turn risks abandoning politics itself to the forces of reaction. The reduction of politics to morality, to the spectacle of a morality play, is just what has occurred in the political public

sphere, culminating in the impeachment proceedings of 1999. Discourse in the public sphere often seems driven by the political right, which sees all political questions in terms of an absolutist morality. In the light of this development, any "turn to ethics" must be regarded, at least initially, with suspicion.

A turn away from the political is precisely how many of those in my own discipline—literary study—have understood the long history of the discipline. Literary critics were supposed once to have been actively engaged in the public sphere, debating the political issues of the day. But over the course of the present century criticism is said to have retreated into the academy, where it was domesticated into an apolitical, professionalized discourse. Only in the last several decades has this tendency been reversed, by virtue of a renewed commitment to the political possibilities of criticism, and against the clamor of those within and without the academy who decry the "politicization" of criticism. In the context of the "culture wars," talk of a turn to the ethical will almost certainly be perceived as a regression from the current *engagé* mode of criticism.

Without endorsing this perception, or its converse, I would nonetheless like to propose that something like a turn to ethics is desirable and even inevitable for literary study at the present time. This turn will not involve, I hasten to add, purging the discipline of its political interests, or denying the relation between literary study and the political domain. Such a turn, in other words, need not be a turn away from the political; it should rather set out from the recognition that the social practice that grounds our discipline, the practice of *reading*, is nothing other than an ethical practice. Any turn to the ethical must be undertaken in the context of a reflection upon this practice, in its specificity. This reflection will mean no more than the *self-recognition* of reading.

Before developing this proposition, it will be necessary to make one other preliminary point. It is my sense that academic

literary critics have attempted to repoliticize literary study without fully understanding the relation between disciplines of study in the university and the political domain. This defect of understanding is nowhere more evident than when we attempt to determine what are the actual effects in the world of what we do, either as teachers or as scholars. We have as yet no credible way to assess these effects, and in the absence of such determinable measures, we tend to indulge in what I will call a political fantasy, the fantasy of transforming the world to a degree vastly greater than can reasonably be expected of perhaps any disciplinary practice. Despite the manifest appeal of this fantasy, there is a reality against which it must always come to grief. However much we may hope to produce specifically political effects, or to "change the world" in a specified political sense, any and every effect we have in the world must be achieved through a practice of reading. The limits of this reading practice constitute the limits of disciplinary power.

The social reality that confounds our best intentions is just this: There is an enormous gap between reading as it is practiced within and without the academy. Our mode of reading, what I will call "professional reading," is characterized by four very particular features: First of all, it is a kind of *work*, a labor requiring large amounts of time and resources. This labor is compensated as such, by a salary. Second, it is a *disciplinary* activity, that is, it is governed by conventions of interpretation and protocols of research developed over many decades. These techniques take years to acquire; otherwise we would not award higher degrees to those who succeed in mastering them. Third, professional reading is *vigilant;* it stands back from the experience of pleasure in reading, not in order to cancel out this pleasure, but in order necessarily to be wary of it, so that the experience of reading does not begin and end in the pleasure of consumption, but gives rise to a certain sustained reflection. And fourth, this reading is a *communal* practice. Even when the

scholar reads in privacy, this act of reading is connected in numerous ways to communal scenes; and it is often dedicated to the end of a public and publishable "reading." It envisions an audience of students or scholars, in the classroom or in print. These performed "readings" thus submit to the response and judgment of other professional readers.

Outside the academy it is very difficult to engage in a practice of reading such as I have just described. This does not mean that some aspects of it cannot be replicated there; but lack of time and resources alone are insuperable impediments to its replication for most nonprofessional or "lay" readers. Lay reading can be characterized by four features which are both opposed to those of professional reading and also simply different, or incommensurable. Lay reading is first of all practiced at the site of *leisure*. The same literary works that we read in the academy, if they are read outside it, are also read outside the context of work. Second, the *conventions* of lay reading are very different from those of disciplinary or professional reading. One has only to invoke the relation between the occasions of reading—breakfast, bedtime, weekends, vacations, on the subway, in the waiting room—and the reading matter appropriate to those occasions—newspapers, magazines, fiction, genre novels, self-help books—in order to see that lay reading is indeed organized by very different conventions than professional reading. Third, lay reading is motivated by the experience of *pleasure*, which may be a sufficient motive for reading. Lay reading may involve a number of other ends—specifically moral or edifying—of which I shall speak presently; but the experience of pleasure will constitute the first and necessary motive of reading. Fourth and finally, lay reading is largely a *solitary* practice. Its scenes of communal reading are seldom formally organized, but rather occur by chance or in an ad hoc manner. It is this solitariness that has come increasingly to characterize lay reading in the modern era.

Given the relative incommensurability of professional and lay reading, it should be evident why contemporary literary study must resort to a political fantasy in order to describe its effects in the world as in any ascertainable way transformative. Those of us who are professional readers cannot hope to see our reading practice simply replicated outside the academy. On the contrary, the difference between professional and lay reading grows ever more marked, given first, that professionalization is an ever more complex process, and second, that leisure time is increasingly shared among many competitive activities in addition to reading. It is in this circumstance that a certain mutual misunderstanding has arisen between lay and professional readers, a sense on the one side that the professors have betrayed their traditional duty to offer guidance to lay readers, and on the other, that sophisticated and politically vigilant techniques of reading can have transformative effects well beyond the sphere of their practice.

It seems to me altogether unrealistic that we should expect those without the academy to exercise the same vigilance in relation to their pleasure as we do in the context of professional reading. But it is also very unfortunate for our society that leisured reading so often falls to the level of immediate consumption, with no other end than pleasure or distraction—or rather, that kind of pleasure which is distraction. Of course I am describing here lay reading and professional reading as they generally are, not as they always are, and certainly not as they must be.[1] The mutual incomprehension of these practices of reading is painfully evident to those of us—I mean those teachers of literature—who want so badly for our best students to go on to graduate school, even when the market for new Ph.D.'s is at best uncertain; for are we not thinking, as are they, that they will never again be able to read as they have learned to read under our professional tutelage, unless that tutelage continues? And those readers outside the academy who have escaped our

seduction, do they not suspect that we would like nothing better than to deprive them of their pleasure, to impose upon them a joyless and disillusioned vigilance, when they are eager for some more uplifting pleasure whose content they cannot name, except by naming great works of literature?

I suggest that this mutual misapprehension is poorly understood when it is invoked as political conflict, between left and right. What is really at issue is the polarization of reading practices in our society, the political significance of which is not at all given. What is most striking about this situation in sociological terms is that it has become very hard to conceive of intermediate practices of reading, between the poles of entertainment on the one side, and vigilant professionalism on the other. Professional reading and lay reading have become so disconnected that it has become hard to see how they are both reading. In order to see the underlying identity of these practices (given also that professional readers are also, in other contexts, lay readers), that is, to understand what reading is as a social practice, it will be necessary to negotiate here a certain turn to the ethical, which is a turn away from the political only in the narrow sense of a turn from political fantasy. Reading is a practice, I propose, that falls within the domain of the ethical. The ethical names the specificity of this practice. Here I must set out what I hope will be a plausible, if radically foreshortened, account of what I mean by an ethical practice. To accelerate this exposition I would like to invoke the precedent of Michel Foucault, who arguably undertook in his later work precisely a turn from the political to the ethical.

The turn of which I speak in Foucault's work occurred between the first and subsequent two volumes of *The History of Sexuality*. This turn coincided with a surprising movement away from the subject of sexuality itself—which, as we all know, had been the occasion for Foucault's reconceptualization of the political in terms of the power/knowledge complement, or "bio-power." It

was by means of the latter formulation that Foucault "politicized" sexuality, thereby bequeathing to a generation of theorists in the United States a paradigm for politicizing the whole cultural field. This paradigm was enthusiastically taken up within the field of literary criticism in connection with a turn in the field to "cultural studies."

In the second and third volumes of the *The History of Sexuality,* sexuality itself recedes from the foreground of Foucault's interest, but so, significantly, does the political.[2] In these latter two volumes, *The Use of Pleasure* and *The Care of the Self,* Foucault set out to discover the form of sexuality in antiquity. Sexuality in the antique world was not, he found, an emanation of power/knowledge—Volume I had already argued that this form was modern—but rather one of a number of "techniques of the self." These practices, which he calls summarily the "care of the self," took as their aim a mastery of the body for the sake of enhancing happiness, well-being, and pleasure. Sexual practice could be ranged with diet and exercise as one among a number of such techniques of the self, or the *ethos.* Sexuality was neither as important as it came to be in modernity, nor was it the object of power/knowledege, or the political. Foucault rather described sexual practice and other correlative practices of the care of the self as "ethical." This turn was very surprising indeed; it allowed Foucault to remark in late interviews that "sex is boring," by which, presumably, he meant sex in modern, disciplinary form, when sex became the object of knowledge, and as such could be delivered over to the the disciplinary society of the doctors and the psychiatrists. In short, the sex that is boring is the sex that is political.[3]

Foucault goes very far indeed in making his turn to the ethical. He remarks in the same late interview from which I have been quoting that he believes "we have to get rid of this idea of an analytical or necessary link between ethics and other social or economic or political structures" (261). In my view Foucault

goes farther than he needs to go in detaching the ethical from the political domain, since demarcating an ethical domain is not a question of positing wholly autonomous practices but of specifying relations among practices. Foucault seems to have insisted on an autonomous domain of the ethical as a way of exploring possibilities for individual action at the present moment, in the face of disciplinary society. What, after all, can ethics be for us? What would it mean to restore sexual practice to the domain of the ethical, as Foucault defines it?

Before touching on Foucault's answer to this question, we will have to acknowledge that another term has to be situated in this scheme of analysis, and which we have simply neglected to mention: *morality*. In fact, we might say that Foucault politicized sexuality by demonstrating that the system of morality was only an expression of power/knowledge. For Foucault, the transition from the "confessional" to disciplinary society represents the appropriation of the moral law into the regime of psychological "normality." To politicize sexuality also meant to politicize morality, and to see normalization as the subtler version of morality under the new politics of power/knowledge. This construction of morality as the agent of the political was immensely strategic for Foucault, because it permitted a sharp distinction between the moral code of modernity and the ethical practice of antiquity. It also explained the relative absence of a discrete ethical practice in modernity. Ethics had disappeared behind the great wall of morality, with its categorical distinction between right and wrong, and its defining character as *obligation*. Every stone of the moral law was mortared into place, and choice within morality could only then be choice between right and wrong, good and evil. Ethics was by contrast a realm in which one chose *between goods*, not between good and evil, and a mode of action distinguished by possibilities of pleasure rather than the sense of obligation. When Foucault looked for ethical practice within modernity he found it only in the realm

of the aesthetic, and as a consequence he tended to speak of the ethical in his later work as an "aesthetics of existence," or an "art of life."

Now I would suggest that in fact Foucault's rediscovery of aestheticism as the recurrence of the ethical glossed over many difficulties in his later theory, which remains permanently underdeveloped as a consequence of his premature death. But I would also like to argue that his turn to the ethical is suggestive for certain problems that beset those of us in literary and cultural studies, who have perhaps assimilated too easily Foucault's own reconstruction of all social relations as relations of power, as the universalization of the field of the political. Aestheticism is an appealing alternative to the politicization of everything, but I wonder whether we should not be troubled by the fact that the great moment of aestheticism—the later nineteenth century— happens to coincide with the consolidation of the regime of power/knowledge, when sexuality itself emerged as the supreme invention of power, the means to extend discipline into the very depths of the psyche by making the psyche itself nothing other than the secret of sexuality. Foucault recoiled against sexuality and into the arms of the Greeks, who seemed to have regarded sexual practice as the construction of individual *ethos,* not as an expression of power/knowledge or social control.[4] But these Greeks may finally only be "other Victorians," just like those Victorians whose aestheticism set itself against the regime of sexuality, with its moralization (and thus politicization) of sexual practice. In such a context, the ethical/aesthetic constituted a negation or denial of the political, in its disciplinary form, rather than the cultivation of a truly autonomous realm. Such autonomy is in any case not possible, and what we shall have to explore instead is the range of possible relations between the ethical/aesthetic and the political/moral.

With this caveat in mind—that the ethical cannot represent a turn from the political in any absolute or unqualified fashion—I

would like to take from Foucault what I hope will be a working concept of the ethical, a concept by means of which we might reconsider the practice of reading, in such a way as to reflect on the polarity between lay and professional reading. We have no concept in current usage, unfortunately, for the category of choice between goods, but let us suppose that conduct can be arrayed along a spectrum extending from morality at one end, the choice between right and wrong, and the aesthetic at the other, the choice among objects of beauty. The ethical then would occupy a terrain in the middle of this spectrum as the choice between goods. This usage would conform more or less to the philosophical problematic descending from Socrates of "how to live," which is a question not reducible to adherence to moral law or "obligation." Ethics is not just a synonym for morality, then, nor does it replace morality. Unfortunately such a clarification will not relieve us of having to live with the ambiguous relation between the concepts of "morality" and "ethics," which are only tenuously distinct in common usage.[5] If ethics has been largely identified with the choice between right and wrong, my adaptation of Foucault may only succeed in reserving a difference or space within ethics for the choice between goods. Finally I would stress that the ethical cannot simply be conflated with the aesthetic, as Foucault was tempted to do. The "aestheticization of life" draws on aesthetic judgment, but it is an ethical practice, a domain of choice about actions. To repeat, the ethical has a relation of continuity with *both* the aesthetic and the moral.

If ethics is a practice of the sort that might entail the "care of the self," it has its proper domain or areas of action. Foucault tended to think that this domain was usurped in modernity by morality or medicine, as the co-agents of power/knowledge, and in fact, it is not difficult to detect this usurpation at work. It occurs every time we conceive an ethical practice as a question of sin or abnormality—every time, for example, we call overeat-

ing a sin, or every time we wonder whether indulging in some particular sexual fantasy makes us abnormal or sick. Ethical practice is in truth very hard to see in our society, but I do not believe that it is absent altogether. I would like to invoke in this context the category of "therapy," and specifically self-therapy or self-help, as the perhaps degraded form of Foucault's ethical practice, but nonetheless a practice not wholly subordinate to the disciplinary authority of the medical expert. Our "therapy culture" contains within it genuinely ethical practices; for example, the rediscovery of exercise—we have indeed reinvented the Greek gymnasium. The tendency of such practices to be experienced on the one hand as "moralized," or on the other as mere acts of consumption, should not obscure their ethical content. Even when the choice among goods is expressed exclusively as the choice among commodities—the other sense of "goods"— consumption still holds out the possibility for actualizing the ethical, as the aestheticization of everyday life, or what Simmel long ago called "lifestyle."

I would like to propose now that reading belongs to the field of the ethical because it is a practice on the self, and because the motive of pleasure in reading contains within it the potentiality for what was known in the early modern period as "self-improvement." So far as I know, Foucault only once mentions reading in connection with the ethical, but I suggest here a certain historical thesis in the spirit of Foucault: that reading is the *principal* ethical practice of modernity, the site where a practice of the self has not been entirely or easily subordinated to the moral code, or rendered solely an instrument of power/knowledge. This is never to say, of course, that reading has no relation to the political, but that its subsumption to the political misconstrues important aspects of its historical development. In the remaining pages, I will attempt to sketch briefly these features of modern reading as ethical practice, with special attention to the question of lay reading.

Let us begin with the recognition that reading has always been an extremely heterogeneous practice, with diverse social functions. I will not pause here over reading in antiquity and the Middle Ages, except to point out that the condition for the full development of reading as an ethical practice of the laity had to await the innovation of silent reading.[6] Until about 1000 A.D. almost all reading was reading aloud, a condition that was correlated to the fact that reading was largely a communal practice, as well as highly ritualized, very closely allied, for example, to prayer and meditation. To be sure, there was pleasure in reading, but this pleasure was difficult to separate from the other functions of reading. It tended to be justified rather as the vehicle for moral doctrine—not as a good in itself.

The development of reading in modernity is marked by the gradual and very uneven demarcation of pleasure as a legitimate end of reading, as an end in itself. At the same time, reading moved out of the domain of the professional reader, the cleric, into the world of the laity, and into the emergent domain of leisure or entertainment. The latter domain was still often the site of communal reading, of reading aloud before groups, but it was also the site in which the solitary reader appeared. Solitary reading for pleasure was initially perceived as socially threatening, subject to suspicion and surveillance. It was not clear at all during the early history of the novel, for example, whether the pleasure of novel reading was sufficiently justified by the moral doctrine novels were supposed to contain. John Brewer reminds us in his recent study of eighteenth-century entertainments that a connection was sometimes made between novel reading by women and masturbation, a fact which conveys very vividly how suspect solitary reading could be.[7] And indeed, one might say that the pleasure of solitary reading was the occasion in the eighteenth century for *problematizing* reading, as a result of which eighteenth-century readers could begin to theorize about the beneficial effects of reading as well as its dangers. As a result

of these reflections, reading came to be regarded as an instrument for self-improvement, or in Foucault's terms, an ethical practice.

Self-improvement in turn had to be seen as the effect of pleasure itself. Pleasure was no longer justified as the sweet shell of the moral kernel, or merely the vehicle of the moral code. One cannot stress too strongly that it was rather the experience of pleasure itself that was to produce the improving effect. Here is one early lay reader, Eliza Haywood, making just this claim in the opening sentences of her subscription series of 1744, *The Female Spectator*: "It is very much by the choice we make of subjects for our entertainment, that the refined taste distinguishes itself from the vulgar and more gross. Reading is universally allowed to be one of the most improving as well as agreeable amusements . . ."[8] For all that can justly be said about the social agendas implicit in the cultivation of the taste Haywood extolls—and her distinction between the vulgar and the refined makes those agendas explicit—we must not overlook the fact that the pleasure experienced in the exercise of judgment has become in some measure detached from the process by which the moral lesson is extracted from the literary work. Here we can see the ethical emerge in its typical modern form, which involves a close alliance between the ethical and the aesthetic, and an uneasy or defensive relation to the moral.

Unfortunately the ethical is too easily and even usually reabsorbed into the moral, on the one hand, or conflated with the aesthetic, on the other (the trajectory whose end is aestheticism). In either case, we lose sight of the ethical as a distinct practice or care of the self, as the choice between goods. It is still possible and even common for lay readers to justify their reading by invoking the end of self-improvement, but all too often self-improvement is understood in narrowly moral terms, as apprehending and internalizing the "moral" of a text. It remains difficult to see pleasure itself, or the quality of a pleasure, as

self-improving, as the substance of a practice on the self. Reading is in truth much more analogous to exercise, or conversation with friends, or sexual practice, than it is to morality. And yet pleasure, even the pleasure of reading, appears within modernity already stigmatized as intrinsically immoral. This stigma is imprinted on even the most rigorous aestheticism as the gestural stance of the "immoralist," who must experience aesthetic pleasure as the negation of the moral law.

It is no small irony of the modern era that the aesthetic is condemned to appear in this negative relation to the moral, but this implacable fate is really the effect of an occultation of the ethical. The practice of reading, as the principal ethical practice of modernity, has suffered in a peculiar way the effect of this occultation, which is nothing other, as I have suggested, than a failure to recognize itself. This failure underlies the mutual misrecognition of lay and professional reading. This is not a question, I should emphasize, of failing to recognize that these distinct modes of reading exist, or that their distinction is inevitable and even necessary, but that lay and professional reading both fail to recognize their identity as *ethical* practice.

This failure of recognition is no less characteristic of professional reading than of lay reading—only professional readers now invoke the name of the "political" when for the most part they mean nothing more than a moral justification for reading, a re-moralization of reading. For professional readers, of course, the pleasure of reading is deferred by the stance of vigilance, or indefinitely diffused through an ascetic disciplinary practice. Yet reading as an ethical practice of self-improvement through pleasure subsists unrecognized within professional reading, in the same way that it subsists within lay reading. If the pleasure of professional reading is "ascetic," a labored pleasure, the end of this pleasure is lost when it is justified only in terms of its *effect on others,* an effect professional readers now like to regard as "political." Suppose we rather conceived the

practice of reading as an ethical practice, whose object is first of all oneself? Would such a practice exclude political vigilance? If we are tempted to think that it would, then I would say in response that we have not understood reading as an ethical practice, that we are still inclined to oppose pleasure to the political in the same way that some still oppose pleasure to the moral. Our understanding of reading thus lingers on this side of a theoretical threshold, awaiting an analysis of the political effects of ethical practice.

Reading emerged as an ethical practice of modernity only to be subsumed on the one side to mere consumption, and on the other to a highly serious, professionalized labor. In the context of mass-mediated pleasures, and of a strict division between work and leisure, lay reading tends to reduce the pleasure of reading to the immediacy of consumption, with no other end than momentary distraction. Professional reading by contrast tends to oppose its ascetic practice to pleasure, or to justify pleasure only as a means to a political end. The distinction between professional and lay reading thus repeats the occultation of the ethical by the moral and the aesthetic, and reinforces the non-recognition of reading as an ethical practice. The ultimate consequences of this nonrecognition, I should like to suggest finally, are *political*. For are we not observing here precisely the effects of noncommunication between the laity and the intellectuals? The fact that the cultures of intellectual expertise fail to communicate across the gap between themselves and the cultures of consumption evacuates the public sphere of any discourse that is not merely entertaining; the political can be admitted into this sphere only in the entertaining form of moral spectacle. If the practice of reading is either lay or professional, either pleasure or labor, but never both, it is difficult to see how the public sphere is ever to be other than it is now, a massified sphere of entertainment, in which the discourse of the professionals is assimilated only in the most refracted and distorted form, as a

threat to the pleasure of the people. The political public sphere depends finally upon the cultivation of an intermediate ethical practice, upon the development of the capabilities of private citizens through their individual practices upon themselves. Reading can be such a practice, but only insofar as it is not reducible to a pure pleasure of consumption, or to the instrument of morality.

The absence of an intermediate practice between lay and professional reading is sadly evident in the case of those lay readers who do seek once again to read for the sake of "self-improvement." Such a practice, known pejoratively as "middlebrow," defers the pleasures of mass distraction without much assurance of other pleasures, and with only a very vague sense of how such reading might be self-improving. Because it defers a more immediate pleasure, this practice of reading can claim to be virtuous, but it fails on that account to be ethical. It is reading as a solitary virtue. Professional reading likewise misrecognizes its own practice, because its political fantasy may conceal nothing more than the aspiration to a kind of communal virtue, which is no less moralist for being communal. In that case, let us, as professional readers, by all means turn to ethics if only to recognize reading for what it is, an ethical practice.

NOTES

1 I am mindful here of the argument of Michel de Certeau, in his *Practice of Everyday Life* (Berkeley: University of California Press, 1984), that we should not underestimate lay reading, which he rightly regards as a productive as well as consumptive activity. Nonetheless I would suggest that when de Certeau describes this reading, he tends to project onto it a certain transgressive desire that may or may not characterize any individual act of lay reading. The analogy of reading to "poaching" in his account, however appealing, projects the political desire of the professional reader onto lay reading practices.

2. See *The Use of Pleasure*, trans. Robert Hurley (New York: Vintage Books, 1985), and *The Care of the Self*, trans. Robert Hurley (New York: Vintage Books, 1986).

3. "On the Genealogy of Ethics: An Overview of Work in Progress" (1983), in *Michel Foucault: Ethics: Subjectivity and Truth, The Essential Works of Foucault 1954–1984*, Vol. I, ed. Paul Rabinow (New York: The New Press, 1994), 253.

4. See "On the Genealogy of Ethics," 254: "I don't think that we can say that this kind of ethics was an attempt to normalize the population." On the question of whether Foucault's understanding of the ancients is accurate, see Pierre Hadot, "Reflections on the Notion of 'the Cultivation of the Self,'" in *Michel Foucault: Philosopher* (New York: Routledge, 1992), 225–32. Foucault was strongly influenced by Hadot's depiction of philosophical culture, which he appropriated in his own philosophical project. This goes some way toward explaining the strong link between antiquity and the later nineteenth century in Foucault's later thought. For a recent and very penetrating account of the later Foucault, in terms close to my own, see Alexander Nehamas, *The Art of Living: Socratic Reflections from Plato to Foucault* (Berkeley: University of California Press, 1998).

5. This confusion is all the worse because it is so discordant with philosophical usage. In English, "ethics" tends to refer to a wider domain of reflection on right and wrong than "morality," and it thus names an area within the discipline of philosophy. "Morality" tends to be used commonly to refer to specific moral systems, such as "Christian morality." But in the German idealist tradition, from which philosophical thought on ethics largely descends, the principal terminological distinction is between *Moralität*, as the domain of reflective and conscious choice between right and wrong, and *Sittlichkeit*, or the "ethical," which refers to the domain of customary morality, and which does not necessarily entail reflective and conscious choice. In adopting Foucault's use of "ethics," despite his occasional misconstruction of this concept in antiquity, I would emphasize on the one hand the continuity of ethics with *Moralität*, as a domain of choice, and its distinction, as the choice between goods. It is also more obviously distinct from *Sittlichkeit*, or custom. For a critique of Foucault's representation of the ethical in antiquity, see Hadot, "Reflections," 225–32. For a recent philosophical attempt to institute a rigorous distinction between morality and ethics, in which ethics is defined by the question of "how to live," and morality is circumscribed as a special kind of ethics, see Bernard Williams, *Ethics and the Limits of Philosophy* (Cambridge, Mass.: Harvard University Press, 1985).

6. I will not attempt to address here the outstanding historiographical problems raised by the history of reading, about which much, but not nearly enough, has been written. For a good introduction to these questions, see Roger Chartier, *The Order of Books: Readers, Authors, and Libraries in Europe between the Fourteenth and Eighteenth Centuries*, trans. Lydia G. Cochrane (Stanford, Calif.: Stanford University Press, 1994). For an interesting discussion of the

very different reading practices of the medieval era, see Ivan Illich, *In the Garden of the Text: A Commentary on Hugh's Didascalicon* (Chicago: University of Chicago Press, 1993). For reading in modernity, see *The Practice and Representation of Reading in England,* ed. James Raven et al. (Cambridge: Cambridge University Press, 1996); Adrian Johns, *The Nature of the Book* (Chicago: University of Chicago Press, 1998); John Brewer, *The Pleasures of the Imagination: English Culture in the Eighteenth Century* (New York: Farrar Strauss Giroux, 1997).

7. Brewer, *The Pleasures of the Imagination,* xxii. See also the discussion of John Cannon, who "claimed to have learned to masturbate as a result of reading *Aristotle's Masterpiece,* a standard work of sexual instruction" (186). For further discussion of this question, see Thomas Laqueur, "Credit, Novels, Masturbation," in Laqueur, *Choreographing History* (Bloomington: Indiana University Press, 1995).

8. *Women Critics: 1660–1820: An Anthology,* ed. Virginia Walcott Beauchamp et al. (Bloomington: Indiana University Press, 1995), 68.

Using People

Kant with Winnicott

Barbara Johnson

sing people, transforming others into a means for obtaining an end for oneself, is generally considered the very antithesis of ethical behavior. And with good reason. Faced with the violence of colonial, sexual, and even epistemological appropriation, ethical theorists have sought to replace domination with respect, knowledge with responsibility. But it sometimes seems as though a thought that begins in intersubjectivity or mutuality ends up sounding like a mere defense of the Other against the potential violence of the Subject. All too often, such theorists conclude, as does the following translator of Emmanuel Levinas, "Ontology becomes

indebtedness to what is, a quiet listening vigilant against its own interference, cautious of its own interventions, careful not to disturb."[1] But if ethics is defined in relation to the potentially violent excesses of the subject's power, then that power is in reality being presupposed and reinforced in the very attempt to undercut it. What is being denied from the outset is the subject's *lack* of power, its vulnerability and dependence. Respect and distance are certainly better than violence and appropriation, but is ethics only a form of restraint? In this paper I take for granted the necessity of critiques of the imperial subject, but I would nevertheless like to question the model of intactness on which such critiques usually rely. Might there not, at least on the psychological level, be another way to use people?

The classic formulation of the stricture against using people is given in Kant's second *Critique:*

> It follows of itself that, in the order of ends, man (and every rational being) is an end-in-himself, i.e., he is never to be used merely as a means for someone (even for God) without at the same time being himself an end. . . . This moral law is founded on the autonomy of his will as a free will, which by its universal laws must necessarily be able to agree with that to which it subjects itself. [2]

Kant, of course, warns against treating people as a means without also treating them as an end, which is not the same as excluding using people altogether. But using people has nevertheless acquired an entirely negative connotation ("I feel so *used!*").

Using people can be understood simply as exploitation, as when a person with power or resources makes use of the undercompensated labor of others in order to increase his or her power or resources. Or, interpersonally, using people is commonly associated with a scenario in which one person professes to be interested in another person in order to obtain something

for him- or herself. Less intrumentally but just as commonly, people can also use other people in the service of their own narcissistic consolidation, as when, in Heinz Kohut's words, "the expected control over the narcissistically cathected object . . . is closer to the concept which a grownup has of himself and of the control which he expects over his own body and mind than to the grownup's experience of others and of his control over them (which generally leads to the result that the object of such narcissistic 'love' feels oppressed and enslaved by the subject's expectations and demands)."[3] The literary elaboration of this narcissistic enslavement takes the form of idealization and thingification, from Pygmalion's beloved ivory girl to the female bodies turned to milk, cherries, pearls, and gold through the magic of poetry. One of the founding insights of feminist criticism has been to point out that the idealized, beloved woman is often described as an object, a thing, rather than a subject. But perhaps the problem with being used arises from an inequality of power rather than from something inherently unhealthy about *willingly* playing the role of thing. Indeed, what if the capacity to become a subject were something that could best be *learned* from an object? Not an idealized object, but rather, say, a smelly blanket with a frayed edge?

That smelly blanket has played a starring role in the theory of transitional objects worked out by D. W. Winnicott, to which I will now attend in some detail. The objectness of the object is fundamental to its function, yet Winnicott is careful to caution against simply equating the transitional object with the blanket, thumb, or teddy bear that may take on this role. Transitional objects, he explains, are the first "not-me" possessions, objects that are neither "internal" to the baby (that is, hallucinatory, like, at first, the mother's breast) nor "external," like reality, of which at first the baby has no knowledge, but something in between. The transitional object is not a narcissistic object—it does not offer an image of body wholeness like the image in

Lacan's mirror. It is not an image but a thing.[4] The most valuable property of the transitional object is probably its lack of perfection, its irrelevance to the question of perfection.

As its name implies, the transitional object is a "between." It is often associated with the blanket or teddy bear to which the child grows attached, but Winnicott tries to keep opening a different space between—between, for example, the thumb and the teddy bear. Winnicott's task is to put something into words that is hard to put into words. In the introduction to *Playing and Reality,* he explains that what he is trying to keep hold of is not an object but a paradox:

> It is now generally recognized, I believe, that what I am referring to in this part of my work is not the cloth or the teddy bear that the baby uses—not so much the object used as the use of the object. I am drawing attention to the paradox involved in the use by the infant of what I have called the transitional object. My contribution is to ask for a paradox to be accepted and tolerated and respected, and for it not to be resolved. By flight to split-off intellectual functioning it is possible to resolve the paradox, but the price of this is the loss of the value of the paradox itself. This paradox, once accepted and tolerated, has value for every human individual who is not only alive and living in this world but who is also capable of being infinitely enriched by exploitation of the cultural link with the past and with the future.[5]

This is a typical move in Winnicott's text: going within a sentence or two from establishing the finest possible distinction to making the broadest possible cultural claims. This is indeed a huge claim, that accepting and tolerating the still-not-really-explained paradox opens the way for all of cultural life. The paradox of the transitional object functions like the transitional object itself, as a domain of play and illusion that allows an interpreter, like an infant, to accept and tolerate frustration and

reality. To intellectualize too soon is here to think of the transitional object as an object rather than a paradox.

Winnicott's theory of transitional phenomena is itself a transitional phenomenon in theory. He describes development as having a beginning, a middle, and an end, and says that theorists have not said enough about the middle. Much of his writing involves making the right space for itself ("prepare the ground for my own positive contribution")—situating exactly what he is saying between two things he is not saying. This expanded middle is where Winnicott's unparalleled subtlety is located, between two crudenesses—the crudeness of the way in which he describes the mother's task of being perfectly available and then optimally frustrating as a task that is only seen from the infant's point of view, and the way he privileges heterosexual reproductivity as a sign of adult health (the blightedness, for example, of those whom he pronounces "not married"). Winnicott's beginning and end shed no new analytical light on normative stereotypes of the good mother and the healthy adult (happily married with children). But in his own domain—somewhere between where the good mother becomes the good enough mother and where the healthy adult can play—he rises to the occasion to "put into words" something which ordinary language has to stretch to render.

"I hope it will be understood that I am not referring exactly to the little child's teddy bear or to the infant's first use of the fist (thumb, fingers). I am not specifically studying the first object of object-relationships. I am concerned with the first possession, and with the intermediate area between the subjective and that which is objectively perceived" (3). Winnicott says he is "reluctant to give examples." The naming and exemplifying functions of language are the ones to hold in abeyance, to make room for something not-to-be-formulated. "Of the transitional object it can be said that it is a matter of agreement between us and the baby that we will never ask the question: 'Did you

conceive of this or was it presented to you from without?' The important point is that no decision on this point is expected. The question is not to be formulated" (12). This, then, is the paradox, which he explains in a later essay in similar terms: "The baby creates the object, but the object was there waiting to be created and to become a cathected object" (89). Winnicott explicitly envisions the transitional object as a kind of navel of the arts: he includes not only objects but also words, patterns, tunes, and mannerisms in his lists of things that can function as transitional objects.

This paradox of unlocatability is also, in fact, similar to the paradox of the moral law in Kant, as stated in a footnote to the *Foundation of the Metaphysics of Morals*:

> The object of respect is, therefore, nothing but the law—
> indeed that very law which we impose on ourselves and yet
> recognize as necessary in itself.[6]

For the moment, I quote this not to say that the moral law *is* the transitional object, but only to suggest that it manifests the same kind of paradox.

The function of the transitional object in Winnicott, then, is to open a space for experience: the transitional object is that through which the baby gains experience of a state between the illusion of the mother's total adaptation to needs and reality's total indifference to them. The object helps the baby learn to tolerate frustration, loss of omnipotence, separation.

The transitional object is not only something that cannot be understood in terms of a dichotomy between subject and object, since it helps bring that dichotomy into being, but it is also something about which there is agreement on what will not be asked. A space is made for the object within language. The transitional object is part of a contract of non-formulation. The apparent one-on-one relation between baby and thing is set in a social, almost legal, dimension agreed to by adults. In one of

Winnicott's many lists, this one a "Summary of Special Qualities in the Relationship," the first special quality is a question of rights: "The infant assumes rights over the object" (5). I'd like to look closely at this list of qualities. Listen for the grammatical roles of the infant, the object, and "us", and for the relations between active and passive verbs.

1. *The infant assumes rights over the object, and we agree to this assumption. Nevertheless, some abrogation of omnipotence is a feature from the start.* In this first point, the infant is the subject, and the object an object. The word "assumption" plays a complicated role here: do we agree to the infant's assumption of rights, or do we agree to the assumption that the infant has rights? Are we agreeing to the rights, or to the idea? In the second sentence, infant, object, and us have all grammatically dropped out. Instead, we find a description of a feature: abrogation of omnipotence. Who is abrogating omnipotence? The infant whose rights are not absolute? Or us, whose agreement is not entirely the law here? An obvious reading would have it that although the infant is allowed power over the object, the nature of this power is from the start a falling away from the kind of power an infant experiences over an internal object. Nevertheless, the sentence describes the abrogation of omnipotence as if it had a separate existence, as if it were functioning as a transitional object in its own right.

2. *The object is affectionately cuddled as well as excitedly loved and mutilated.* In this second point, and in all five remaining points, the object is the subject of the sentence. Here, the infant is the implicit agent of verbs in the passive voice. Why is the infant not mentioned? It is as though the sentence has to be written from the point of view of the object, as though the actions of cuddling, loving, and mutilating had to be experienced by the object rather than enacted by the infant. As though the infant cannot be allowed to have so much agency without violating the nature of the transitional phenomenon.

3. *It must never change, unless changed by the infant.* This is a law, but whose? Is it a warning to the parents not to wash the blanket? Is it a condition of the object's being considered a transitional object by the infant? Is it a rule the object must obey, or the adults? Or an apprenticeship in agency that must be practiced by the infant?

4. *It must survive instinctual loving, and also hating and, if it be a feature, pure aggression.* Is this a law or a test? The difference between this point and the second one is the emphasis on survival, about which we will say more in a moment.

5. *Yet it must seem to the infant to give warmth, or to move, or to have texture, or to do something that seems to show it has vitality or reality of its own.* Why does this "it must" begin with "yet"? This feature has a logical relation of contrast to the preceding one, but what is the contrast? It must survive . . . yet it must seem to live. Is survival not an appearance of life? Perhaps the object's survival is a sign of its inanimateness—its thingliness resists destruction as a living thing could not. And yet it does have vitality to the extent that it has reality.

6. *It comes from without from our point of view, but not so from the point of view of the baby. Neither does it come from within; it is not a hallucination.* This point in many ways returns to the first point. Baby and adult points of view are both mentioned, this time with more contrast. It is a question of inside and outside in two ways: Where is the object (inside or outside the baby)? Where is the point of view (inside or outside the baby)? The second sentence is a return to the abrogation of omnipotence: the object is not a hallucination. Thus the baby's point of view is not described: only what it is not (the object comes neither from without nor from within—this was the question not to be formulated, and it is still, in a sense, not formulated here).

The seventh feature begins like the others, but the voice of the theorist soon takes over, with a celebration of culture that reads like an epitaph to the object:

7. *Its fate is to be gradually allowed to be decathected, so that
in the course of years it becomes not so much forgotten as relegated
to limbo. By this I mean that in health the transitional object does
not "go inside" nor does the feeling about it necessarily undergo
repression. It is not forgotten and it is not mourned. It loses mean-
ing, and this is because the transitional phenomena have become
diffused, have become spread out over the whole intermediate terri-
tory between "inner psychic reality" and "the external world as
perceived by two persons in common," that is to say, over the
whole cultural field.* Its fate is to be gradually allowed to be
decathected. . . . What is the point of view of this sentence? It
begins from the point of view of the object, facing its fate.
Winnicott's capacity to capture the pathos of the object as it loses
meaning, and to do so without overt personification, is somehow
very moving. Yet the sentence is not entirely from the object's
point of view: its fate is to be *gradually allowed to be* decathected.
Temporality belongs to the infant, not to the object. Unless of
course the object always wanted to be decathected, and is gradu-
ally freed from the infant's interest. The infant's role in the
object's experience of fate is to let the object go. But Winnicott
does not say: "The infant gradually outgrows the object." The
change in the infant is experienced as a change in the object, yet
it is only experienced *by* the object, since it is a change that
involves losing the object's capacity to have a point of view.

After these seven points, Winnicott concludes, "At this point
my subject widens out into that of play, and of artistic creativity
and appreciation, and of religious feeling, and of dreaming, and
also of fetishism, lying and stealing, the origin and loss of affec-
tionate feeling, drug addiction, the talisman of obsessional ritu-
als, etc." Winnicott, in his description of these manifestations of
play, does not play so freely as to fail to distinguish, by adding
the word "also," between good play and bad play.

But what about the question of using people? Doesn't "using
people" still sound like something unethical? Let us return to

Winnicott, this time to an essay entitled, "The Use of an Object and Relating through Identifications" (86–94). In this paper, Winnicott distinguishes between object-relating and object-use. Some patients, it seems, are unable to "use" the analyst. Instead, they "relate to" the analyst by constructing a false self capable of finishing the analysis and expressing gratitude. But the real work has not been done. What is that real work? In comparing the analyst to the transitional object, Winnicott suggests that the subject's problem is an inability to "use people." This, then, is the notion of "using people" that I wish to explore through Winnicott. It seems to me that his analysis shows that, in some patients, the inability to use people leaves them trapped in a narcissistic lock in which nothing but approval and validation, or disapproval and invalidation, can be experienced. The whole scenario of destruction and excited love, which the transitional object must survive, cannot happen. The properly used object is one that survives destruction. The survival of the object demonstrates that the baby is not omnipotent, that the object is not destroyed by destruction, that the object will not retaliate in kind if the baby attacks, that the object will not leave if the baby leaves. Separation is only possible if the baby believes the object will still be there to come back to. The baby cannot *use* the object for growth if the baby cannot separate from it for fear of destroying it or losing it—object-relating is contrasted with object-use in that object-use involves trust that separation can occur without damage, while object-relating means that attention to the object must be constantly maintained and damage repaired, otherwise the object will be destroyed or will leave. At stake is the place of reality: "If all goes well; the infant can actually come to gain from the experience of frustration, since incomplete adaptation to need makes objects real, that is to say, hated as well as loved"—that is, ambivalence is a sign that the object is real. Analytic patients who are unable to "use" the analyst are stuck in a fantasy of omnipotence (the analyst will not

survive my rage), which is based on a denied dependency (I cannot survive if the analyst does not survive). Thus, the relation implies a power inequality that is both exaggerated and denied. Such people think the analyst cannot survive use, which might involve "excitedly loving and mutilating." But if the patient does learn to "use people," Winnicott writes,

> In psychoanalytic practice the positive changes that come about in this area can be profound. They do not depend on interpretive work. They depend on the analyst's survival of the attacks, which involves and includes the idea of the absence of a quality change to retaliation. These attacks may be very difficult for the analyst to stand. . . .

At this point, Winnicott drops a footnote: "When the analyst knows that the patient carries a revolver, then, it seems to me, this work cannot be done." The patient must experience the infantile magnitude of his destructiveness without making it real. Which means that the analyst must remain in the power position—not truly in danger—in order to exercise therapeutic inertness. "Using" the analyst means experiencing all the infantile feelings of omnipotence and dependency so as to learn to tolerate and integrate them rather than shut them out through a false system of premature respect and concern. The ethical position of the analyst is to refrain from retaliating *and* to refrain from interpreting. In this, the analyst is in the classic ethical position of the powerful one exercising restraint. It is in the less powerful position that, paradoxically, restraint has become the problem. By allowing the patient the space and the time to try out both the feelings—of omnipotence and powerlessness—and their meanings, the patient comes into a more realistic and creative relation to his true strengths and limits. The object becomes real because it survives, because it is outside the subject's area of omnipotent control. The narcissistic lock of reparation and retaliation is opened to let in the world.

As is usual with Winnicott, something other than a mere description of these psychic processes happens in his text *in language.* Let me quote an extended passage from the middle of the essay.

> This change (from relating to usage) means that the subject destroys the object. From here it could be argued by an armchair philosopher that there is therefore no such thing in practice as the use of an object: if the object is external, then the object is destroyed by the subject.

The armchair philosopher is here playing the role of the intellectualizer away of the paradox: the object is either inside or outside, destroyed or not destroyed. But look at what happens to the armchair philosopher in the next sentence:

> Should the philosopher come out of his chair and sit on the floor with his patient, however, he will find that there is an intermediate position.

The dead metaphor of the chair comes alive in order to propel the philosopher onto the floor, where what he will find is an intermediate position. Something about that intermediate position is enacted by this passage from metaphor to literality. The intermediate position is not in space but in what it is possible to say.

> In other words, he will find that after "subject relates to object" comes "subject destroys object" (as it becomes external); and then may come *"object survives* destruction by the subject."

The intermediate position is the between as beyond.

> But there may or may not be survival.

The realness of the object requires that the possibility exists for it to really be destroyed.

A new feature thus arrives in the theory of object-relating. The subject says to the object: "I destroyed you," and the object is there to receive the communication. From now on the subject says: "Hullo object!" "I destroyed you." "I love you." "You have value for me because of your survival of my destruction of you." "While I am loving you I am all the time destroying you in (unconscious) *fantasy*."

The object is there to receive the communication. The structure of address animates the object as a "you," a destroyed "you," a loved because destroyed "you." The object's survival of destruction is what makes it real. The reality of others depends on their survival, yes, but also on their destruction (in fantasy).

Winnicott's dramatized direct address to the object seems excessive with respect to what is required by the description. That is, the language of address adds something. What does it add? As a way of approaching this question, let me return for a moment to Kant. This moment in Winnicott recalls a strange moment in Kant's *Critique of Practical Reason,* in which he suddenly, and without warning, directly addresses duty in one long sentence:

> Duty! Thou sublime and mighty name that dost embrace nothing charming or insinuating but requirest submission and yet seekest not to move the will by threatening aught that would arouse natural aversion or terror, but only holdest forth a law which of itself finds entrance into the mind and yet gains reluctant reverence (though not always obedience)—a law before which all inclinations are dumb even though they secretly work against it: what origin is there worthy of thee, and where is to be found the root of thy noble descent which proudly rejects all kinship with the inclinations and from which to be descended is the indispensable condition of the only worth which men can give themselves?[7]

Isn't this a version of the question not to be formulated about the transitional object—did you create that or did you find it? Could there be a relation between duty and the teddy bear, not because the teddy bear teaches concern for others but because in neither case is it possible to say whether the object is inside or outside the subject? And does direct address to an abstract or inanimate object somehow act out the paradox that must be tolerated if there is to be a full range of cultural life?

The ludic side of Kant is usually quite well concealed. Yet here, in the middle of a discussion of "the incentives of pure practical reason," after scornful comments about fanaticism and sentimentalism, Kant suddenly feels an impulse to play. In a long drawn single breath, he utters an apostrophe, playing at animating Duty, sublime and mighty name. In the midst of describing duty as that which "elevates man above himself as a part of the world of sense," that which gives "personality, i.e., the freedom and independence from the mechanism of nature," Kant's language suddenly generates a personality beyond the world of reference, a personification to receive the communication.

In Winnicott, as we have seen, the subtle animation of the object, or at least the object's point of view, is a constant feature. That Winnicott's language is often out in a space of play ahead of him, or encrypted in a space within him, is something of which he himself occasionally takes note. Beginning an essay entitled "The Location of Cultural Experience" with an epigraph from Tagore, he writes, "The quotation from Tagore has always intrigued me. In my adolescence I had no idea what it could mean, but it found a place in me, and its imprint has not faded" (95). His ability to describe language as having a place rather than a meaning is already a structure of object use. In another essay, Winnicott finds himself quoting a Shakespeare sonnet, and lets it lead him where he wasn't necessarily planning to go.

The object is repudiated, re-accepted, and perceived objec-
tively. This process is highly dependent on there being a
mother or mother figure prepared to participate and to give
back what is handed out.

This means that the mother (or part of mother) is in a "to
and fro" between being that which the baby has a capacity
to find and (alternatively) being herself waiting to be found.

If the mother can play this part over a length of time with-
out *admitting impediment (so to speak)* then the baby has
some experience of magical control. . . .

In the state of confidence that grows up when a mother can
do this difficult thing well (not if she is unable to do it), the
baby begins to enjoy experiences based on a *"marriage"* of
the omnipotence of intrapsychic processes with the baby's
control of the actual (47, emphasis mine).

Marriage follows upon not admitting impediments not
because all roads in Winnicott should lead to marriage
(although they do) but because Winnicott is capable of *using*
language in just the way he speaks of *using* objects—using lan-
guage to play fort-da with, and letting language play him. His
actual interpretations often draw his material back into a frus-
tratingly familiar ideology,[8] but his descriptions of language act-
ing in him or on him somehow escape that closure. (Even his
anti–birth control essay, "The Pill and the Moon,"[9] involves his
involuntary composition of a poem.)

Winnicott ends the paragraph of dialogue between infant and
object, and by implication between patient and therapist, by
concluding, "In these ways the object develops its own auton-
omy and life, and (if it survives) contributes-in to the subject,
according to its own properties." The object's own properties
operate like a third in the relation between baby and object—a

third that makes it possible to experience the world, a third composed of the interaction itself. Winnicott concludes his article on the use of an object by saying:

> Study of this problem involves a statement of the positive value of destructiveness. The destructiveness, plus the object's survival of the destruction, places the object outside the area of objects set up by the subject's projective mental mechanisms. In this way a world of shared reality is created which the subject can use and which can feed back other-than-me substance into the subject (94).

Perhaps a synonym for "using people" would be, paradoxically, "trusting people," creating a space of play and risk that does not depend on maintaining intactness and separation. It is not that destructiveness is always or in itself good—far from it. The unleashed destructiveness of exaggerated vulnerability or of grandiosity without empathy is amply documented. But *excessive* empathy is simply counterphobic. What goes unrecognized is a danger arising not just from infantile destructiveness but from the infantile *terror* of destructiveness—its exaggerated and paralyzing repression. Winnicott describes the process of learning to overcome *that* terror, which allows one to trust, to play, and to experience the reality of *both* the other *and* the self. And this, it seems to me, suggests the ethical importance of "using people."

NOTES

1. See Emmanuel Levinas, *Ethics and Infinity*, trans. Richard A. Cohen (Pittsburgh: Duquesne University Press, 1985). Levinas himself avoids thus grounding ethics in *restraint* by defining the subject not in isolation but always in relation to the Other, for whom and to whom the subject is responsible, without any prior intactness or guarantee. My quarrel here is more with a sort of "Levinas effect" than with any particular writing, whether by Levinas or by others.

2. Immanuel Kant, *Critique of Practical Reason,* trans. Lewis White Beck (New York: Macmillan, 1956), 136.

3. Heinz Kohut, *The Analysis of the Self* (New York: International Universities Press, 1971), 33.

4. To give you an idea of the horror of a transitional object that *would* be a mirror double, I refer you to My Twinn, a company that makes dolls "individually crafted to look like your daughter," now available online. The proud parent is invited to choose among skin tones, eye colors, hair color and style, and to diagram birthmarks, moles, and freckles. Renaissance blazons that dismembered the female body were nothing compared to this parental dissection and commodification of the living child. Suppose the girl gets one for her birthday, and the dog eats it? Wouldn't the doll require a kind of protection that is the very model for enslavement to the ideal I? As if the daughter does not have enough trouble with the mirror stage, she must be haunted by this Dorian Gray–like perfect unchanging object as she herself grows up, gets pimples, falls into puberty . . .

5. D. W. Winnicott, *Playing and Reality* (London: Tavistock, 1971), xi–xii. Page numbers in parentheses refer to this volume.

6. Immanuel Kant, *Grounding for the Metaphysics of Morals,* in *Ethical Philosophy,* trans. James W. Ellington (Indianapolis, Ind.: Hackett, 1983), 14.

7. Kant, *Critique of Practical Reason,* 89.

8. For an excellent feminist critique of Winnicott's image of motherhood, see Carolyn Dever, *Death and the Mother from Dickens to Freud* (Cambridge: Cambridge University Press, 1998), chapter 2 ("Psychoanalytic Cannibalism").

9. See D. W. Winnicott, "The Pill and the Moon," in Winnicott, *Home Is Where We Start From* (New York: Norton, 1986), 196–97.

The Best Intentions
Newborn Technologies and Bioethical Borderlines

Perri Klass

"*g*hosts in the nursery"—a famous phrase in pediatrics, in psychology, in the understanding of parents and children. Made famous by Selma Fraiberg, it refers to the powerful echoes of the parent's own past evoked by the new child and by the experience of caring for that child. But I want to talk here about ghosts of another kind in another kind of nursery, about the whispered presence of the babies we would have saved and couldn't, might have saved but didn't, couldn't save then but would save now. And I mean that *we* to refer both to the group of individual practitioners, each looking back at an array of signature lost babies, and also to the professional

collective, looking back on the past populations of newborns. A perspective of personal reminiscence, a mix of guilt, pride, and confusion strongly flavored with sentiment and sentimentalism, all focused on the advances of bioscience and technology actually may offer a surprisingly valid layering for the discussion of the relatively newborn science of newborn bioethics; in many ways it mirrors the mix of knowledge and emotions which has accompanied, understood, constructed, and implemented the medical changes of the last decades. By looking at some of the specific technologic advances in the resuscitation and ventilation of the smallest newborns, by examining the professional impetus to treat and treat effectively those smallest newborns, I hope to trace some of the ethical and scientific vectors which can locate us more securely on our professional matrix of medical aggressiveness and ethical uncertainty.

This is the story of neonatology or, at least, one side of the story of neonatology: You look for techniques which will allow you to reduce morbidity and mortality in the babies you are already trying to save. You find those techniques. And then you begin to wonder about applying them to babies just over the borderline, a little younger and a little smaller. And you make that jump for good humanitarian reasons—because you see a baby who is struggling to survive, who is almost making it, because a family begs you to try. But also for the other reasons which drive doctors: to be a hero, to see if it can be done, to push the envelope. And then, in their turn, those become the babies you can save—but for whom you would like to improve outcome, and you look for new refinements of that technology. The short history of neonatology is a history of pushing back the borders, whether or not that was the goal of the research; the pace of change means whatever you learned when you trained is by definition obsolete.

In participating in a gathering of ethicists, in speaking about neonatology, I am made very aware that I myself have no training

in ethics and am certainly no neonatologist. The sense of two overlying discourses, neither of them my own, each rich in subtlety, terminology, and even jargon, leaves me prone, I am afraid, to take refuge in the tabloid journalism of my profession, namely, in war stories and, as I said, in sentimentality. I was much struck by an early discussion among the ethicists at which all agreed that the great trap in ethics, to be avoided at all costs, is sentimentality, and I give warning that I intend to be rankly and frankly sentimental, both to stamp my status as amateur, and also to reflect fairly the tenor of the interviews I conducted with a variety of people involved with the medical practice of neonatology, from the founders of the field to younger practitioners. It is only fair to add that I have always found that physicians meet general approval when we allow ourselves to be sentimental; it is always interpreted as "sensitivity." There are clear perils to the uses of sentimentality, of the personal narrative in medical ethics, and of the ghosts of the could-have-saved, should-have-saved babies; this kind of conversation, one could argue, leads to medical decision making, clinical judgment, and resource allocation predicated on the equivalent of the photo wall of "graduates" present in every newborn intensive care unit, a bulletin board papered with photos and Christmas cards, smiling toddlers, active schoolchildren, beaming parents. And yet, these faces on the bulletin board are one collective truth of neonatology, and they deserve in some sense to be balanced into the equation.

So I want to talk about ethics in practice, and use the double meaning of practice: ethics in everyday medical practice, ethics as practiced every day in medicine. Or perhaps even a triple meaning: as an intern and as a resident, I was in some very real sense practicing on my patients, learning how do it right—just as during the past few decades, everything that has happened at the frontiers of neonatology has essentially been collective professional practicing, and as a profession, we have steadily gotten better.

The babies with whom we are concerned are younger than the babies discussed by Barbara Johnson, whose analysis of transitional objects resonates on multiple levels to a pediatrician (see her essay "Using People: Kant with Winnicott" in this volume): I am looking at the often analyzed field of newborn medicine because the practice of neonatology makes you talk about ethics all the time, forces you to make with full awareness life-and-death decisions of ethical moment every day, every week, every month. The stunning ethical complexity of this job invites consideration of the history of the field, a look at the technology and the thinking behind the technology that got us to where we are—operating always with the very best of intentions (and I should say clearly that I identify as a pediatrician here, who saw the interviews referred to in the following pages as opportunities to examine the thinking of the heroes of her profession).

The history of neonatology, recent, fast-moving, heroic, and at times bewildering, offers a paradigm of the complex texturing when ethics and science come together before anyone is ready for them to come together in the matter-of-fact busy daily business of medicine, where a variety of imperatives combine with the microethics of medical authority to push the least experienced practitioners into moments of ethical crux. These imperatives—the desire to save lives, to heal, to help, the desire to fulfill the Hippocratic oath and the professional responsibilities of the medical role, the desire to play the hero, the desire to avoid malpractice suits, the desire to be always prepared, the desire to learn and to meet the demands of your training, the desire to survive your training—become heightened in settings of high drama and hard work, and perhaps nowhere as much as under the lights of the newborn intensive care unit.

Here, where the smallest patients in the hospital are connected to multiple monitors, bathed by ultraviolet bilirubin lights, hooked to umbilical artery lines and gastric tubes, we

find a correspondingly complex matrix of ethical systems—an ethics of size, an ethics of borders and borderlines, an ethics of power and authority, all yielding a microethics, if you will, a microethics of the micromanagement of microbabies, in which human beings who exist only because of our science pose us problems in the further application of that science—and of our humanity.

It starts, for the most part, with running to deliveries. As an intern in the NICU, one month out of medical school in July of 1986, I was handed the DR beeper—first call for the delivery room. And I remember clearly going to a very premature delivery with one of the neonatology fellows, that same month; as we hurried down the hall to the delivery room suite, he warned me that there would in all probability be nothing we could do for this baby. He would show me how to judge the gestational age, he promised, because after all, you could never be sure just by the EDC—an anachronistic medical term for a baby's due date, it stands for estimated date of confinement. So the first thing you have to ask when a baby is coming too soon is this: how good are her dates? (A normal human gestation lasts forty weeks; anything less than thirty-six weeks means the baby is considered premature. Just to give a very general ballpark estimate, the kind the fellow gave me as we gowned and gloved, a thirty-two-weeker would weigh something over three pounds, and would nowadays be expected to do very well; a twenty-eight-weeker might weigh two pounds, and, back in 1986, a twenty-six-weeker was thought to be at the outer limit of viability; younger than that, and there was no hope at all.)

And so, on the job, at the bedside, hovering over the warming table, we learned to do the assessment of gestational age and viability: if the skin was gelatinous, if the eyelids were fused, the baby was probably too young to save. And then there were the signs of life—movement, respiratory effort, a good heart rate—which we had to factor into the calculation for a baby at the

borderline, looking at whether the baby was "trying to live." There was nothing even mildly theoretical about this; it was blood-smeared and emotional and often agonizing, right from the beginning, as I, as my colleagues, stood at the bedsides of women who had just given birth, and watched people a few more years along the path "make the call": do we resuscitate or do we not?

And then there was the peculiarly matter-of-fact protocol we learned for what to do if we did not resuscitate, a protocol developed in large part, we learned, by the nurses, who would stay with the grieving parents after the heroically minded but helpless doctors ran off to await the next delivery, the next decision. When the baby was too young to save, I learned, you clean the baby off, wrap the baby in a blanket, give the baby to the mother, offer to take pictures—the nurses had put together a special kit, with a Polaroid camera, an ink pad to take footprints, a birth certificate. You make sure the baby gets baptized, if that's what the parents want, even if it means doing it yourself, and you give the parents some privacy and wait for the baby to die. Or, sometimes, if the parents prefer, you take the baby back to the nursery, and you wait for the heart to stop.

So in 1986 and 1987, I baptized quite a few babies, many or most of whom would now (in 1999 as I write this) be aggressively resuscitated, and some of whom would make it, even make it reasonably intact, with body and brain in pretty good shape, going home to grow up, sending Christmas photos for the NICU bulletin board. Not all, but some.

And even then we knew it was complicated, and we could reel off the dilemmas. We knew (and I am using the collective we of residency received wisdom), for example, that there were more aggressive doctors and less aggressive doctors. The more aggressive doctors believed in resuscitating every baby—you bring 'em back to the NICU, and you sort 'em out there. None of this wrap-it-in-a-blanket-and-give-it-to-the-mom stuff. And we knew there

was a recurring issue with regard to how much say the parents had, assuming there was time to discuss it first. Do you resuscitate a baby you think has no chance at all, if the parents beg you to? Do you let a borderline baby who might be "trying to live" gasp out his last breaths if the parents say no? And, inevitably, do you treat the much-wanted child of a couple who have been through years of fertility treatments differently than the offspring of a fourteen-year-old who didn't know she was pregnant till she went into premature labor, probably stimulated by illicit substances?

And of course, if we did go ahead and resuscitate, that led to other questions. How aggressive to be, how far to go, how much pain to cause. How many millions of dollars to spend on babies who weighed a kilogram or less. How to interpret the information about prognosis—the head bleeds, the oxygen deprivation, the uncertain elements which might mean severe brain damage and, then again, might not. And finally, of course, how that changed the treatment plan.

And then, at every stage of the treatment plan, we had to consider over and over, how much the parents got to decide. I can clearly remember occasions of serious disagreement between parents and medical team in both directions—there were parents who wanted us to be less aggressive than we thought was appropriate, and there were parents who wanted us to be more aggressive. And my memory is that we talked about this all the time, in formal rounds, in late night exhausted conversations about the meaning of life, in quick crowded communications as we hurried through the hallways, that a necessary obligatory concomitant of working with neonates was the everyday incorporation of unresolvable ethical questions into our high-tech medical rhythm.

The pressures of this practitioner paradigm call for a new ethical model which doesn't simply incorporate scientific and economic issues as factors in the ethical calculation, but in which

ethical decision making is actually embedded in a matrix of bio-
medical science and sociopolitical economy. And these hospital
issues point toward a larger epistemic shift in the production
of ethical decisions which not only recognizes but actively
embraces the paradox by which individual decisions carrying
the weight of lives and thereby worthy of long and serious con-
sideration and judicious weighing must often be made at rushed
moments by people whose training and background are greatly
weighted toward other expertises. In fact, the process of making
these ethical "judgment calls" may not be experienced as being
mainly about ethics, but may instead be interpreted through a
more biomedical frame of reference.

What vocabulary, what jargon, what shorthand do we use to
talk about these questions? As a profession, we are only now
acquiring a vocabulary, a syntax of ethics—we adapt instead the
vocabulary we do have, giving special loaded meanings to words
like "aggressiveness," which I have used many times already. Or
consider the loading with additional significance of "complex."
Imagine this note in the medical chart: *"complex medical situa-
tion with uncertain prognosis, need to assess appropriate level of
support."*

Is that the way we say, What the hell were you crazy people
thinking when you brought this baby out of the delivery room?

What is the appropriate language, the appropriate syntax, the
appropriate discourse, for those who are already engaged in the
biomedical discourse and already deeply engaged with what we
can call the folklore and oral history of neonatology? We knew
so many stories, true, apocryphal, and somewhere in between:
the neonatologist who rushed to the delivery of very premature
quadruplets, made the call that they were too small, too young,
nothing to be done, and then suddenly one of them moved,
breathed, kicked—so he resuscitated that baby, and that baby
was perfect, no problems when he got out of the NICU. So you

know what that story's punchline was, don't you: so the doctor said, maybe I should have resuscitated the others!

But there were so many more stories on the other side. Our sickest and bitterest jokes as residents were about the borderline babies we pulled back from the dead who did not go on to be miracles, about the "train wrecks," the micropremies, the babies with one-minute Apgars of one and five-minute Apgars of one and ten-minute Apgars of two.*

Modern neonatology is a relatively short story; a few decades worth of phenomenal advances which have brought us now to a point at which doctors regularly resuscitate infants born sixteen or seventeen weeks too early, babies born weighing less than a pound. Some extreme subgroups of these very low birthweight babies (VLBWs, in medical parlance) have low survival rates, and many of those who do survive are left with terrible problems. There are many intriguing aspects of this story, including the increased visibility of the fetus, the opening up (in some cases literally, with fetal surgery) of the pregnant secret womb, and the increased vision of the fetus as a separate and personified entity. Going back farther, in fact, conception itself is increasingly visible and subject to manipulation. And going forward, we have the increased visibility and the extended external lives of infants who ought to be third trimester, or even second trimester, fetuses. Over the next few decades, neonatologists will inevitably grapple with the next set of questions, pushing always to improve outcomes for the babies already being saved, babies clearly not yet ready to be outside the womb.

I should perhaps say that I came to neonatology as a beginner, came upon this new and complex world with a certain

*The Apgar score is a standard assessment of a newborn's condition; the baby is assigned a score from zero to ten based on such parameters as color, heart rate, and muscle tone. An Apgar score under 6 is worrisome; a low initial Apgar score that doesn't improve is very worrisome indeed.

amount of ethical certainty, and even a certain disgusted arrogance: how did these guys ever let things get to this point? As residents, some of us shook our heads and imagined cowboys, scientific cowboys always pushing the envelope, clinical cowboys rubbing their hands together: wouldn't it be great if we could save the twenty-two-weekers! And, we keened, all this with never, oh never, a thought for the consequences, the suffering! We shook our heads; if only *we*—the sensitive thoughtful ones—had been consulted, if only we had been there all along! And this was a largely if not completely false vision; these conversations that we ourselves were holding, these examinations and reexaminations of conscience and consequence, were merely our own latest iteration of discussions which had gone on in the field from its earliest days, and we were, with our training, taking up an ongoing and essential conversation, not inventing a new and revolutionary perspective.

For this is and has been a field always much concerned with borders and borderlines: what is too small, what is the limit of viability, who can survive outside the womb, whom shall we try to save?

For historical perspective, there is one baby who is always cited, one iconic benchmark baby, whose birth and death illustrate where we were and how far we have come. In 1960 Jacqueline Kennedy gave birth to a son, born at thirty-four weeks' gestation. The baby died of premature lung disease; even for the President's child, there was simply nothing that could be done. No way to ventilate artificially, no way to help the baby survive. And not a tiny premie either, but a baby of thirty-three to thirty-five weeks—these babies now have a relatively easy start, their problems are usually easily overcome. And the border continues to move.

In 1996, I interviewed Steven Ringer, M.D., the director of the newborn intensive care unit at the Brigham and Women's Hospital in Boston. When I was a pediatric resident, training in

the NICU, he was one of my teachers. I reminded Dr. Ringer that when I was a resident, seven years earlier, he and the other neonatologists used to tell us we had reached the final border of viability: at twenty-six weeks, they told us, we have reached a natural boundary. Babies younger than this, smaller than this, do not have enough lung tissue to survive outside the womb.

But of course, that was before artificial surfactant, a therapy which allows us to replace a vital factor missing in premature lung disease. Without the substance known as surfactant, premature lungs are stiff, unable to inflate and deflate easily for gas exchange. Ventilators have to force oxygen in, banging on the tiny lungs at dangerously high pressures, often blowing holes in them, often leaving them damaged for life. And that twenty-six-week "natural boundary" was also before high-frequency ventilation, a technique sometimes used now with the very sickest babies. Now there's artificial surfactant, now there's hi-fi, and a host of other ventilatory management options, now the boundary is at twenty-three or twenty-four weeks. Now premature infants weighing five hundred grams or even a little less are routinely being resuscitated.

"And babies today of six hundred grams have a reasonable chance of surviving and surviving reasonably intact," Dr. Ringer pointed out; "that was completely inconceivable even when you were doing your residency. And when *I* was a resident, babies of a thousand grams who survived were miracles—nowadays we put signs up on cribs: you made it, you reached a thousand grams!"

The precise probabilities of survival at any given birthweight and gestational age, the probabilities of "good outcome," as distinct from mere survival (and let us note in passing that the question of what actually constitutes a good outcome is itself ethically charged and leads immediately to a host of other questions about disability and quality of life)—these statistics change mightily with time and with place. These calculations,

then, represent an ethical matrix of medical measurements, analogous to the relatively new growth charts for premature infants, on which we carefully plot each gram gained or lost as the days go by. They are the calculations which may yield us a microethics of medical authority in which science produces ethics rather than the conventional and perhaps archaic paradigm of ethics mediating science.

Dr. Ringer pointed with pride to the areas in which neonatal science has been driven by such nonscientific forces as common sense, mother-wisdom, and custom: "In our NICU now we have mothers in big cushy armchairs holding their tiny babies and mothering them—hooked up to technologic equipment. We react to the mother's assessment, we depend on those primal instincts—but at the same time, we have pulse oximetry. It's an interesting and crazy dichotomy; as we've overcome a lot of the technologic hurdles, more and more attention can be paid to these basic primal instincts." Ruefully, he concluded, "The more advanced we get in medicine, the more we learn that everything my grandmother told me was right!"

So now, I asked him, now do you say that at twenty-three weeks we've reached a natural boundary? And seven years from now, where will that boundary be? Will we be attacking the problems that come up after you have "solved" the lung issue— the skin, for example, which at twenty-two or twenty-three weeks' gestation is gelatinous, subject to extremely high insensible water loss, which can send a tiny infant into shock, and vulnerable to overwhelming infections? "It's a monumental research endeavor to learn to be as smart as the placenta," commented Mary Ellen Avery, M.D., one of the founders of the discipline, who did much of the work to define and explain premature lung disease in the first place. "Nature has had millions of years to sort this out."

"There's a huge experiment going on," said Jerold Lucey, M.D., Wallace Professor of Neonatology at the University of

Vermont and editor of *Pediatrics,* the major journal in the field. "The world's never seen a lot of six-hundred- to seven-hundred-gram babies before. All of us are flying blind; follow-ups of two, four, five years aren't enough. I intend to devote my life to trying to do the follow-up. And the next step is under five hundred grams—that worries all neonatologists."

I am troubled—as were all these doctors, as is every sensible person—by the resuscitation of borderline premature infants, by the increasing numbers of five-hundred-gram babies on ventilators, by Dr. Lucey's "experiment" in progress. When I worked in the newborn intensive care unit, I was often disturbed by the aggressiveness of the medical care I was helping to dish out— and argued that side of the question, and wrote my share of articles and essays saying, there has to be such a thing as just too small. And, to speak personally again, I am very easy in my own mind about what I would want if I went into labor at twenty-three, twenty-four, twenty-five weeks—a gentle easy old-fashioned private too-short life, free of pain and intervention, for a baby born too small to survive. And yet, and yet. There is another side to speaking personally, for anyone who has worked in this area. There are the patients you carry around with you, the shadows at your shoulder, the ghosts in the special care nursery, the ones you couldn't help back then, but imagine being able to help now. For me, I think of a night during my last year of residency, in 1989. Of a woman, not young, on her ninth pregnancy, carefully followed every step of the way by ultrasound; she had made it further into gestation than ever before, she was hoping this time, after ten miscarriages, to have a baby. And it was the twenty-third week, and she was in labor.

And there was nothing we could do. She begged, she cried. And a troop of us went to the delivery, and the baby was on the other side of the line. Fused eyelids, gelatinous skin. A little girl. A fetus who would have been a little girl. We wrapped the baby in a blanket. We took Polaroid photos of mother and baby. I

know this was the right thing to do; I know a few short hours or even days of aggressive medical futility would not have made this better. But I still hear her voice in my mind as she crooned to her dying too-tiny infant, in those minutes which were the sad closest she had come to holding a baby of her own, as she spoke lovingly to her daughter, and called her "My precious one." I would have given *anything*, right there and then, to have had something to offer, some way to save that baby. Three weeks further into gestation, even in 1989, we would have had a fighting chance. Two weeks further, even one week further, that baby would today be resuscitated, almost without question. So when I shake my head over the extreme measures, the resuscitation of twenty-three-weekers, that mother and baby look over my shoulder. And of course, the people who spend their lives in this field see many more faces massed in the distance, many more chances lost.

At the extreme end of the research spectrum, some scientists are making preliminary approaches to an "artificial womb"; there is a Japanese lab in which fetal goats are routinely kept alive on machines that circulate and reoxygenate their blood. In another research group, liquid ventilation is explored; the immature lungs could be filled with a fluorocarbon liquid containing dissolved oxygen, rather than with air. These lines of research represent, again, new avenues for trying to improve survival and outcome for those borderline tiny premature infants who are already being resuscitated and cared for in newborn intensive care units. And virtually everyone who is working on new techniques in neonatology will explain that no, these new techniques are not intended to push things back beyond twenty-three weeks, only to improve survival rates—and most of all, intact survival rates—in that group of very tiny premature infants we are already saving.

But in fact, we started saving them because artificial surfactant and hi-fi and other advances in management, aimed at

improving the survival of older, bigger babies, offered for the first time a chance, even a one-in-ten chance, to save the smaller, younger ones. And the next steps, at the next frontiers, will pose the same dilemmas.

When I interviewed Professor Arthur L. Caplan, director of the Center for Bioethics at the University of Pennsylvania, he argued that many scientists and neonatologists are in fact deliberately conservative in their public utterances. "People are fearful, there's almost a conscious decision to take it off the table. I think they all go home at night and dream, if we had the right ECMO machine. . . ." ECMO: extracorporeal membrane oxygenation. The most high-tech treatment for a newborn, a machine that actually empties out the baby's blood and runs it through a membrane oxygenator, in an ongoing state of newborn heart-lung bypass. We can do it for full-term infants with severe lung disease, but we can't do it for premies. This is where Dr. Kawabara's fetal goat research could lead; his technique, EUFI (extrauterine fetal incubation) is a kind of ECMO for the immature fetus.

But is that what they dream about, the right ECMO machine? What about the ghosts? Alan Fleischman, M.D., senior vice president of the New York Academy of Medicine and professor of pediatrics at Albert Einstein College of Medicine, who directed the neonatal program at Einstein Montefiore for twenty years and now concentrates his attentions on bioethics, told me his story, or one of them. He recalled a twenty-eight-week infant born in 1969, when he was a medical student working in the nursery at Jacobi Hospital. He was told to let the baby die, there was nothing to be done. "I stayed up all night bagging the baby"—that is, breathing for the baby with a bag and mask—"and then in the morning, the attending came in and asked me to come in to his office and have a cup of coffee—and nobody bagged the baby." Neonatologists who have been in the field for several decades universally look back on babies who

were once too small to save, who would now stand an excellent chance of survival—and survival without major problems.

On the other hand, William A. Silverman, M.D., referred me to another kind of ghost, chronicled in his essay, "Overtreatment of Neonates? A Personal Retrospective," published in the journal *Pediatrics* in 1992. Silverman tells the story of a baby born after five and a half months' gestation, weighing six hundred grams, in the Bronx in 1945. Because the baby breathed spontaneously, and because she continued breathing for a full day, the obstetrician sent her to the Babies Hospital in Manhattan, where the young Dr. Silverman took care of her. She lived for three and a half months, "and I was not unmindful of the fact that she was setting a new hospital record for longevity!" The baby's parents, he writes, "did not share these joyous feelings of high adventure. . . . I tried to focus their attention on the miraculous present, and I was annoyed that their thoughts were fixed on an uncertain future." Dr. Silverman has devoted much of his attention to the uncertain future faced by premature babies who are resuscitated and treated as part of what we call in medicine the "learning curve," babies on whose bodies medicine learns many of its hardest lessons. He still follows a group of adults who were blinded as infants by exposure to high concentrations of oxygen—a therapy which was adopted with enthusiasm and without careful study.

"For the past twenty years I have been interviewing families of adults blinded in the original retrolental fibroplasia disaster, and, more recently, parents of seriously damaged ex-premature infants. I have been told how some families feel about their fate to provide lifelong care for a blind, deformed, or brain-damaged child kept alive by heroic medical interventions. Some families are enobled, but too many are boiling with anger. Parents of a badly damaged baby often resent the implied demand that their family is required to pass a 'sacrifice test' to satisfy the moral

expectations of those who do not have to live, day after day, with the consequences of a diffuse idealism."

"Outcome—what's the outcome?" asks Dr. Silverman, looking at each new advance. "What are we doing? What is the goal of neonatal medicine? To increase the number of surviving infants, or to reduce pain and suffering?"

Experienced neonatologists, as a group, are thoughtful, cautious in their predictions, and often very hesitant about the question of pushing back the boundaries. Jeffrey Horbar, M.D., professor of pediatrics at University of Vermont College of Medicine and executive director of the Vermont-Oxford Neonatal Network, predicted, "in ten years we'll be dealing with twenty- to twenty-one-weekers pretty routinely—I'm not really looking forward to it." The pioneers of neonatal technology tend to cite the need to devote research and energy to prevention of prematurity, to improving public health. "If we could apply existing knowledge, we could halve the mortality rate," says Dr. Avery. "Should we try to save every life?" asks Dr. Lucey. "A million dollars or so to save someone who weighs five hundred grams?"

And yet, the march continues forward, with impetus both from scientific discovery and from clinical practice. "The next generation of neonatologists will focus on creating artificial womb environments—take a newborn, with ECMO plus some kind of renal dialysis—," says Dr. Fleischman. "It will come from the commitment to enhanced survival and quality of life—once you get committed to the tiny ones, as we did with the surfactant revolution."

Once you get committed to the tiny ones. We are, like it or not, committed to the tiny ones, to improving their chances—and thereby, almost inevitably, to opening up chances for the even tinier. Driven by the best intentions, these are the small steps, the microscience and microethics of microinfants. Surely we have an obligation—almost a clear obligation, a semi-Hippocratic

obligation, to bend technology and science to the ends of our patients, once we have accepted them as our patients. And though there is much breast-beating, and though the elder statesmen of the field one and all cry caution, the clinical drumbeat goes on.

To return to the sentimental for a moment, to the power of the photos on the NICU bulletin board: I mentioned this subject recently to a well-informed friend outside the pediatric profession, who hauled off and let me have it: you doctors are wasting millions of dollars on high-tech treatments, he said, treatments for premature babies when there isn't any money for prevention, prenatal care, primary care. You're keeping babies alive forever on respirators—and don't many of them end up brain damaged? Your whole profession is in love with inhumane technology!

Well, yes, I said, but, but, but—well, I said, hemming and hawing my share, but then they bring out a mother with a beautiful happy child in her best party dress, and the mother says, look at my miracle! And we all start to get a little teary-eyed.

Oh, said my friend. Right. There's one like that in my office. Her mother has all the pictures hanging up. He paused. Actually, he said, I can think of two.

The administration of artificial surfactant, the refinement of hi-fi ventilation techniques and apparatus—these are in fact the great ethical revolutions of neonatology, and it would be impossible to separate the scientific protocols from the ethical calculus. In balancing the various ethical imperatives, we often find ourselves somewhat unsteadily located among the professional impulse to help, the needs of the newborn, the wishes of the parents, the social costs of extreme intervention, the medical science imperative to learn by working on the edge, and the humane and sometimes sentimental wish for the simplest of happy endings, even if achieved by the most complex technology. We continue to create, and perhaps must recognize and even codify, professional situations in which the actual integra-

tions in this ethical calculus must be carried out by those with less training, not more, those facing more distractions and more clinical chaos, not less, and those working in the most intense and pressured settings, rather than those with any luxury of time, rest, or contemplation. And thus, as the science and the medicine, the technology and the training, produce a certain ethical synthesis, so do the scientific advances and technologic developments produce a shifting ethics of shifting borders and borderlines.

Neonatology over the past few decades has played out again and again the parabolas of medical discovery and complexity: we can do more than we ever could for the babies we could almost save, or could sometimes save—and we have something to offer the babies who would once have been beyond our reach. And so our reach extends, and with it extends and deepens the ethical density of the medical environment, refashioning the whole concept of ethics as it is experienced by those who provide and receive medical care.

Which Ethics for Democracy?

Chantal Mouffe

*e*thics and Morality have recently become very fashionable. In the most varied domains from politics to marketing, from philosophy to journalism, from humanitarian campaigns to the recent popular sanctification of figures like Mother Teresa and Princess Diana, the leitmotiv is the need for consensus, shared values, and involvement in "good causes." I do not intend to dwell on the causes of this phenomenon, though I believe that a lot could be said about the characteristics of this new zeitgeist. I want to focus instead on what I consider to be one of the main characteristics of the present mood—what I take to be a retreat from the political.

What we are witnessing with the current infatuation with humanitarian crusades and ethically correct good causes is the

triumph of a sort of moralizing liberalism that is increasingly filling the void left by the collapse of any project of real political transformation. This moralization of society is in my view a consequence of the lack of any credible political alternative to the current dominance of neoliberalism.

In the field of political philosophy, which is the one I am familiar with and which I will use to develop my argument, the language of morality has now become dominant. In the approach that under the name of "deliberative democracy" is fast imposing the terms of the discussion, a strong link is established between moralism and rationalism, a combination that I submit can have deadly consequences for democratic theory. One of its main tenets is that political questions are of a moral nature and therefore susceptible of a rational treatment. The objective of a democratic society is, according to such a view, the creation of a rational consensus reached through appropriate deliberative procedures whose aim is to produce decisions that represent an impartial standpoint equally in the interests of all. All those who put into question the very possibility of such a rational consensus and who point to the constitutive role of power relations in society and the fact that there cannot be a consensus that would not entail some form of exclusions are presented as undermining the very possibility of democracy.

The reason I believe that this trend to conflate politics with morality understood in rationalistic and universalistic terms has very negative consequences for democratic politics is that it erases the dimension of antagonism, which I take to be ineradicable in politics. I want to inquire into the reasons for this blindness of liberal democratic theory in front of the phenomenon of antagonism, and this requires going back to its origins and examining the basic tenets of the Enlightenment.

We can find useful insights for such a reflection in a recent book, *The Laws of Hostility*,[1] in which Pierre Saint-Amand proposes a political anthropology of the Enlightenment. By scruti-

nizing the writings of Montesquieu, Voltaire, Rousseau, Diderot, and Sade through the perspective developed by René Girard, he brings to the fore the key role played by the logic of *imitation* in their conception of sociability while, at the same time, unveiling its repressed dimension. He shows how, in their attempt to ground politics on Reason and Nature, the philosophes of the Enlightenment were led to present an optimistic view of human sociability, seeing violence as an archaic phenomenon that does not really belong to human nature. According to them, antagonistic and violent forms of behavior, everything that is the manifestation of hostility, could be eradicated thanks to the progress of exchange and the development of sociability. Theirs is an idealized view of sociability that only acknowledges one side of what constitutes the dynamics of imitation. Pierre Saint-Amand indicates how in the *Encyclopedie* human reciprocity is envisaged as aiming exclusively at the realization of the good. This is possible because only one part of the mimetic effects, those linked to empathy, are taken into account. However, if one recognizes the ambivalent nature of the concept of imitation, its antagonistic dimension can be brought to light and we get a different picture of sociability. The importance of Girard is that he reveals the conflictual nature of mimesis, the double bind by which the same movement that brings human beings together in their common desire for the same objects is also at the origin of their antagonism. Rivalry and violence far from being the exterior of exchange are therefore its ever present possibility. Reciprocity and hostility cannot be dissociated, and we have to realize that the social order will always be threatened by violence.

By refusing to acknowledge the antagonistic dimension of imitation, the philosophes failed to grasp the complex nature of human reciprocity. They denied the negative side of exchange, its dissociating impulse. This denial was the very condition for the fiction of a social contract from which violence and hostility would have been eliminated and where reciprocity could take

the form of a transparent communication among participants. Although, in their writings many of them could not completely elude the negative possibilities of imitation, they were unable to formulate conceptually its ambivalent character. It is the very nature of their humanistic project: the ambition to ground the autonomy of the social and to secure equality among human beings that led them to defend an idealized view of human sociability.

However, the fictitious character of this view was revealed by Sade who denounced the idea of a social contract and celebrated violence. Sade can be seen as the embodiment of a form of "aberrant liberalism" whose motto could be that private vices work toward the general vice. He cannot be separated from Rousseau whose idea of a transparent community he reproduces in a perverted form: the general will becomes the voluptuous will and the immediacy of communication becomes the immediacy of debauchery.

The main lesson to be learned from this brief journey into the beginnings of our modern democratic perspective is that, contrary to what Habermas and his followers argue, the epistemological side of the Enlightenment is not to be seen as the precondition for its political side: the democratic project. Far from being the necessary basis for democracy, the rationalist view of human nature, with its denial of the negative aspect inherent in sociability, appears as its weakest point. By foreclosing the recognition that violence is ineradicable, it renders democratic theory unable to grasp the nature of "the political" in its dimension of hostility and antagonism.

Contemporary liberals, far from offering a more adequate view of politics, are in a sense even less willing to acknowledge its dark side than were their forerunners. They believe that the development of modern society has definitively established the conditions for a "deliberative democracy" in which decisions on matter of common concern will result from the free and uncon-

strained public deliberation of all. Politics in a well-ordered democratic society is, according to them, the field where a rational consensus will be established through the free exercise of public reason, as in Rawls, or under the conditions of an undistorted communication, as in Habermas. As I indicated at the beginning, they conceive political questions as being of a moral nature and see political philosophy as representing a specialized domain of moral philosophy—moral philosophy applied to the basic institutions of society. By denying the ineradicability of antagonism, this approach forecloses the possibility of grasping the dynamics of its possible forms of emergence. No wonder that when confronted with the very antagonism that their perspective aims at denying, liberal theorists can only evoke a return of "the archaic."

Alas, it is not by denying the violence that is inherent in sociability, violence that no contract can eliminate because it constitutes one of its dimensions, that democratic politics can be secured and enhanced. On the contrary, it is by finally acknowledging the contradictory pulsions set to work by social exchange and the fragility of the democratic order that we will be able to grasp the task confronting democracy. This is why I consider that it is high time to understand that, despite Habermas, the critique of Enlightenment rationalism does not constitute a threat to the modern democratic project. In fact, it is exactly the opposite. Indeed, it is only when we relinquish rationalism and approach politics in a way that permits us to acknowledge its ethical dimension that we can begin to understand how it is possible to defend and deepen democratic institutions.

DEMOCRACY, JUSTICE, AND THE SOCIAL CONTRACT

The antirationalist approach that I am advocating puts the emphasis on the irreducible alterity that represents both a

condition of possibility and a condition of impossibility of every identity. This helps us understand that conflict and division are to be seen neither as disturbances that, unfortunately, cannot be completely eliminated, nor as empirical impediments that render impossible the full realization of a good constituted by a harmony that we cannot reach, because we will never be completely able to coincide with our rational universal self. By revealing that a nonexclusive public sphere of deliberation where a rational consensus could be attained is a *conceptual* impossibility, such an approach brings to the fore the inescapable moment of *decision* with which political actors are confronted and the ethico-political choices that they are forced to make. And this is of course what the deliberative approach is unable to acknowledge.

Putting emphasis on the ethico-political can help us to clarify some of the issues that are at stake in the debate about the role of procedures in the modern conception of democracy. Such emphasis reveals that a considerable amount of what Wittgenstein called "agreements in judgments" must already exist in a society before a given set of procedures can work. Indeed, procedures only exist as a complex ensemble of practices with their ethico-political dimensions. Those practices constitute specific forms of individuality and identity that make possible the allegiance to the procedures. It is because they are inscribed in shared forms of life and agreements in judgments that procedures can be accepted and followed. They cannot be seen as rules that are created on the basis of principles and then applied to specific cases. Rules are always abridgments of practices; they are inseparable from specific forms of life with their specific ethos. In consequence there cannot be such a clear-cut distinction between procedural and substantial, or between the field of justice (universal morality) and the field of the good (ethics) as Habermas asserts. In the case of justice, for instance,

I do not think that one can oppose procedural to substantial justice without recognizing that procedural justice already presupposes acceptance of certain values. The emphasis on procedures is part of the liberal conception of justice that posits the priority of the right over the good. But this is already the expression of a specific good embodied in a specific form of life. To accept some form of priority of the right over the good is of course the condition required in order for one to be seen as a competent liberal democratic citizen. However, it is misleading to present such an exigency as grounded in reason or on universal morality.

This has important consequences for the way we envisage democratic politics. It reveals that it is mistaken to imagine that it is by providing them with rational grounding that adherence to liberal democratic institutions can be secured. It indicates that allegiance to liberal democratic institutions depends on identification with the practices, the languages games that are constitutive of this particular form of life. They can only be defended in a "contextualist" manner, as being constitutive of our form of life, and we cannot ground our commitment to them on something supposedly more profound or more solid. There cannot be any final guarantee in those matters, and the only thing that we can do to consolidate democracy is to multiply the institutions, the practices, and the discourses that create and reproduce democratic forms of individuality. Only when individuals recognize that their identity—which of course is an identity that they must value—depends on the existence of the liberal democratic form of life will they be prepared to defend those institutions and to fight for them when needed. This is why the multiple forms of exclusion that we are witnessing in advanced liberal democracies represent a great danger for the survival of those democracies since an increasing number of persons do not have any reason to feel that they are participant in a valuable way of life.

The prime task of democratic politics is not, as deliberative democrats argue, to eliminate passions or to relegate them to the private sphere in order to establish a rational consensus in the public sphere. It is to mobilize those passions toward democratic designs. It is necessary to understand that far from jeopardizing democracy, agonistic confrontation is in fact its very condition of possibility.

To deny that there ever could be a free and unconstrained public deliberation of all about matters of common concern is therefore crucial for democratic politics. When we accept that every consensus exists as a temporary result of a provisional hegemony, as a stabilization of power, and that it always entails some form of exclusion, we can begin to envisage the nature of a democratic public sphere in a different way. Modern democracy's specificity lies in the recognition and legitimization of conflict and the refusal to suppress it by imposing an authoritarian order. Breaking with the symbolic representation of society as an organic body—which is characteristic of the holiest mode of social organization—a democratic society makes room for the expression of conflicting interests and values. To be sure, pluralist democracy demands some form of consensus, but such a consensus concerns only its ethico-political principles. But since those ethico-political principles can only exist through many different and conflicting interpretations, such a consensus is bound to be a "conflictual consensus." This is why a pluralist democracy needs to make room for dissent and for the institutions through which it can be manifested. Its survival depends on collective identities forming around clearly differentiated positions, as well as on the possibility of choosing between real alternatives. When the agonistic dynamic of the pluralist system is hindered because of a lack of democratic identities with which one could identify, there is a risk that this will multiply confrontations over essentialist identities and non-negotiable moral values.

THE ETHICS OF DEMOCRACY

To be able to think of the relation between ethics and politics in a way that does not collapse the two domains and that acknowledges the necessary tension that will always exist between them, one needs to come to terms with the very impossibility of a nonexclusive public sphere of rational argument where a noncoercive consensus can be attained. Showing that such a consensus is a *conceptual* impossibility does not put in jeopardy the democratic ideal as some would argue. On the contrary, it protects pluralist democracy against any attempts of closure. Indeed, such a rejection constitutes an important guarantee that the dynamics of the democratic process will be kept alive.

Instead of trying to erase the traces of power and exclusion, democratic politics requires that they be brought to the fore, to make the moment of *decision* visible so that decisions and their effects can enter the terrain of contestation. And the fact that this must be envisaged as an unending process should not be cause for despair because the desire to reach a final destination can only lead to the destruction of democracy. In a democratic polity, conflicts and confrontations, far from being a sign of imperfection, indicate that democracy is alive and inhabited by pluralism. Indeed the great virtue of modern pluralist democracy is, as Claude Lefort has argued, its recognition and institutionalization of division and conflict.

To the Kantian-inspired deontological model of democracy that envisages its realization under the form of an ideal community of communication, as a task conceived as infinite, to be sure, but which has nevertheless a clearly defined shape, as well as to the model of democracy around a neo-Aristotelian ethics of the good advocated by the communitarians, we should oppose a conception of democracy inspired by another type of ethics, an ethics not of harmony but of *dis-harmony*. Such a conception of democracy would be suspicious of any attempt to

impose a univocal model of democratic discussion and would make room for the "differend" (Lyotard). Aware of the dangers of rationalism and moralism, this is a view that does not dream of mastering or eliminating undecidability and of establishing transparency. Abandoning the very idea of a complete reabsorption of alterity into oneness and harmony such an ethics would strive to create among us a new form of bond, a bond that recognizes us as divided subjects and does not dream of an impossible reconciliation. To institute this new sort of ethical bond that includes the knowledge of the ineradicability of antagonism and violence is precisely the aim of the agonistic conception of democracy that I am trying to develop. What to do with this violence, how to deal with this antagonism, those are the ethical questions to which a democratic politics will forever be confronted and for which there can never be a final solution.

NOTE

1. Pierre Saint-Amand, *The Laws of Hostility, Politics, Violence and the Enlightenment* (Minneapolis: University of Minnesota Press, 1996).

Recognition without Ethics?

Nancy Fraser

for some time now, the forces of progressive politics have been divided into two camps. On one side stand the proponents of "redistribution." Drawing on long traditions of egalitarian, labor, and socialist organizing, political actors aligned with this orientation seek a more just allocation of resources and goods. On the other side stand the proponents of "recognition." Drawing on newer visions of a "difference-friendly" society, they seek a world where assimilation to majority or dominant cultural norms is no longer the price of equal respect. Members of the first camp hope to redistribute wealth from the rich to the poor, from the North to the South, and from the owners to the workers. Members of the second, in contrast,

seek recognition of the distinctive perspectives of ethnic, "racial," and sexual minorities, as well as of gender difference. The redistribution orientation has a distinguished philosophical pedigree, as egalitarian redistributive claims have supplied the paradigm case for most theorizing about social justice for the past 150 years. The recognition orientation has recently attracted the interest of political philosophers, however, some of whom are seeking to develop a new normative paradigm that puts recognition at its center.[1]

At present, unfortunately, relations between the two camps are quite strained. In many cases, struggles for recognition are disso-ciated from struggles for redistribution. Within social movements such as feminism, for example, activist tendencies that look to redistribution as the remedy for male domination are increas-ingly dissociated from tendencies that look instead to recognition of gender difference. And the same is largely true in the intellec-tual sphere. In the academy, to continue with feminism, scholars who understand gender as a social relation maintain an uneasy arms-length coexistence with those who construe it as an identity or a cultural code. This situation exemplifies a broader phenome-non: the widespread decoupling of cultural politics from social politics, of the politics of difference from the politics of equality.

In some cases, moreover, the dissociation has become a polar-ization. Some proponents of redistribution see claims for the recognition of difference as "false consciousness," a hindrance to the pursuit of social justice. Conversely, some proponents of recognition reject distributive politics as part and parcel of an outmoded materialism that can neither articulate nor challenge key experiences of injustice. In such cases, we are effectively presented with what is constructed as an either/or choice: redis-tribution or recognition? class politics or identity politics? mul-ticulturalism or social equality?

These, I have argued elsewhere, are false antitheses.[2] Justice today requires *both* redistribution *and* recognition; neither

alone is sufficient. As soon as one embraces this thesis, however, the question of how to combine them becomes pressing. I maintain that the emancipatory aspects of the two problematics need to be integrated in a single, comprehensive framework. The task, in part, is to devise an expanded conception of justice that can accommodate both defensible claims for social equality and defensible claims for the recognition of difference.

MORALITY OR ETHICS?

Integrating redistribution and recognition is no easy matter, however. On the contrary, to contemplate this project is to become immediately embroiled in a nexus of difficult philosophical questions. Some of the thorniest of these concern the relation between morality and ethics, the right and the good, justice and the good life. A key issue is whether paradigms of justice usually aligned with "morality" can handle claims for the recognition of difference—or whether it is necessary, on the contrary, to "turn to ethics."

Let me explain. It is now standard practice in moral philosophy to distinguish questions of "justice" from questions of "the good life." Construing the first as a matter of "the right" and the second as a matter of "the good," most philosophers align distributive justice with Kantian *Moralität* (morality) and recognition with Hegelian *Sittlichkeit* (ethics). In part this contrast is a matter of scope. Norms of justice are thought to be universally binding; they hold independently of actors' commitments to specific values. Claims for the recognition of difference, in contrast, are more restricted. Involving qualitative assessments of the relative worth of different goods, they depend on culturally and historically specific horizons of value.

Much of recent moral philosophy turns on disputes over the relative standing of these two different orders of normativity. Liberal political theorists and deontological moral philosophers

insist that "the right" take priority over "the good." For them, accordingly, the demands of justice trump the claims of ethics. Communitarians and teleologists rejoin that the notion of a universally binding morality independent of any idea of the good is conceptually incoherent. Preferring "thick" accounts of moral experience to "thin" ones, they rank the substantive claims of culturally specific community values above abstract appeals to Reason or Humanity.

Partisans of "the right," moreover, often subscribe to models of distributive justice. Viewing justice as a matter of fairness, they seek to eliminate unjustified disparities between the life-chances of social actors. To identify these disparities, they invoke standards of fairness that do not prejudge those actors' own (varying) views of the good. Partisans of "the good," in contrast, reject the "empty formalism" of distributive approaches. Viewing ethics as a matter of the good life, they seek to promote the qualitative conditions of human flourishing rather than fidelity to abstract requirements of equal treatment.

These philosophical alignments complicate the problem of integrating redistribution and recognition. Distribution evidently belongs on the "morality" side of the divide. Recognition, however, seems at first sight to belong to "ethics," as it seems to require substantive judgments of the value of various goods. It is not surprising, therefore, that many deontological theorists simply reject claims for the recognition of difference as violations of liberal neutrality, while concluding that distributive justice exhausts the whole of political morality. It is also unsurprising, conversely, that many theorists of recognition align themselves with "ethics" against "morality"; following the same reasoning as their liberal counterparts, they conclude that recognition requires qualitative judgments of value that exceed the capacities of distributive models.

In these standard alignments, both sides agree that distribution belongs to morality, recognition belongs to ethics, and the

twain can never meet. Thus, each assumes that its paradigm excludes the other's. If they are right, then the claims of redistribution and the claims of recognition cannot be coherently combined. On the contrary, whoever wishes to endorse claims of both types courts the risk of philosophical schizophrenia.

It is precisely this presumption of incompatibility that I wish to reject. Contra the received wisdom, I shall argue that one *can* integrate redistribution and recognition without succumbing to schizophrenia. My strategy will be to construe the politics of recognition in a way that does not deliver it over immediately and directly to "ethics." Rather, I shall try to account for claims for recognition as *justice claims* within an expanded understanding of justice. The initial effect will be to recuperate the politics of recognition for *Moralität* and thus to resist the turn to ethics. This is not, however, precisely where I will end up. Rather, after pushing as hard as I can to avoid the turn to ethics, I will describe a scenario in which ethical evaluation is an integral component of reasoning about justice. The end result will be to destabilize the distinction between *Moralität* and *Sittlichkeit*—despite my firm conviction that it is a distinction one cannot simply drop.

IDENTITY OR STATUS?

The key to my strategy is to break with the standard "identity" model of recognition.[3] On this model, what requires recognition is group-specific cultural identity. Misrecognition consists in the depreciation of such identity by the dominant culture and the consequent damage to group members' sense of self. Redressing this harm means demanding "recognition." This in turn requires that group members join together to refashion their collective identity by producing a self-affirming culture of their own. Thus, on the identity model of recognition, the politics of recognition means "identity politics."

This identity model is deeply problematic. Construing misrecognition in terms of damaged identity, it stresses psychic structure over social institutions and social interaction. Thus, it risks substituting intrusive forms of consciousness engineering for social change. The model compounds these risks by positing *group* identity as the object of recognition. Enjoining the elaboration and display of an authentic, self-affirming, and self-generated collective identity, it puts moral pressure on individual members to conform to group culture. The result is often to impose a single, drastically simplified group identity, which denies the complexity of people's lives, the multiplicity of their identifications, and the cross-pulls of their various affiliations. Likewise, the model entrenches a reified conception of culture. Ignoring transcultural flows, it treats cultures as sharply bounded, neatly separated, and noninteracting, as if it were obvious where one stops and another starts. As a result, it tends to promote separatism and group enclaving in lieu of transgroup interaction. Denying internal heterogeneity, moreover, the identity model assumes that a "culture" contains a single coherent set of ethical values whose meaning is clear and uncontested. It obscures the struggles *within* social groups for the authority, and indeed for the power, to represent them. As a result, it masks the power of dominant fractions and reinforces intragroup domination. In general, then, the identity model lends itself all too easily to repressive forms of communitarianism.

For these reasons, I shall propose an alternative analysis of recognition. My proposal is to treat recognition as a question of *social status.* From this perspective, what requires recognition is not group-specific identity but rather the status of group members as full partners in social interaction. Misrecognition, accordingly, does not mean the depreciation and deformation of group identity. Rather, it means *social subordination* in the sense of being prevented from *participating as a peer* in social life. To redress the injustice requires a politics of recognition, to be sure.

But this does not mean identity politics. On the status model, rather, it means a politics aimed at overcoming subordination by establishing the misrecognized party as a full member of society, capable of participating on a par with other members.

Let me explain. To view recognition as a matter of status is to examine institutionalized patterns of cultural value for their effects on the relative standing of social actors. If and when such patterns constitute actors as *peers,* capable of participating on a par with one another in social life, then we can speak of *reciprocal recognition* and *status equality.* When, in contrast, institutionalized patterns of cultural value constitute some actors as inferior, excluded, wholly other, or simply invisible, hence as less than full partners in social interaction, then we can speak of *misrecognition* and *status subordination.*

For example, most societies institutionalize androcentric patterns of cultural value, which privilege traits associated with masculinity. Pervasively institutionalized, such patterns inform marriage, tax, and citizenship laws; health, welfare, and education policies; and many other key determinants of social status. Their effect is to constitute women and girls as subordinate and deficient others who cannot participate as peers in social life. Serious injustices of status subordination follow as a matter of course: for example, sexual assault and domestic violence; genital mutilation and sexual enslavement; diminished access to housing, food, land, employment, health care, property, and education; impaired immigration, naturalization, and asylum rights; exclusion from or marginalization in civil society and political life; media stereotyping and objectification. Quintessential instances of misrecognition, these injustices prevent women and girls from participating fully in social life.

Construed in this way, as a species of status subordination, misrecognition constitutes a serious injustice. Hence, a "politics of recognition" is apropos. But note precisely what this means: aimed not at valorizing group identity, but rather at remedying

subordination, claims for recognition seek to establish the subordinated party as a full partner in social life, able to interact with others as a peer. They aim, that is, to *deinstitutionalize patterns of cultural value that impede parity of participation and to replace them with patterns that foster it.* In the case of gender, then, the politics of recognition does not aim to valorize a putative feminine identity. It aims rather to deinstitutionalize androcentric value patterns in favor of alternatives that promote women's capacity to participate on a par with men in social life.

This status model avoids many difficulties of the identity model. First, by rejecting the view of recognition as valorization of group identity, it avoids essentializing such identities. Second, by focusing instead on the effects of institutionalized norms on capacities for interaction, it resists the temptation to substitute the reengineering of consciousness for social change. Third, by enjoining status equality in the sense of parity of participation, it valorizes cross-group interaction, as opposed to separatism and group enclaving. In general, then, the status model avoids reifying culture, while nevertheless appreciating culture's political importance. Aware that institutionalized patterns of cultural value can be vehicles of subordination, it seeks to deinstitutionalize patterns that impede parity of participation and to replace them with patterns that foster it.

Finally, the status model possesses another major advantage. Unlike the identity model, it construes recognition in a way that does not deliver that category prematurely to ethics. Conceiving recognition as a matter of status equality, defined in turn as participatory parity, it provides a deontological account of recognition. Thus, it frees recognition claims' normative force from direct dependence on a specific substantive horizon of value. Unlike the identity model, then, the status model is compatible with the priority of the right over the good. Refusing the traditional alignment of recognition with ethics, it aligns it with morality instead. Thus, the status model permits one to com-

bine recognition with redistribution—without succumbing to philosophical schizophrenia. Or so I shall argue next.

JUSTICE OR THE GOOD LIFE?

Any attempt to integrate redistribution and recognition must address four crucial philosophical questions. First, is recognition a matter of justice, or is it a matter of self-realization? Second, do distributive justice and recognition constitute two distinct, sui generis, normative paradigms, or can either of them be subsumed within the other? Third, does justice require the recognition of what is distinctive about individuals or groups, or is recognition of our common humanity sufficient? And fourth, how can we distinguish those claims for recognition that are justified from those that are not?

How one answers these questions depends on the conception of recognition one assumes. In what follows, I will employ the status model in order to resist turning prematurely to ethics. Drawing on that model, I shall expand the standard conception of justice to accommodate claims for recognition. By stretching the notion of morality, then, I intend to postpone as long as possible the turn to ethics. In the end, however, I will suggest that ethical evaluation is unavoidable, although deeply problematic.

I begin with the question, Is recognition a matter of justice, and thus of morality, or is it rather a matter of the good life, and thus of ethics? Two major theorists, Charles Taylor and Axel Honneth, understand recognition as a matter of the good life. Unlike them, however, I propose to treat it as an issue of justice. Thus, one should not answer the question "What's wrong with misrecognition?" by saying that it impedes human flourishing, as Taylor does.[4] Nor should one follow Honneth and appeal to a "formal conception of ethical life" premised on an account of the "intersubjective conditions" for an "undistorted practical relation-to-self."[5] One should say, rather, that it is unjust that

some individuals and groups are denied the status of full part-
ners in social interaction simply as a consequence of institution-
alized patterns of cultural value in whose construction they
have not equally participated and which disparage their distinc-
tive characteristics or the distinctive characteristics assigned to
them. One should say, that is, that misrecognition is wrong
because it constitutes a species of unjust status subordination.

This approach offers several important advantages. First, by
appealing to a deontological standard, it permits one to justify
claims for recognition as morally binding under modern condi-
tions of value pluralism.[6] Under these conditions, there is no
single conception of self-realization or the good that is univer-
sally shared, nor any that can be established as authoritative.
Thus, any attempt to justify claims for recognition that appeals
to an account of self-realization or the good must necessarily be
sectarian. No approach of this sort can establish such claims as
normatively binding on those who do not share the theorist's
conception of ethical value.

Unlike such approaches, the status model of recognition is
deontological and nonsectarian. Embracing the modern view
that it is up to individuals and groups to define for themselves
what counts as a good life and to devise for themselves an
approach to pursuing it, within limits that ensure a like liberty
for others, it appeals to a conception of justice that can be
accepted by people with divergent conceptions of the good.
What makes misrecognition morally wrong, in my view, is that
it denies some individuals and groups the possibility of partici-
pating on a par with others in social interaction. The norm of
participatory parity invoked here is nonsectarian in the required
sense. It can justify claims for recognition as normatively bind-
ing on all who agree to abide by fair terms of interaction under
conditions of value pluralism.

Treating recognition as a matter of justice has a second
advantage as well. It conceives misrecognition as a species of

status subordination whose locus is social relations, not interpersonal psychology. To be misrecognized, in this view, is not simply to be thought ill of, looked down on, or devalued in others' conscious attitudes or mental beliefs. It is rather to be denied the status of a full partner in social interaction and prevented from participating as a peer in social life as a consequence of institutionalized patterns of cultural value that constitute one as comparatively unworthy of respect or esteem. When such patterns of disrespect and disesteem are institutionalized, they impede parity of participation, just as surely as do distributive inequities.

Eschewing psychologization, then, this approach escapes difficulties that plague rival approaches. When misrecognition is identified with internal distortions in the structure of self-consciousness of the oppressed, it is but a short step to blaming the victim, as one seems to add insult to injury. Conversely, when misrecognition is equated with prejudice in the minds of the oppressors, overcoming it seems to require policing their beliefs, an approach that is authoritarian. In the status view, in contrast, misrecognition is a matter of externally manifest and publicly verifiable impediments to some people's standing as full members of society. And such arrangements are morally indefensible whether or not they distort the subjectivity of the oppressed.

Finally, by aligning recognition with justice instead of the good life, one avoids the view that everyone has an equal right to social esteem. That view is patently untenable, of course, because it renders meaningless the notion of esteem. Yet it seems to follow from at least one prominent account of recognition in terms of self-realization.[7] The account of recognition proposed here, in contrast, entails no such reductio ad absurdum. What it *does* entail is that everyone has an equal right to pursue social esteem under fair conditions of equal opportunity. And such conditions do not obtain when, for example, institutionalized

patterns of cultural value pervasively downgrade femininity, "nonwhiteness," homosexuality, and everything culturally associated with them. When that is the case, women and/or people of color and/or gays and lesbians face obstacles in the quest for esteem that are not encountered by others. And everyone, including straight white men, faces further obstacles if they opt to pursue projects and cultivate traits that are culturally coded as feminine, homosexual, or "nonwhite."

For all these reasons, recognition is better treated as a matter of justice, and thus of morality, than as a matter of the good life, and thus of ethics. And construing recognition on the model of status permits us to treat it as a matter of justice.

But what follows for the theory of justice?

EXPANDING THE PARADIGM OF JUSTICE

Supposing that recognition is a matter of justice, what is its relation to distribution? Does it follow, turning now to the second question, that distribution and recognition constitute two distinct, sui generis conceptions of justice? Or can either of them be reduced to the other? To arrive at a plausible answer, let's begin with the question of reduction which must be considered from two different sides.

From one side, the issue is whether existing theories of distributive justice can adequately subsume problems of recognition. In my view, the answer is no. To be sure, many distributive theorists appreciate the importance of status over and above the allocation of resources and seek to accommodate it in their accounts.[8] But the results are not wholly satisfactory. Most such theorists assume a reductive economistic-cum-legalistic view of status, supposing that a just distribution of resources and rights is sufficient to preclude misrecognition. In fact, however, not all misrecognition is a byproduct of maldistribution, nor of maldistribution plus legal discrimination. Witness the case of the

African-American Wall Street banker who cannot get a taxi to pick him up. To handle such cases, a theory of justice must reach beyond the distribution of rights and goods to examine patterns of cultural value. It must consider whether institutionalized patterns of cultural value impede parity of participation in social life.[9]

What, then, of the other side of the question? Can existing theories of recognition adequately subsume problems of distribution? Here, too, I contend the answer is no. To be sure, some theorists of recognition appreciate the importance of economic equality and seek to accommodate it in their accounts.[10] But once again the results are not wholly satisfactory. These theorists tend to assume a reductive culturalist view of distribution. Supposing that all economic inequalities are rooted in a cultural order that privileges some kinds of labor over others, they assume that changing that cultural order is sufficient to preclude all maldistribution.[11] In fact, however, not all maldistribution is a byproduct of misrecognition. Witness the case of the skilled white male industrial worker who becomes unemployed due to a factory closing resulting from a speculative corporate merger. In that case, the injustice of maldistribution has little to do with misrecognition. It is rather a consequence of imperatives intrinsic to an order of specialized economic relations whose raison d'être is the accumulation of profits. To handle such cases, a theory of justice must reach beyond cultural value patterns to examine the structure of capitalism. It must consider whether economic mechanisms that are relatively decoupled from cultural value patterns and that operate in a relatively impersonal way can impede parity of participation in social life.

In general, then, neither distribution theorists nor recognition theorists have so far succeeded in adequately subsuming the concerns of the other. Thus, instead of endorsing one of their conceptions to the exclusion of the other, I propose to develop an expanded conception of justice. My conception treats distribution

and recognition as distinct perspectives on, and dimensions of, justice. Without reducing either perspective to the other, it encompasses both dimensions within a broader, overarching framework.

The normative core of my conception, as I have already noted, is the notion of *parity of participation*.[12] According to this norm, justice requires social arrangements that permit all (adult) members of society to interact with one another as peers. For participatory parity to be possible, I claim, at least two conditions must be satisfied.[13] First, the distribution of material resources must be such as to ensure participants' independence and "voice." This I call the "objective" precondition of participatory parity. It precludes forms and levels of material inequality and economic dependence that impede parity of participation. Precluded, therefore, are social arrangements that institutionalize deprivation, exploitation, and gross disparities in wealth, income, and leisure time, thereby denying some people the means and opportunities to interact with others as peers.[14]

In contrast, the second condition for participatory parity I call "intersubjective." It requires that institutionalized patterns of cultural value express equal respect for all participants and ensure equal opportunity for achieving social esteem. This condition precludes institutionalized cultural patterns that systematically depreciate some categories of people and the qualities associated with them. Precluded, therefore, are institutionalized value schemata that deny some people the status of full partners in interaction—whether by burdening them with excessive ascribed "difference" or by failing to acknowledge their distinctiveness.

Both the objective precondition and the intersubjective precondition are necessary for participatory parity. Neither alone is sufficient. The objective condition brings into focus concerns traditionally associated with the theory of distributive justice, especially concerns pertaining to the economic structure of

society and to economically defined class differentials. The intersubjective precondition brings into focus concerns recently highlighted in the philosophy of recognition, especially concerns pertaining to the status order of society and to culturally defined hierarchies of status. Thus, an expanded conception of justice oriented to the norm of participatory parity encompasses both redistribution and recognition, without reducing either one to the other.

This approach goes a considerable way toward resolving the problem with which we began. By construing redistribution and recognition as two mutually irreducible dimensions of justice, and by submitting both of them to the deontological norm of participatory parity, it positions them both on the common terrain of *Moralität*. Avoiding turning prematurely to ethics, then, it seems to promise an escape route from philosophical schizophrenia.

RECOGNIZING DISTINCTIVENESS?

Before proclaiming success, however, we must take up the third question: Does justice require the recognition of what is distinctive about individuals or groups, over and above the recognition of our common humanity? If the answer proves to be yes, we will have to revisit the question of ethics.

Let us begin by noting that participatory parity is a universalist norm in two senses. First, it encompasses all (adult) partners to interaction. And second, it presupposes the equal moral worth of human beings. But moral universalism in these senses still leaves open the question whether recognition of individual or group distinctiveness could be required by justice as one element among others of the intersubjective condition for participatory parity.

This question cannot be answered, I contend, by an a priori account of the kinds of recognition that everyone always needs.

It should rather be approached in the spirit of pragmatism as informed by the insights of a critical social theory. From this perspective, recognition is a remedy for injustice, not the satisfaction of a generic human need. Thus, the form(s) of recognition justice requires in any given case depend(s) on the form(s) of *mis*recognition to be redressed. In cases where misrecognition involves denying the common humanity of some participants, the remedy is universalist recognition. Where, in contrast, misrecognition involves denying some participants' distinctiveness, the remedy could be recognition of difference.[15] In every case, the remedy should be tailored to the harm.

This pragmatist approach overcomes the liabilities of two other mirror-opposite views. First, it rejects the claim, espoused by some distributive theorists, that justice requires limiting public recognition to those capacities all humans share. That approach dogmatically forecloses recognition of what distinguishes people from one another, without considering whether such recognition might be necessary in some cases to overcome obstacles to participatory parity. Second, the pragmatist approach rejects the opposite claim, equally decontextualized, that everyone always needs their distinctiveness recognized.[16] Often favored by recognition theorists, that approach cannot explain why it is that not all, but only some, social differences generate claims for recognition, nor why only some of those claims, but not others, are morally justified. More specifically, it cannot explain why those occupying advantaged positions in the status order, such as men and heterosexuals, usually shun recognition of their (gender and sexual) distinctiveness, claiming not specificity but universality.[17] Nor why, on those occasions when they do seek such recognition, their claims are usually spurious. By contrast, the approach proposed here sees claims for the recognition of difference pragmatically and contextually—as remedial responses to specific harms. Putting questions of justice at the center, it appreciates that the recognition needs of subordinated actors differ from those of

dominant actors; and that only those claims that promote parity of participation are morally justified.

For the pragmatist, accordingly, everything depends on precisely what currently misrecognized people need in order to be able to participate as peers in social life. And there is no reason to assume that all of them need the same thing in every context. In some cases, they may need to be unburdened of excessive ascribed or constructed distinctiveness. In other cases, they may need to have hitherto underacknowledged distinctiveness taken into account. In still other cases, they may need to shift the focus onto dominant or advantaged groups, outing the latter's distinctiveness, which has been falsely parading as universality. Alternatively, they may need to deconstruct the very terms in which attributed differences are currently elaborated. Finally, they may need all of the above, or several of the above, in combination with one another and in combination with redistribution. Which people need which kind(s) of recognition in which contexts depends on the nature of the obstacles they face with regard to participatory parity.

We cannot rule out in advance, therefore, the possibility that justice may require recognizing distinctiveness in some cases.

JUSTIFYING CLAIMS FOR RECOGNITION

Up to this point, I have managed to answer three major philosophical questions about recognition while remaining on the terrain of *Moralität*. By construing recognition on the model of status, I have given it a deontological interpretation. And by expanding the standard paradigm of justice, I have treated redistribution and recognition as two mutually irreducible dimensions of, and perspectives on, justice, both of which can be brought under the common norm of participatory parity. Thus, I have so far avoided the turn to ethics and escaped philosophical schizophrenia.

At this point, however, the question of ethics threatens to return. Once we accept that justice *could,* under certain circumstances, require recognition of distinctiveness, then we must reconsider the problem of justification. We must ask: What justifies a claim for the recognition of difference? How can one distinguish justified from unjustified claims of this sort? The crucial issue is whether a purely deontological standard will suffice—or whether, on the contrary, ethical evaluation of substantive contents is required. In the latter event, one will have to turn to ethics after all.

Let us begin by noting that not every claim for recognition is warranted, just as not every claim for redistribution is. In both cases, one needs an account of criteria and/or procedures for distinguishing warranted from unwarranted claims. Theorists of distributive justice have long sought to provide such accounts, whether by appealing to objectivistic criteria, such as utility maximization, or to procedural norms, such as those of discourse ethics. Theorists of recognition, in contrast, have been slower to confront this question. They have yet to provide any principled basis for distinguishing justified from unjustified claims.

This issue poses grave difficulties for those who deliver recognition prematurely to ethics. Theorists who justify recognition as a means to self-realization are especially vulnerable to serious objections. According to Axel Honneth, for example, everyone needs their distinctiveness recognized in order to develop self-esteem, which (along with self-confidence and self-respect) is an essential ingredient of an undistorted identity.[18] It seems to follow that claims for recognition that enhance the claimant's self-esteem are justified, while those that diminish it are not. On the basis of this hypothesis, however, the racist identity of poor "white people" would merit recognition, as it enables them to maintain their sense of self-worth by contrasting themselves with their supposed inferiors. Antiracist claims would be hard

to justify, in contrast, as they threaten the self-esteem of poor "whites." Unfortunately, cases like this one, in which prejudice conveys psychological benefits, are by no means rare. They suffice to disconfirm the view that enhanced self-esteem can supply a justificatory standard for claims for recognition. At the same time, they expose the general weakness of teleological theories that seek to justify such claims in terms of self-realization.

How, then, *should* recognition claims be judged? What constitutes an adequate criterion for assessing their relative merits?

The approach developed here proposes the deontological standard of participatory parity. As we saw, this norm overarches both dimensions of justice, distribution and recognition. Thus, for both dimensions the same general criterion serves to distinguish warranted from unwarranted claims. Whether the issue is distribution or recognition, claimants must show that institutionalized arrangements prevent them from participating on a par with others in social life. Redistribution claimants must show that social arrangements unjustly deny them resources and opportunities that are necessary objective conditions for participatory parity. Recognition claimants, in contrast, must show that institutionalized patterns of cultural value unjustly deny them the equal respect and/or equal opportunity for achieving social esteem that are necessary intersubjective conditions for participatory parity. In both cases, therefore, the norm of participatory parity is the general standard for warranting claims.

As we shall see, efforts to apply this norm are bound to be controversial. Nevertheless, it represents a considerable improvement over the "self-realization" standard just discussed. Focusing on capacities for participation, the status model condemns the institutionalization of racist values even in cases where the latter provide psychological benefits to those who subscribe to them. Nevertheless, it remains to be seen whether the norm of participatory parity is by itself sufficient to distinguish justified from unjustified claims for the recognition of difference.

RACISM, HOMOPHOBIA, AND PARTICIPATORY PARITY

The problem is that not all disparities are per se unjust. Theorists of distributive justice have long appreciated this point with respect to economic inequalities. Seeking to distinguish just from unjust economic disparities, some of them have drawn the line between those inequalities that arise as a result of individuals' choices, on the one hand, and those that arise as a result of circumstances beyond individuals' control, on the other, arguing that only the second, and not the first, are unjust.[19] Analogous issues arise with respect to recognition. Here, too, not all disparities are unjust—because not all institutionalized value hierarchies are unjust. What is needed, consequently, is a way of distinguishing just from unjust disparities in participation. The key question here, once again, is whether the deontological norm of parity of participation is sufficient for this purpose. And whether, if not, one must turn to ethics.

Let us consider some heuristic examples. It is intuitively clear that when racist norms are institutionalized, the resulting disparity in participation between blacks and whites is unjust. Yet there is no injustice, by contrast, when antiracist norms are institutionalized, even though the effect may be to impede racists from participatory parity with nonracists *in certain respects*. One reason is that antiracist norms embody the principle of participatory parity, whereas racist values contravene it. Thus, blacks disadvantaged in the first case can consistently appeal to the principle, whereas racists disadvantaged in the second case cannot. Another reason is that racists have the option of overcoming their disadvantage by the simple expedient of changing their beliefs; blacks, in contrast, can do nothing to achieve parity of participation with whites so long as racist norms continue to be institutionalized. In this

case, consequently, the deontological norm of participatory parity is sufficient to draw the line.

This conclusion holds, moreover, if we delve deeper into the matter and examine the phrase "in certain respects." The idea here is that while some ways of denying participatory parity to racists are consistent with justice, others in contrast are not. For example, institutionalizing antiracist norms, such as affirmative action, may impede equal participation for racists qua racists in hiring decisions; but this is not, for the reasons already noted, a violation of justice. Institutionalizing norms barring racists from access to health care, in contrast, does constitute such a violation. The reason is that the requirement of freedom from racist prejudice is intrinsic to the norm-governed social practice of hiring; its rejection violates the meaning of that practice and entails denying participatory parity to blacks. Yet this requirement is not germane, let alone essential, to the social meaning of receiving health care, which should be governed by medical need, not moral worth. Nor, in addition, does according parity of medical access to racists entail denying parity to anyone else. Thus, here, too deontological principles suffice.

Suppose, however, that we vary the example by substituting homophobia for racism. And suppose we assume that sexual orientation is not genetically hard-wired but is subject to an element of choice. In that case, we cannot take recourse to one of the arguments invoked above; we cannot say that, while homophobes can overcome their disadvantages in nonhomophobic societies by adapting their beliefs to the institutionalized norms, homosexuals cannot overcome theirs in homophobic societies unless the institutionalized norms are changed. (In fact, it is to avoid this problem that some proponents of gay-and-lesbian rights have recently insisted, in my view implausibly, that homosexuality is genetically determined.) On what basis, then, can we say that the marginalization of homosexuals in the one case violates justice, while the marginalization of homophobes in the

other does not? Can we justify these judgments on deontological grounds alone? Or must we, rather, turn to ethics and attempt an ethical evaluation of the substantive worth of homosexuality and heterosexuality?

Deontological standards clearly suffice for justifying relatively neutral forms of recognition, such as antidiscrimination measures. Here, too, we can say, as with racism, that antiheterosexist values embody the principle of participatory parity, whereas heterosexist values contravene it. Thus, homosexuals disadvantaged in the one case can consistently appeal to the principle, whereas homophobes disadvantaged in the other case cannot. But can deontological standards suffice to justify other, more positive forms of recognition, such as legalization of same-sex marriage? Initially, such measures seem to require more— namely, a substantive judgment that homosexual unions are ethically valuable. Here, too, however, one cannot appeal directly to "the good." After all, in our society citizens holding divergent conceptions of the good differ as to the ethical value of same-sex unions. Thus, any argument that appeals to a substantive assessment must be sectarian and lack binding force. In such cases, it is essential to appeal to "the right." And the right, construed via the principle of participatory parity, requires that homosexuals not be excluded from any privileges or benefits accorded to heterosexuals. Thus, those who object, on ethical grounds, to same-sex marriage face a choice. They can either accept its legalization as "political liberals," who, mindful of others' ethical perspectives, refrain from imposing their own and allow "choice." Or, if they cannot live with positive state recognition, they can opt to deinstitutionalize marriage altogether, withdrawing from heterosexual unions privileges they are unwilling to extend to gays and lesbians. Either option is consistent with the deontological principle of participatory parity. Thus, even an issue as apparently value-laden as the recognition of same-sex marriage can be resolved without turning to ethics.

CULTURAL MINORITIES AND THE DOUBLE REQUIREMENT

One suspects, however, that the preceding examples are too easy. After all, they concern injustices premised on ascribed characteristics, which lend themselves easily to deontological reasoning. Suppose, therefore, we consider the apparently more challenging case of cultural minorities. And let us focus, for the sake of simplicity, on recognition claims of religious minorities within multicultural polities. Here the question is, Can their claims for public recognition of religious-cultural distinctiveness really be settled by appeal to the norm of participatory parity? Or is ethical evaluation unavoidable?

From the perspective of the status model, participatory parity enters the picture at two different levels. First, at the *intergroup* level, it supplies the standard for assessing the effects of institutionalized patterns of cultural value on the relative standing of *minorities vis-à-vis majorities.* Thus, one invokes it when considering, for example, whether erstwhile Canadian rules mandating uniform headgear for Mounted Police constituted an unjust *majority communitarianism,* which effectively closed that occupation to Sikh men. Second, at the *intragroup* level, participatory parity also serves to assess the *internal effects of minority practices* for which recognition is claimed. At this level, one invokes it when considering, for example, whether Orthodox Jewish practices of sex segregation unjustly marginalize girls and women and thus are unworthy of public recognition.

Taken together, these two levels constitute a double requirement for claims for minority cultural recognition. Claimants must show, first, that the institutionalization of majority cultural norms denies them participatory parity and, second, that the practices for which they seek recognition in order to remedy the disparity do not themselves deny participatory parity to some of their own members. In the status model of recognition,

both requirements are necessary; neither alone is sufficient. Only claims that meet both of them are deserving of public recognition.

Clearly, this approach sets a stringent standard for justifying claims for the recognition of cultural difference. Yet it remains wholly deontological. Applied in this double way, the norm of participatory parity suffices to rule out many unwarranted cultural claims, without any recourse to ethical evaluation.

The question remains, however, whether participatory parity suffices in every case, or whether it must be supplemented by ethical considerations in some. In the latter event, not all cultural claims that passed the deontological test would be justified. Rather, only those that survived a further round of ethical examination would be deemed worthy of public recognition. On the basis of this hypothesis, participatory parity would be a necessary but not sufficient condition of justification. While serving to filter out claims that are unacceptable on deontological grounds, it would be incapable of supplying the final step, namely, assessing the *ethical value* of cultural practices. Thus, it would be necessary, in the end, to turn to ethics.

RECOGNITION OR REDISTRIBUTION?

The hypothesis here is that some unjustified claims cannot be ruled out on deontological grounds alone. Rather, they require the supplementary judgment that the minority's practice lacks ethical value.

To test this hypothesis, let us consider the following hypothetical example. Suppose that nonliterate citizens mobilized as a cultural minority. Suppose they claimed that they were unjustly denied parity of participation thanks to the institutionalization of the majority's norms privileging literate culture. And suppose that what they demanded to redress the disparity was not a mas-

sive educational effort to stamp out illiteracy but rather equal recognition of their distinctive oral culture.[20]

To be sure, this example is counterfactual. Nevertheless, it poses an important challenge to those, like me, who harbor the strong intuition that what is needed here is education, not recognition. Specifically, it challenges us to justify that intuition without turning prematurely to ethics—without, that is, having recourse to the ethical judgment that oral culture is intrinsically inferior. Thus, the question, once again, is whether deontology suffices for this purpose. More precisely, does the norm of participatory parity suffice to vindicate the view that privileges education over recognition? Or do we require something more—namely, the substantive (and highly controversial) ethical judgment that literate culture is superior to oral culture?

Initial appearances notwithstanding, ethical judgment is unnecessary in this case. As an empirical matter, recognition of oral culture cannot avail, in the modern world, to overcome impediments to participatory parity for the nonliterate. On the contrary, it can only constrict that group's options for social participation. To assume otherwise is to suffer the delusion that one can reverse longstanding global processes of social and cultural modernization. In the real world, recognizing orality can only deprive its intended beneficiaries of the resources they need in order to participate as peers in social life. Here the recognition strategy is misplaced. What the claimants intend as cultural self-valorization will end up functioning as stigmatization.

This conclusion holds even when one acknowledges that no one should be forced to participate against her or his will. From that perspective, one incurs a prima facie obligation to respect the choice of nonliterate adults to opt out of modern social life. But even so, one cannot justify denying education to their children, who are in no position as yet to make ethical choices. To substitute recognition for education would be to deprive those

children of their entitlement to one of the necessary *objective conditions* for participatory parity.

Thus, the claim for recognition is unjustified—because it misconstrues the claimants' situation. The real barrier to their participation is not the undervaluation of their oral culture but their lack of education. What they view as a problem of misrecognition is actually a problem of maldistribution. In the modern world literacy functions not as one culture among others but rather as an all-purpose resource, a general good that is necessary to the pursuit of more specific goods. Thus, the remedy for the injustice is education, not recognition.

In general, then, the priority of education over recognition can be established on deontological grounds alone. No recourse to ethics is required. On the contrary, one can even concede the claimants' point that something of value, let us say the charm of an older way of life, will be lost in their assimilation to cultural modernity, while nevertheless insisting that justice requires it.[21]

This example suggests a third requirement for claims for the recognition of cultural difference. In addition to applying the standard of participatory parity at both the intergroup and intragroup levels, one must determine whether the injustice in question is a matter of misrecognition or maldistribution. In the latter case, the appropriate remedy is redistribution, and the claim for recognition is unjustified.

THE ETHICAL (RE)TURN?

Have we now reached the end of the line? Are there no cases in which all three deontological requirements are satisfied and yet the claim for recognition is unwarranted? And if so, is ethical evaluation unavoidable?

Consider, as a final example, the hypothetical case of a society organized to promote the integrity and sustainability of the environment. Let us suppose that the social arrangements in

this society institutionalize eco-friendly patterns of cultural value. Let us also suppose that the effect is to disadvantage social actors who identify with modern Western eco-exploitative cultural orientations. Suppose, too, that those actors mobilized as a cultural minority and demanded equal recognition of their cultural differences. Suppose, that is, that they demanded the institutionalization of a new pattern of cultural value that ensured parity for eco-friendly and eco-exploitative cultural practices? Suppose, finally, that their claims met all three of our deontological requirements. Does it follow that these claims are justified?

Clearly, the answer is no. There is no injustice in institutionalizing eco-friendly patterns of cultural value—even if the result is to deny participatory parity to those who seek to exploit nature for short-term advantage. The reason is that it makes no sense to institutionalize parity between eco-friendly and eco-exploitative orientations; that would be like being a little bit pregnant. In this case, society is effectively constrained to opt for one orientation or the other. By hypothesis, however, deontological considerations do not suffice to determine the choice. Recourse to ethical evaluation is necessary. Citizens must weigh the practical and ethical merits of two opposing sets of values and ways of life. If the majority opts for environmentalism, the minority has no justifiable claim for recognition of its difference—provided that the process of deliberation and decision making was open, democratic, and fair.

Here at last we encounter the limits of *Moralität*. With this artificial but revealing example, we encounter the necessity of an ethical moment in the process of assessing a claim for recognition. This moment cannot be circumvented by deontological means. When it arrives—properly at the end, not the beginning, of a long line of moral reasoning—ethical evaluation has to kick in. Yet such evaluation is problematic. Always contextually embedded, it lacks the binding character of deontological

reasoning. Thus, it is subject to dispute whenever divergent evaluative horizons come into contact.

For this reason, as well as the others I have offered here, one should postpone the turn to ethics as long as possible. Granted, one may not be able to postpone it forever; but one should make the effort nevertheless. The alternative, after all, is turning prematurely to ethics. That approach, which is favored, alas, by most recognition theorists, forecloses the option of developing a deontological interpretation of recognition. Failing to expand the idea of justice, it misses the chance to reconcile claims for the recognition of difference with claims for egalitarian redistribution. Thus, it lands us in philosophical schizophrenia.

Given that unpalatable alternative, it is reassuring to see just how far one can get with a deontological interpretation of recognition. And we *did* here get remarkably far. By employing the status model, with its principle of participatory parity, it was possible to handle apparently ethical questions, such as the recognition of same-sex marriage, on the one hand, and of minority religious and cultural practices, on the other, without in fact turning to ethics. That turn proved inescapable *only* when we contrived the highly stylized, artificial example of an environmentalism devoid of injustice.

CONCLUSION

In general, then, there is no need to pose an either/or choice between the politics of redistribution and the politics of recognition. It is possible, on the contrary, to construct a comprehensive framework that can accommodate both—by following the path pursued here. First, one must construe recognition in the first instance as a matter of justice, not as one of self-realization or "the good life." Thus, one must replace the standard identity model with the status model of recognition. Then, one must

expand one's conception of justice to encompass distribution and recognition as two mutually irreducible dimensions, while bringing both of them under the deontological norm of participatory parity. Next, after acknowledging that justice could in some cases require recognizing distinctiveness over and above common humanity, one must subject claims for recognition to the justificatory standard of participatory parity at both the intergroup and intragroup levels, asking whether institutionalized patterns of cultural value unjustly deny claimants the intersubjective conditions for full participation in social life. Finally, one must determine that the injustice really is a matter of misrecognition, as opposed to maldistribution. Only then, after all these steps, *might* one encounter a rare situation in which it *could* prove necessary to turn to ethics. Apart from such cases, one will succeed in remaining on the terrain of *Moralität* and in avoiding the ethical turn.

It is possible, I conclude, to endorse both redistribution and recognition while avoiding philosophical schizophrenia. The inspiration for doing so is as much political as philosophical. In my case the deeper motive is the desire to devise some conceptual resources that could help to answer what I take to be the central political question of the day: How can we develop a coherent orientation that integrates redistribution and recognition? How can we develop a framework that integrates what remains cogent and unsurpassable in the socialist vision with what is cogent and irrefutable in the new, apparently "postsocialist" vision of multiculturalism?

If we fail to ask this question, if we cling instead to false antitheses and misleading either/or dichotomies, we will miss the chance to envision social arrangements that can redress both economic and cultural injustices. Only by looking to integrative approaches that unite redistribution and recognition can we meet the requirements of justice for all.

NOTES

1. Portions of this essay are adapted and excerpted from my Tanner Lecture on Human Values, delivered at Stanford University, April 30–May 2, 1996. The text of the lecture is published as "Social Justice in the Age of Identity Politics: Redistribution, Recognition and Participation," in *The Tanner Lectures on Human Values*, vol. 19, ed. Grethe B. Peterson (Salt Lake City: University of Utah Press, 1998), 1–67. I am grateful to the Tanner Foundation for Human Values for permission to adapt and reprint this material. I thank Elizabeth Anderson and Axel Honneth for their thoughtful responses to the Tanner Lecture and Rainer Forst, Theodore Koditschek, Eli Zaretsky, and especially Erik Olin Wright for helpful comments on earlier drafts. I also benefited from Rainer Forst's probing comments on an earlier draft of the present essay.

2. See Fraser, "Social Justice in the Age of Identity Politics." Nancy Fraser, *Adding Insult to Injury: Social Justice and the Politics of Recognition*, ed. Kevin Olson (London: Verso, forthcoming); and my contributions to Nancy Fraser and Axel Honneth, *Redistribution or Recognition? A Political-Philosophical Exchange* (London: Verso, forthcoming).

3. For a fuller discussion of this strategy, see Nancy Fraser, "Rethinking Recognition: Overcoming Displacement and Reification in Cultural Politics," *New Left Review* (forthcoming in 2000).

4. Charles Taylor, "The Politics of Recognition," in Taylor, *Multiculturalism: Examining the Politics of Recognition*, ed. Amy Gutmann (Princeton, N.J.: Princeton University Press, 1994).

5. Axel Honneth, *The Struggle for Recognition: The Moral Grammar of Social Conflicts*, trans. Joel Anderson (Cambridge: Polity Press, 1995).

6. I am grateful to Rainer Forst for help in formulating this point.

7. In Axel Honneth's account, social esteem is among the "intersubjective conditions for undistorted identity formation," which morality is supposed to protect. It follows that everyone is morally entitled to social esteem. See Honneth, *The Struggle for Recognition*.

8. John Rawls, for example, at times conceives "primary goods" such as income and jobs as "social bases of self-respect," while also speaking of self-respect itself as an especially important primary good whose distribution is a matter of justice. Ronald Dworkin, likewise, defends the idea of "equality of resources" as the distributive expression of the "equal moral worth of persons." Amartya Sen, finally, considers both a "sense of self" and the capacity "to appear in public without shame" as relevant to the "capability to function," hence as falling within the scope of an account of justice that enjoins the equal distribution of

basic capabilities. See John Rawls, *A Theory of Justice* (Cambridge, Mass.: Harvard University Press, 1971), §67 and §82; Rawls, *Political Liberalism* (New York: Columbia University Press, 1993), 82, 181, and 318 ff.; Ronald Dworkin, "What Is Equality? Part 2: Equality of Resources," *Philosophy and Public Affairs*, 10:4 (Fall 1981): 283–345; and Amartya Sen, *Commodities and Capabilities* (Amsterdam: North-Holland, 1985).

9. The outstanding exception of a theorist who has sought to encompass issues of culture within a distributive framework is Will Kymlicka. Kymlicka proposes to treat access to an "intact cultural structure" as a primary good to be fairly distributed. This approach was tailored for multinational polities, such as Canada, as opposed to polyethnic polities, such as the United States. It becomes problematic, however, in cases where mobilized claimants for recognition do not divide neatly (or even not so neatly) into groups with distinct and relatively bounded cultures. It also has difficulty dealing with cases in which claims for recognition do not take the form of demands for (some level of) sovereignty but aim rather at parity of participation within a polity that is crosscut by multiple, intersecting lines of difference and inequality. For the argument that an intact cultural structure is a primary good, see Will Kymlicka, *Liberalism, Community and Culture* (Oxford: Oxford University Press, 1989). For the distinction between multinational and polyethnic politics, see Will Kymlicka, "Three Forms of Group-Differentiated Citizenship in Canada," in *Democracy and Difference*, ed. Seyla Benhabib (Princeton, N.J.: Princeton University Press, 1996).

10. See especially Honneth, *The Struggle for Recognition.*

11. Ibid.

12. Since I coined this phrase in 1995, the term "parity" has come to play a central role in feminist politics in France. There, it signifies the demand that women occupy a full 50 percent of seats in parliament and other representative bodies. "Parity" in France, accordingly, means strict numerical gender equality in political representation. For me, in contrast, "parity" means the condition of being a *peer*, of being on a *par* with others, of standing on an equal footing. I leave the question open exactly what degree or level of equality is necessary to ensure such parity. In my formulation, moreover, the moral requirement is that members of society be ensured the *possibility* of parity, if and when they choose to participate in a given activity or interaction. There is no requirement that everyone actually participate in any such activity.

13. I say "*at least* two additional conditions must be satisfied" in order to allow for the possibility of more than two. I have in mind specifically a possible third class of obstacles to participatory parity that could be called "political," as opposed to economic or cultural. Such obstacles would include decision-

making procedures that systematically marginalize some people even in the absence of maldistribution and misrecognition, for example, single-district winner-take-all electoral rules that deny voice to quasi-permanent minorities. (For an insightful account of this example, see Lani Guinier, *The Tyranny of the Majority* [New York: The Free Press, 1994].) This third, "political" kind of obstacle to participatory parity might be called "marginalization" or "exclusion." I do not develop it here, however. Here I confine myself to maldistribution and misrecognition, while leaving the analysis of "political" obstacles to participatory parity character for another occasion.

14. It is an open question how much economic inequality is consistent with parity of participation. Some such inequality is inevitable and unobjectionable. But there is a threshold at which resource disparities become so gross as to impede participatory parity. Where exactly that threshold lies is a matter for further investigation.

15. I say the remedy *could* be recognition of difference, not that it must be. Elsewhere I discuss alternative remedies for the sort of misrecognition that involves denying distinctiveness. See my contribution to Fraser and Honneth, *Redistribution or Recognition?*

16. Taylor, "The Politics of Recognition." Honneth, *The Struggle for Recognition.*

17. Linda Nicholson, "To Be or Not to Be: Charles Taylor and the Politics of Recognition," *Constellations: An International Journal of Critical and Democratic Theory*, vol. 3, no. 1 (1996): 1–16.

18. Honneth, *The Struggle for Recognition.*

19. Dworkin, "What Is Equality? Part 2: Equality of Resources."

20. I am grateful to Jeffrey Weintraub for suggesting this example (comments at the annual meeting of the Conference on Political and Social Theory, Columbia University, Spring 1997).

21. I am grateful to Rainer Forst for help in formulating this argument.

Ethics of the Other

Beatrice Hanssen

*It is a long time since the starry sky that took
away Kant's breath revealed the last of its secrets to us.
And the moral law is not certain of itself.*

—Frantz Fanon, *Black Skin, White Masks*

*M*arx, misquoting Hegel, once observed that all events in world history, including revolutions, happen at least twice, first as tragedy, then as their comic, parodic reenactment, or farce.[1] Perhaps the same can be said about philosophical models of interpretation. For if, in our postsocialist, post-Marxist condition, the demise or deficit of the Marxist project, as embodied in state socialism,

has become apparent, then it also seems that the specter of Hegel, hiding behind the figure of Marx, has returned to haunt us with renewed force.[2] Hegel returns not just once, but many times, and in many guises. Donning a conservative cloak, mediated and altered through Kojève, Hegel has been invoked to assert the "end of history," or the coming of eschatological posthistory, as Fukuyama did in his notoriously wrong-headed triumphalist defense of a globalized liberalism.[3] However, as the ally of more left-leaning liberals, Hegel's chapter on self-consciousness, especially the section on the master-slave dialectic from the *Phenomenology of Spirit*, has been mined for its models of recognition (*Anerkennung*), intersubjectivity, and alterity, which, it seems, never have been more popular than at present.

Yet, if Hegel still is very much *with us*, then it is, to be sure, not so much because of the first economic, still feudal contract of inequity that followed on the heels of the life-and-death combat between self and other—a social contract, whose measures of economic inequality, for the longest time, formed the target of the Marxist program. Even when Laclau and Mouffe drafted their programmatic study on hegemony, pointing to the necessary displacement of the universalizing category of class by the multiple subject positions of the new social movements—those that rallied around race, gender or ecology—they still very much did so within an amended Marxist paradigm. Today, by contrast, it is Hegel's struggle for recognition *as such* (*an sich*), uncoupled from socioeconomic inequity, or the need for redistribution,[4] that has moved to the heart of dialogues between liberals of various persuasions, be they of the neo-Aristotelian, communitarian mold, such as Charles Taylor, or rather those who have joined the cause of Jürgen Habermas's discourse ethics. These authors' positions attest to the undiminished topicality of recognition, witness their respective interventions in the multiculturalism debates, collected in *Multiculturalism:*

Examining the Politics of Recognition.[5] Conducted in the tall shadow cast by Hegel's *Phenomenology,* the exchange between Taylor, Habermas, Appiah, and others demonstrated that "recognition" did not simply refer to an act of identification, to the gleam of pleasure the infant's face shows as it discerns itself in the mirror, nor to the glance of recognition that lights up in the eye of the other as I pass by, nor simply to the conferring of respect or prestige on an-other. In the final analysis, it signaled the demand for universal *political* recognition, or equal respect, premised on the equitable actualization of the system of rights that modern liberal democracies advocate. As Appiah phrased it, at stake was "a politics that asks us to acknowledge *socially* and *politically* the authentic identities of others."[6] To recognize in this sense didn't only mean to acknowledge an individual's or group's identity or authenticity existentially, but, crucially, to vindicate the other politically and institutionally, as the bearer of equal rights. But where this liberal narrative of universal, reciprocal political recognition in a fictional past of pure origins and unalloyed homogeny seemed straightforward enough, then, today—so the narrative continues—multicultural democracies struggle due to the proliferation of such demands. In Taylor's stark rendition, the multiculturalism debates appear to come to a head in the confrontation between two equally unbending, even adversarial positions, the one vying to assert absolute difference (identity politics), the other, "color-blind" sameness (neo-Kantian proceduralism). In this view, the model underlying these conflictual interpretations of recognition appears to be that of reflection, in which either the mirror of *sameness* is held up to the other—as when "color-blind" liberals promote a neutral liberalism—or else radical *difference* and asymmetry between self and other are asserted.

But is it quite clear what we mean when we speak of recognizing the other? Who, indeed, is the other, and what does recognition, or misrecognition, for that matter, entail? And why

the need to consider, across the multiculturalism debates, as I want to claim, an ethics of the other? To be sure, much of twentieth-century philosophy and liberation politics can be seen as an attempt to undo epistemic and ontological regimes of the self that violate the alterity of the other, from Husserl's phenomenological conception of the alter-ego, Buber's dialogical philosophy of I and Thou, and Levinas's asymmetric other, to Lacanian psychoanalysis and deconstruction. Of the many variants of what collectively has come to be called the "philosophy of the other," some have been founded on a theologically conceived dialogism, others on a Hegelian conception of intersubjectivity, sometimes mediated through Sartre's existentialism. But all have sought to bid farewell to the monologism of a Cartesian philosophy of consciousness no less than Kant's anti-instrumental, nonstrategic moral philosophy, whose universalizable categorical imperative—even as it mandated that the other be regarded as an end in herself, not a means—could not safeguard against the imposition of violence onto the other, as Benjamin already knew.[7] No matter how diverse these proposals for thinking the other may have been, one problem in particular invariably has plagued them. Put in simplest terms: how to combine a commitment to the universal recognition of others—whether it be a matter of ethical, cultural, or legal recognition—with a respect for the concrete particularism, difference, or asymmetry of others? How to dispel the figment of the "generalized other" that dominates substantialist versions of universalism in order to acknowledge particularized others? How to avoid the presumed ethnic, class, or gender bias that comes with imagining, let alone, recognizing the other?[8] And, additionally, how not to rarefy the otherness of the other to such a degree that she is turned into an abstract alterity (slipping from the position of other, or *autrui*, back into the reified, objectified *autre*).[9] Lastly, and most crucially, in what way to redress the

epistemic violence enacted by hegemonic Western discourses that silence or slight the subaltern other?[10]

The purpose of this inquiry can't be to stage a grand genealogy of the other—a pursuit that quickly risks yielding yet another transhistoric metanarrative. Nor is it my aim, as my title might misleadingly suggest, to retrace Levinas's footsteps by arguing for an "ethics of the other" as first philosophy.[11] Instead, I wish to approach the matter more locally, across some of the multiculturalism debates, with an eye on qualifying the prominence that Hegel's struggle for recognition has gained in liberal variants of these discussions. For, first, if the goal is to design a more hospitable liberalism, one that can accommodate difference, as Taylor seems to want to do in his "The Politics of Recognition," then it might be expedient to invite interlocutors to the debating table who traditionally have been excluded from such deliberations—interlocutors such as the Antillean psychiatrist, revolutionary, and activist philosopher, Frantz Fanon. To be sure, Taylor briefly cites Fanon approvingly to demonstrate that "misrecognition" ought to be added to the catalog of harms that can be inflicted upon others, in addition to "inequality, exploitation, and injustice." Fanon's forceful indictment of Western colonialism in his *Wretched of the Earth*, he agrees, rightly charged "that the major weapon of the colonizers was the imposition of their image of the colonized on the subjugated people."[12] Nonetheless, it seems to me that Fanon's work deserves a lengthier discussion and reappraisal, not in the least because he explicitly wrote a response to Hegelian philosophy in an essay titled "The Negro and Recognition"[13]—an essay that sought not so much to stand Hegel's master-slave dialectic back on its feet (to cite Marx's favorite figure of reversal) as to undo it radically. Even more worthy of note, I will suggest, is that Fanon's major works merit to be rediscovered as a large-scale probe into the conditions of possibility that enable ethics and

the moral law in a postcolonial context, and, by extension, in our multicultural condition.[14] This position, admittedly, is at first less obvious if one only zeroes in on Fanon's incendiary, antiliberal embrace of revolutionary violence, which he advocated as he found himself in the throes of the colonial struggle in Algeria.

Second, by isolating the question of recognition as it inflects these debates, I will suggest that multiculturalism—at least, in one of its moments—ought to be reinterpreted as *multi-ethics*, if indeed that elusive noun "ethics"—should one obey the laws of the English grammar—bears being used in the plural. This is why the title of this essay deliberately invokes at once a subjective and objective genitive, referring not only to an ethics *about* the other, but also to ethics *belonging* to the other, or more precisely, *others*. If one extrapolates from this position, it follows that for a radical democracy multiculturalism involves not merely the cohabitation of multiple cultures, ethnic groups, or identities, with their respective claims to authenticity, equal dignity, respect, rights, or economic equity; the challenge relates also to how the coexistence of many versions of *ēthos*, ethical habits, conventions, gestures, and (substantivist) narratives about the "good life" is still possible in a rationalized modern world. As such, the question about identity and identification raised earlier—"Who is the other?"—must now be compounded by the query, "Whose ethics?"—a question that reverberates with Chantal Mouffe's similarly probing inquiry: Which ethics for democracy?[15]

Thirdly, it seems to me that, taken together and scrutinized against the letter of Hegel's text, the current multiculturalism debates in their manifold, contentious manifestations at once provide vastly diverse, often incompatible, but always revealing renditions of Hegel's chapter on self-consciousness, depending on whether they call up the specter of violence or emphasize intersubjective, peaceful cohabitation instead. It can hardly be

cause for wonder, naturally, that conservative accounts stress the element of violent battle in the struggle, most crassly perhaps in Fukuyama's *End of History*. Multicultural difference here signals the possible relapse into a bellicose state of nature, a battle reminiscent of Carl Schmitt's *The Concept of the Political*, in which "us" and "them," rather than being engaged in dialogical encounter, divide into friend and enemy, mutually threatened by the possible existentialist experience of one's imminent death. In the margins, it might be noted that this conservative take inadvertently also resonates in the somewhat overused, seemingly benign term "culture wars," which currently, together with "Balkanization," circulates in critical circles, as if cultures were at war with one another, tribalisms, locked in mortal strife, all contending for ascendance. Deleting this implicit bellicose intent from the Hegelian allegory, liberal positions, by contrast, have focused on selves being drawn out of them-selves in peaceful encounters with others, and in some instances—if they have pondered the potential sublation, even obliteration, of alterity that might come with an unreflected liberal stance—have unmasked the possible blots of misrecognition that always threaten to impair any such acts of recognition.

Though liberal accounts have sought to remain true to the democratic principle of nonviolence, an element of strife almost unintentionally has come to define the exchange between interlocutors. Certainly, in Taylor's communitarian account identity politics and procedural, so-called color-blind liberalism are rift apart by a logic of mutual contradiction, in which the particularism of identity claims propagated in the name of group rights is at odds with a difference-leveling universalism that adheres to basic rights. Thus, in discussing neo-Kantian procedural liberalism—especially in its Rawlsian and Dworkian variants—Taylor reasserts his allegiance to a neo-Aristotelian communitarianism, which criticizes the preference of formal rights over substantive goods. Procedural formalism, according to him, is

deficient because it must reject all identity politics for proffering particularistic claims that are not automatically universalizable. To craft a more hospitable liberalism that will avert the inadequacies of its leveling procedural counterpart, he therefore proposes that the politics of equal respect be complemented by the recognition of a minority culture's equal value. Paired off against one another, procedural and communitarian versions of liberalism thus can be seen to be representative of the conventional distinction made between Kant's moral theory (*Moralität*) and Hegel's *Sittlichkeit* (ethical life), or between a monological understanding of moral reasoning and an intersubjective, dialogical interpretation of community. In overcoming the deficiencies of Kant's subjective idealism, it is commonly held, Hegel showed the path away from an atomistic conception of the self—despite remedial categories, such as "empathy" or "enlarged mentality,"[16] meant to correct the Kantian subject's monadic self-enclosure—to a model that defined the self as constitutively directed toward the other. As he demonstrated in the *Phenomenology*, the state of a consciousness-in-and-for-itself (*an und für sich*) could only be reached through the double movement of two forms of consciousness, which "*recognize* themselves as mutually *recognizing* one another."[17] In altered guise, these two seemingly mutually exclusive renditions of subjecthood—one Kantian, the other Hegelian—still imbue the encounters between neo-Kantian liberals and civic republican communitarians, the first wedded to honoring individual rights, the second to giving priority to a collective, neo-Aristotelian *ēthos*, to which such rights are bound. That the two positions need not necessarily be mutually exclusive is certainly one of the repeated points Habermas makes in his contribution to the debate, as he does elsewhere. Occupying the middle ground between the two, his procedural discourse ethics has sought to mediate between Kantian and Hegelian practical philosophy,

wedding justice to solidarity, and proposing "an intersubjective interpretation of the categorical imperative by taking over Hegel's theory of recognition, but without dissolving the moral in the ethical." Insofar as for Habermas private and public autonomy are inherently and necessarily entwined, the Kantian misconception of reading basic rights morally, that is, "as the legal expression of the mutual respect that persons ought to show one another as morally autonomous agents,"[18] is thereby also overcome. In shifting the emphasis away from Taylor's still all too abstract discussion of basic or group rights to their contextualized actualization, Habermas certainly makes visible the ethical fabric that must inexorably sustain any procedural recognition of the other.

Now, in using, in what follows, the term "ethics" rather than "moral law," I assume the philosophical convention that defines these debates, of distinguishing Kant's *Moralität* from Hegel's *Sittlichkeit*, understood as an intersubjective, dialogical conception of community. Centrally, Kant and Hegel also very much define the two poles between which Fanon wrote his major works, insofar as he took his theory of "violence as imposition" from Hegel's struggle for recognition, while holding on to the Kantian dream of universalism. What I will seek to do, then, in invoking Fanon's thought as an alternative vantage point from which to gauge the multiculturalism debates, is to ask what its conventional, mainly First World interlocutors might learn from his work, hinged as it is between Kant and Hegel. Given the need for pluralist democracies that can come to terms with multiculturalism, how might Fanon complicate the existing dialogue between speech partners? Further, how might his writings intensify attempts to grapple with the dialectic between ethnic, cultural particularism and universalism? Asking about Fanon's unabated, contemporary relevance also has the added advantage, crucially, of restoring him to his proper place as a

philosopher who desired to be remembered for the intrinsic political value of his contributions, beyond the particularism of the historical condition to which he refused to be reduced. By reclaiming the theory of recognition from Hegel, Marx, but also Lacan, Fanon at once sought to take back the dream of a true universalism in which he demanded his rightful place to participate. In revisiting the corpus of his work from this less common perspective, I will argue that his thought, first of all, lends credibility to the suspicion that liberalism in many ways still works with a monolithic understanding of recognition, one that neglects the power dynamics or different modalities of recognition that Hegel articulated in the master-bondsman relationship. Going against domesticated liberal narratives of the Hegelian dialectic, Fanon asks us to reconsider the pernicious power relations, the dynamics of subordination, and the deep antagonisms that imbue pluralistic difference.[19] Against this background, I will seek to lend new currency to a psychoanalytic phrase Fanon coined, that of *ethical transit [glissement]*—a term that might be understood to refer to the operations of *ethical transitivism*, or the unconscious identification with uncontested hegemonic subject positions, which burden certain liberal scripts of recognition. Lastly, Fanon also urges us to revisit the overdetermined, embattled term "universalism," whose prominence in current political arguments in many ways seems to be another version of the humanism controversies of earlier decades. Certainly, Fanon's relevance for the recognition debates might be contested on the grounds that his advocacy of violence stands in stark contrast with the doctrines of nonviolence advocated by Gandhi, Nehru, or King. Yet, only if one focuses uniquely on his embrace of revolutionary violence must one fail to see the prophetic philosophy of recognition that overarched all of what he wrote.[20] In more than one way, his thought points us to the interrelations between the ethical and the political at the center of the multiculturalism debates.

CONTEXTUALIZING THE STRUGGLE FOR RECOGNITION

In view of the prominence Hegel's struggle for recognition recently has gained, one does well to contemplate the plurality of Hegel commentaries that for the longest time have existed side by side, in addition to political liberalism's better-known exegesis, which emphasizes intersubjectivity, normativity, and political (legal) recognition, at the expense, quite often— though by no means always—of the dynamics of power. Surely one of the most provocative, no less than troubling texts to have been generated by Western philosophical modernity, Hegel's philosophical parable of self and other—encapsulated in the *Phenomenology*'s section on self-consciousness—from the start lent itself to an unusually broad spectrum of interpretations, of which the Marxist variant is undoubtedly the better-known one. Where more conventional, contractarian readings understood the section to allude to the overcoming of the state of nature, following Hobbes's *Leviathan*, Marx interpreted the ensuing social contract as typical of prepolitical, premodern feudal societies, while Kojève would offer an anthropologized account of the allegory's scene of violence. In placing unusual emphasis on how existentialist human action proceeded by means of negating violence, Kojève would prove to have an inordinate influence on generations of pre- and postwar intellectuals. Rejecting this Eurocentric account for adulating bare violence and self-fulfillment through forceful subordination, the writings of David Brion Davis, Orlando Patterson, and Paul Gilroy have established how the Hegelian narrative can be interpreted as a vindication of Western colonialism and slavery.[21] Conjecturing that "the time has come for the primal history of modernity to be reconstructed from the slaves' points of view," Gilroy especially has called for a heightened awareness of how the Hegelian dialectic functions as the deep structure not just

of Western subjecthood but also of hegemonic articulations of its history.[22]

What has occupied generations of Hegel interpreters is precisely the fact that he did not conceive of the "self coming to itself," or self-consciousness, as a process that transpired in monadic isolation, but as one that was mediated, reflected—quite literally—through the eyes and presence of another. In doing so, Hegel moved from an *ontological* dialectic between same and otherness (*das Andere*), examined early on in the chapter, to an *existential* encounter between self and other, that is, to a reflexive confrontation with a personified other (*der Andere*).[23] This encounter with the other, however, as he affirmed, was fraught from the outset by the prospect of violence. Reworking Hobbes's account of the *status naturalis*, Hegel's grand narrative about self-consciousness chronicled the first violent encounter between two only seemingly self-contained beings, their ensuing, potentially mortal combat, and their eventual decision to turn the forceful battle into a power balance that mediated two socially determined positions: mastery and servitude. In effect, several tempos punctuated the process through which the subject laid claim to the universal truth of self-consciousness, the first ruled by specular symmetry, the other—the so-called social dialectic—rift by a wrenching asymmetry. Initially projected along the mechanisms of a mirror reflection, the original dialectic between self and other staged the dynamics between two participants who gained self-enhancement through an interactive mediating process of mutual recognition. Describing what he termed a process of duplication (*Verdopplung*), Hegel observed that, in this stage, "each sees the *other* do the same as it does," only to conclude that eventually "they *recognize* themselves as *mutually recognizing* one another."[24] Or, to reiterate Hegel's chiastic turn of phrase, "I" turns out to be "we," "we" "I." Almost immediately, however, a dramatic change upset the seeming equanimity and

balance of the scene. A moment of disharmony entered the stage, a radical inequality that, on the face of it, was generated by force, or violence, as self and other became antagonists, locked in mortal combat. Remarkably, the fierce battle upon life-and-death that ensued in truth was said to enact the self's bid for freedom through a trial by death. But for all the battle's fury, in the end ultimate death was averted as the elimination of both adversaries would result in mutual abstract negation and objectification, a dead unity that lacked the dialectical tension between extremes. Instead, what had started out as a battle of forces now transformed into a power relation of dominatation and subordination, establishing the socially defined (institution-alized) positions of master and bondsman. In this asymmetrical dialectic, the master, through the mediation of the serf's labor, could satiate his desire for the (manufactured) object, while the serf for his part, paradoxically, gained freedom through self-consciousness in servile labor, thus also overcoming his fear of death.

Though this compact, slightly narrativized rendition of the master-slave dialectic hardly does justice to the parable's philo-sophical complexity, it will serve the purpose of throwing some of its elements into starker relief. Ultimately, the Hegelian pas-sage demonstrated that there existed not just one single mode of recognition—as liberal renditions of the allegory all too often fail to acknowledge—but various modalities, depending on whether one was recognized as master or bondsman. Further-more, it is precisely in the switch from radical symmetry in *equality* to disymmetry in *inequality*, engendered through the ini-tiation of force, that lies the potential for the highly divergent interpretations these few pages have received, historically speak-ing. Particularly pernicious have been those commentaries that have isolated the dialectic of violence, turning it into an anthro-pological justification of an eternal human nature, mapped, sub-sequently, onto an existentialist fold of subjecthood, or—more

likely—onto a masculinity that masquerades as the universal mean. Indeed, as noted, in Kojève's highly anthropologized, even vitalistic reading of Hegel, the mortal combat gained immoderate precedence to the point where violence no longer merely referred to the lawlessness of the state of nature, but transformed into the most primordial human deed. Modeled on Genesis, the act of human creation transformed "the world that is hostile to a human project into a world in harmony with this project." At once "humanizing and anthropogenetic," explained Kojève, such action amounted to "the act of imposing oneself on the 'first' other man one meets," resulting in reciprocal violence.[25] To be sure, Kojève sincerely was interested in the "end of war," or the end of human negating action, believing in Hegel's diagnosis that the Napoleonic era spelled the "end of history." Yet it was precisely through his description of the negating principle that defined human action, desire, and freedom that he would impact Sartre, Lacan, but also Fanon. Divesting Kojève's Hegel reading of its existentialist aura, Fukuyama teased out its conservative program when he mapped the "end of history" onto the post–Cold War triumph of liberalism. On first impression, his philosophico-political interpretation seemed seductive enough as it postulated that "the end of history," or the end of totalitarian violence, meant universalized equality, the recognition of all on a "mutual and equal basis."[26] The French Revolution, as Hegel announced, but also the American one, had turned "slaves into masters" through the politics of citizenship and the granting of rights. Yet, such seemingly moderate plausible pronouncements were accompanied by the disconcerting logic of a difference-obliterating liberalism and a belief in presentism, as the "now" of the present was turned into the realization, actualization of a universalized liberalism.[27] In teasing out the Nietzschean strands in Kojève, Fukuyama in fact operated with two models of recognition—a good and a bad one: one, in which the struggle for life disintegrated into a Hobbesian or

Nietzschean "state of nature"—a battle, waged by the last men, revolving around pure prestige and pure materialism, whose contemporary variant Fukuyama discerned in the material pursuits of inner city youths; the other, the true liberal one, which welded economic prosperity to *thymos* (Plato's version of self-esteem), and was realized in the posthistorical world of a correctly understood liberalism. As a further sign of this framework's conservatism, cultural diversity was put on a par with a troublesome relativism, as especially came to the fore in the book's concluding chapter. Arguing against "cultural relativism," Fukuyama actively advocated the convergence or "homogenization of mankind" so that in the end "the apparent differences between peoples' 'languages of good and evil' will appear to be an artifact of their particular stage of historical development."[28] Rather, then, than finding an ethical philosophy of the other in Fukuyama's work, we encounter a conservative moralistic frame, one that not only threatened to eliminate pluralism or difference but confused ideological globalization with universalism.

In more positive Hegel commentaries, in contrast—principally in the variants designed by Frankfurt School theorists Jürgen Habermas and Axel Honneth—the emphasis has been placed on how the section fit within Hegel's broader theory of intersubjectivity.[29] Above all, Hegel was seen to pave the way for a profound reconceptualization of normativity, which was no longer justified abstractly, but realized communicatively. In fact, in his *Philosophical Discourse of Modernity*, Habermas maintained that the young Hegel, in crafting his budding new theory of intersubjectivity, proved potentially far more radical, even in his early Jena philosophy, than the mature philosopher of the *Phenomenology* and the *Philosophy of Right*. In the stress Hegel's juvenile writings, such as the "Spirit of Christianity and Its Fate," placed on "just fate," love, and life, Habermas detected the early seeds of a "communicative reason," lodged against

Kant's subjective reflection and abstract practical reason. But this potentially explosive insight—so Habermas, and in his wake Honneth, argued—was quelled when later he recuperated intersubjectivity by assimilating it into the constitution of self-consciousness. Eventually, the model of intersubjectivity thus was subjected to the laws of absolute spirit, so that the *Phenomenology*, in truth, ended up advancing a "critique of subjectivity puffed up into an absolute power."[30] To do so meant not simply to sublate the alterity of the other into the self-same, but furthermore to lapse into the entrapments of a philosophy of consciousness and reflection. By slipping into the model of self-consciousness, Hegel, not unlike Kant, eventually proved unable to escape the philosophy of reflection. Evidently, Habermas was not interested in gleaning from the passage on self-consciousness a contractarian political model, or a parable of social alienation, the way the young Marx did in his early Paris manuscripts, the older in *Capital*. Rather, his main point was that by embedding intersubjectivity in the specular formation of self-consciousness, Hegel perpetuated the metaphysical violence endemic to the idealistic philosophy of consciousness. Struggling against this tradition, Habermas for his part sought to overcome its metaphysical legacy by turning to language philosophy, pragmatism, in discourse ethics. As he elaborated further on Habermas's comments, Honneth similarly jettisoned Marx's labor paradigm and concern with economic redistribution, seeking to distill "the foundations for a social theory with normative content"[31] out of Hegel's struggle for recognition. Minimizing the importance of the social struggle, Honneth instead aimed for a theory of communicative action, anchored in a "concept of morally motivated struggle," of which there were three forms: love, law, and solidarity (or love, rights, and esteem). Marx's interest in economic competition and inequity, he declared, exposed the predominance of a utilitarian streak in his thought to the detriment of the more fundamental moral struggle. [32]

Interested in the moral struggle for recognition more so than in the social struggle for economic redistribution, Habermas and Honneth condemned Hegel's lapse back into subject philosophy. But however plausible their historicized Hegel reading might be, it should not detract from the fact that, in the move to self-consciousness, Hegel's *Phenomenology* spelled the very truth of a psychic regime of power or force,[33] as elucidated by the use to which his dialectic of recognition has been put in psychoanalytic theory. For, however erroneous it might seem, judged from Habermas's standpoint, to read the chapter on self-consciousness as a process of *psychogenesis,* Lacan nonetheless put the error to great benefit, when, along Hegelian lines, he demonstrated the specularity, or *misrecognition (méconnaissance)*, that lies at the foundation of the first constitution of the ego in the mirror phase—the phase in which a primordial *imago* is fashioned, refracted through the other. Misrecognition can, as Taylor pointed out, manifest itself as the withholding of equal respect or as the false projection of the self onto the other, a moment that Lacan, via his own reading of Hegelian self-consciousness, saw as constitutive of a first, so-called presocial identification, which yielded the Ideal-I, mediated through the image of the other.[34] In fact, by displacing these Hegelian and Lacanian systems in turn into the realities of the colonial struggle, the Antillean psychiatrist Fanon corrected them even further, revising them by means of a sociogenic (not just phylogenetic or ontogenetic) account that demonstrated how this primordial moment of "recognition in mis-recognition" among colonial subjects really came about through the pathogenic incorporation of the white other as Ideal-I.

FANON'S ETHICS OF RECOGNITION

Fanon's multifaceted Hegel interpretation certainly can count as one of the more complex adaptations of that narrative, as it

interweaves psychoanalytic, existentialist, and Marxist strands of analysis.[35] In all of his works, Fanon advocated an "ethics of recognition," though in the period of anticolonial activism his message went hiding under the very force with which he sought to set an end to colonialism's imposition of force, striving to rupture the colonizer's cycle of violence. His was a philosophy animated by the sincere, albeit utopian, belief that it might be possible to recapture a new concrete, universalist humanism that would once and for all supplant its earlier, abstract parody, or farce, though this should never happen at the expense of recognizing diverse cultural identities, whether it be the literary movement of *négritude* or the culture of the *Maghreb*.

Familiar with Hegel's philosophy through Hyppolite's translation of the *Phenomenology,* Kojève's lecture courses, and Sartre's *Being and Nothingness,* Fanon radically refracted the dialectic of recognition through the colonial experience. The new understanding he furnished of the Hegelian paradigm comprised two distinct phases. First, prior to his active involvement in Algeria's anticolonial struggle, his psychoanalytic essays—collected in *Black Skin, White Masks*—used Hegel to amend Adler's inferiority complex and correct Lacan's mirror stage, all in an attempt to diagnose the defective self-image of the Antillean subject. Already here, before his revolutionary activism, he illuminated how Hegel's master-slave dialectic might be comprehended not just as a fictional parable but as a philosophical justification of real Western colonialism. Second, in the revolutionary phase of *Wretched of the Earth,* he further teased out the implications of Hegel's "violence of imposition" and the frenzied desire for substitution it awakened in the colonized native, likening the colonial experience to the Hobbesian state of nature. Additionally, he brought the model of recognition to bear on Marxism, whose view of the class struggle and the role of the *Lumpenproletariat* needed to be altered, making it fit to account not only for the inequalities in economic distribution, but also for colonial

racism and the process of decolonization. Still, it would be a gross misconception to label Fanon's work on recognition, as it emerges from these writings, as simply "reactive," written out of "ressentiment" by an (elite) colonized intellectual—to invoke the odious Nietzschean rhetoric he himself frequently deployed in *Black Skin, White Masks.* To say so would mean to imply that he remained purely "fixated," traumatized, by the particularism that defined his historical position. Rather, in reclaiming the theory of recognition, from Hegel, Lacan, but also Marx, Fanon at once sought to take back the dream of a true universalism, mediated or articulated through the cultural particularism of the Antillean subject.

In *Black Skin, White Masks,* Fanon demonstrated how the primordial process of "recognition in mis-recognition" among colonial but also postcolonial subjects involved the pathogenic incorporation of the white other as Ideal-I. Writing the psychopathology of everyday colonial life, Fanon historicized Lacan's phenomenological reading of Hegel, which emphasized the specular dynamics that informed the look of recognition. As he entered the phenomenal world of the white gaze, Fanon wrote, the black subject was rejected at the level of body image, stigmatized as the unidentifiable, unassimilable not-self, the *non-semblable,* who represented absolute alterity in nonhuman form. But this phenomenological experience for the Antillean, he continued, proved hardly analogous to that of the exemplary white subject, insofar as, on the imaginary level, he perceived his fellow black neighbor not in absolute but in comparative white terms. In the long corrective footnote he dedicated to Lacan's mirror stage, Fanon further compounded the fictionality that already structured the process of ego formation, adding yet another frame, which resulted in a double displacement of the imaginary, so to speak. If the process of ego formation already involved the alienating assumption of the *imago* of one's *semblable,* then in the colonized subject it additionally entailed

the adoption of the white double as "Ideal-I," yielding the imaginary of the imaginary, so that the process of alienation was raised to the second degree. Beleaguered by an internalized inferiority complex and weak ego, the Antillean subject became an obsessional neurotic, engaged in constant self-reproach, nausea, and despair, provoked by the incorporated *imago* that obsessed him.[36] As his traumatic experience in metropolitan Paris indisputably revealed, Fanon's face-to-face with the little white child that named his difference from the white norm resulted in the fragmentation of his body image, lending a new meaning to the aggression inherent in the Hegelian battle for recognition.

In an effort to reverse this specular dynamic of *méconnaissance*, Fanon called his book a mirror that was meant to reflect this "unconscious" alienation back to the Antillean subject, so as to end it once and for all.[37] By advancing a Nietzschean genealogy of colonial morals, he intended to bring the "Manicheism delirium"[38] of colonialism and its neurosis of ethics into full view. To be sure, Hegel—so Fanon observed, paraphrasing the *Phenomenology*—had posited that "man is human only to the extent to which he tries to impose his existence on another man in order to be recognized by him."[39] But in imposing his existence onto the black slave—so Fanon continued, now reading Hegel through Nietzsche's *Genealogy of Morals*—the white master at once had instituted a pathological, dualistic moral system. Along lines similar to Nietzsche's transvaluation of values, Fanon posited that the result of this "imposition of culture" was the forceful impressing of contingent values onto the Antillean subject, as a result of which he, structurally speaking, could only see himself as defined by "mere comparison." Alluding, no doubt, to the psychological phenomenon of transitivism, known in child psychology as a child's inadvertent imitation, mimicry, of another child's gestures or affects, Fanon added that such cultural imposition effected what he termed an ethical transit

[*glissement*]⁴⁰ in the Antillean subject. The result of an unconscious identification with a white moral agent, this phenomenon of ethical transitivism pointed to the surreptitious mechanism through which the colonial subject split off his black self, turning it into a Kleinian abject object of disgust and moral depravity. Indeed, what else, one might again ask, did Fanon relive in the well-known scene, when the white child pointed in horror at him—what else did he relive than the exemplary reenactment of this traumatic scene of moral splitting?

In *Black Skin, White Masks,* Fanon sought to remedy the internalized colonialism that persisted in the postcolonial Antillean subject, doing so via the intellectual work of *désalienation,* laboring on a revised cultural theory that, in helping to undo the Antillean subject's *misrecognition* of self, might operate as effective, therapeutic ideology critique. Essentially, he sought to release the black subject from the neuroses in which he remained trapped, the captive of too much memory—for Freud the predicament of the hysteric—prisoner of a particularist past that blocked off equal access to the universal. Yet, Fanon's application of the Hegelian dialectic in *Black Skin, White Masks* was, at the very least, overdetermined. In the introduction he clearly stated, "man is not merely a possibility of recapture or of negation," adding: "If it is true that consciousness is a process of transcendence, we have to see too that this transcendence is haunted by the problems of love and understanding. Man is a *yes* that vibrates to cosmic harmonies."⁴¹ It is, then, between the aspiration to attain such transcendence in love and understanding, on the one side, and the negativity of force, on the other, that his dis-alienating project oscillated. That for Fanon the Antillean could only attain self-consciousness by resorting to violence clearly emerged in "The Negro and Hegel," a subsection of the essay "The Negro and Recognition." Having established the psychological condition of the black Antillean subject as fraught by an Adlerian inferiority

complex, Fanon explained—now applying the Hegelian model to the postcolonial present—how he had failed to traverse all the steps in the fierce struggle for freedom through recognition. For did not the quality of being human, Fanon implied, depend on one's forceful *imposition* of oneself onto another in order to be recognized? Like Kojève, Fanon chose to isolate the intense aggression in the dialectic of the encounter with the other.[42] If at the foundation of the Hegelian dialectic lay "absolute reciprocity," through mediation and recognition, then the "human reality in-itself-for-itself" was to be achieved through conflict and through the risk of life, as one sought to satiate one's desire for recognition. "This risk means that I go beyond life toward a supreme good that is the transformation of subjective certainty of my own worth into a universally valid objective truth," bringing about "a transformation of subjective certainty (*Gewissheit*) into objective truth (*Wahrheit*)."[43] Such an induction into the realm of universality, however, was not the prerogative of the Antillean subject. Living in the postcolonial condition of Martinique, this subject merely occupied a position that preceded the first step necessary for the attainment of self-consciousness. Because of Martinique's liberation from slavery by the French—unlike Haiti, where the revolution of the black Jacobins was lead by Toussaint L'Ouverture—the struggle of life-and-death had gone missing, so that even freedom had been imposed externally, from above. And, contrary to the *Phenomenology*, the French white master did not even quest after recognition from the Antilleans. Laughing "at the consciousness of the slave," what the white master demanded from him was not recognition but simply labor.[44] Having failed to fight for their lives themselves, Antilleans had not even attained the stage of Kierkegaardian anxiety—the result of having too much freedom at one's disposal—let alone gained access to the universal right to self-consciousness and subjectivity.[45]

Seeking to undo this *pathos of distance,* enforced by the "aristocratic" white colonizer or barbaric settler, Fanon predicted—using unmistakable Nietzschean locution—that the struggle for recognition henceforth could only take one form: it would mean relinquishing the passivity of slave morality, so as to assume a position of actional agency, a new positing of values that would no longer be belated, reactive, or merely comparative. But this meant taking up a contradictory position, answering the white other with both a "yes" and a "no." Indeed, Fanon did not seek to reduce the position of the black subject to pure negativity and alterity, as in fact Sartre had done in his "Black Orpheus," that primer of the white subject's alienated consciousness.[46] Instead, he demanded that the Antillean subject occupy a double, a-logical position, which joined affirmation to negation: "*Yes* to life. *Yes* to love. *Yes* to generosity. But man is also a *no. No* to scorn of man. *No* to degradation of man. *No* to exploitation of man. *No* to the butchery of what is most human in man: freedom."[47]

This contradictory logic clearly punctuated all of the psychoanalytic essays, suspended as they remained between the emphatic affirmation of love and the negating force of violence. But the full span of this logic's potential applications only truly surfaced in *Wretched of the Earth.* Composed in the throes of the anticolonial struggle, Fanon's famous revolutionary manual did not just spell out the violent logic that issued from Hegel's struggle for recognition, but, in the course of doing so, also rewrote earlier advocacies of revolutionary violence. Mapping the class struggle onto the colonial one, it hailed the coming of a new humanism, for the outcome of violent decolonization was "the creation of new men," via all means possible, the only valiant one being "absolute violence."[48] Clearly, violence was not an end in itself, but a way of leaving the state of inactivity, inaction, *ressentiment,* passivity, through the rhythm of revolutionary *élan.* But the *yes* of affirmation, it appeared, now could only be

realized in and through the *no* of violence. Fundamentally, Fanon asserted, the opposition between settler and native violated Aristotle's logical principle of noncontradiction: as two irreconcilable adversaries, colonizer and colonized were clasped in a pattern of "reciprocal exclusivity."[49] In view of this violation of classical logic, a rational confrontation no longer proved possible—only obliterating violence could ensue. Ruled by an Aristotelean, not Hegelian (or dialectical) logic of contradiction in which mediation was still possible, colonialism now proved governed by a ruthless antagonism, in which adversaries sustained themselves by a fierce desire for substitution, without the aspiration for reciprocal recognition.

Siding with the "starving peasant, outside the class system," not the elitist colonized intellectual, who—together with the liberals in the colonizing home country—embraced the values of the "universal abstract,"[50] Fanon described colonialism as "violence in its natural state," which "will only yield when confronted with greater violence."[51] Written from amidst the ranks of the colonized *Lumpenproletariat*, in whose revolutionary potential he, unlike Marx, believed, his tract depicted the colonial situation as a real, not just imaginary, warring "state of nature," in which settler and native were caught in a vicious cycle of violence. Fixed in the confines of this frame, the colonized subject saw no exit, remaining the hostage of the desire to radically and violently usurp the place of the settler. To shed further clarity on this state of affairs, Fanon returned to the Manichean world order, first propounded in *Black Skin, White Masks*. Colonialism, he vouched, was "not a treatise on the universal, but the untidy affirmation of an original idea propounded as an absolute. The colonial world is a Manichean world."[52] In the dualistic mind-set that ruled the colonial world, the native functioned as absolute evil, as "insensible to ethics," and hence "the enemy of values."[53] But from this binary logic that the settler inflicted upon the native followed that it could

only be countered by a mirroring logic, emanating from the oppressed: "On the logical plane, the Manicheism of the settler produces a Manicheism of the native. To the theory of the 'absolute evil of the native' the theory of the 'absolute evil of the settler' replies."[54] Force, it followed, was the only appropriate means to set an end to the aggressor's violence. Citing Engels's *Anti-Duehring* approvingly, Fanon hailed the instrumental force of violence, stressing the need for the colonized to reclaim not just the means of production, but in particular the instruments of violent reproduction, if they hoped to become contenders in the spiral that linked the armament race to the manufacturing of weapons. In the vicious cycle of violence and counterviolence, "the violence of the colonial regime and the counterviolence of the native balance each other and respond to each other in an extraordinary reciprocal homogeneity."[55] Influenced not just by Engels, but also Sorel's *Reflections on Violence*, Fanon proposed a typology of violence that eventually—in a cynical twist of the quest for a concrete, not just abstract, universalism that he celebrated—seemed to become a new unifying, if not universalizing, force. Advocating a form of "universal violence"[56] that would unite the oppressed, he contended that, "at the level of individuals, violence is a cleansing force. It frees the native from his inferiority complex and from his despair and inaction; it makes him fearless and restores his self-respect."[57] As he anatomized the different stages in the natives' uprising against colonizing forces—from traumatic, internalized revolt to the successful overthrow of the settlers—he also listed the successive transitions and changes in the channels of violence: from ritualized religious activities and cathartic manifestations of violence enacted in dance; acting out as the neurosis of aggression inflicted upon fellow sufferers; to the fully externalized unleashing of violence upon the settlers, whose fervor amounted to history-making action or agency. It was Sartre, tellingly, who—responding almost immediately to Fanon's

call—recapped the various stages of this process, as he laid it out for the public in the colonizer's home country. Recognizing the mirrorings of a reflective logic that had gone awry, he summarized the three phases of violence as follows: that of the settler's, followed by the destructive violence turned inward of the colonized, and, finally, the return of violence to its point of origin. Like a boomerang,[58] the violence launched by the settler was hurled back at him, at the moment the natives' volcanic, "mad fury" erupted. [59] Thus, in Fanon's advocacy of revolutionary violence, Sartre discerned the historical dialectic that lay hidden under the hypocritical veil of liberalism: "the same violence is thrown back upon us as when our reflection comes forward to meet us when we go toward a mirror."[60]

Though Fanon's endorsement of violence never functioned as an end in itself, but as the situated, historical response to colonial violence, there is no doubt that it was infused by a theory of Sorelean spontaneism and a highly problematic creative vitalism.[61] His position was entirely at odds with the tradition of pacifism, situated at a far remove as it was from Gandhi's principle of *ahimsa*, or nonviolence, which, sheltered in the seat of the heart, was to be mustered against the fetish of force. As a consequence, it has virtually been impossible to glimpse in Fanon's unambiguous embrace of violent struggle the ethical impulse that so clearly marked the earlier work. To grant his ethics of recognition more relief, it might therefore be worthwhile to place his work briefly in line with Levinas's philosophy, despite the ostensible dissimilarities that separate the one from the other. As he aspired to reach an ethics of the other, Levinas sought to overcome the polemical realm of politics, which, as *Totality and Infinity* suggested, propagated the continuation of war by other means. In positing that ethics resolutely preceded the arena of politics, Levinas abandoned the Hegelian battle for recognition, or the struggle of life and death, demanding that the other no longer be assimilated to the self, in its pursuit of self-certainty in

self-consciousness. In other words, ethics was to be situated logically, temporally, but also ontologically, before politics, war, the state of nature—terms that, despite obvious conceptual differences, functioned interchangeably. In so doing, Levinas jettisoned the interpsychic dynamics of the Hegelian model to posit a "non-symmetrical,"[62] hence nonreciprocal intersubjective relation, which radically modified the figment of mutual requittal.[63] Letting go of the other meant letting the other be, and seeing the other no longer entailed subjugating him to an imposing, specular gaze but respecting the other's infinity, as it emanated from his face. Levinas thus described a subject that was no longer driven by the need to command the other fully. Assuming the subject position instead meant that one acquiesced to being "subject-ed"—not in the Foucauldian disciplinary sense, but that one relinquish oneself to the other, and, crucially, to one's responsibility for the other. The main trope that structured this ethical task was that of substitution, a "substitution for another," not to usurp his place, but to place one's responsibility for his well-being before the Hegelian struggle for life and death.[64]

Fanon, too, repeatedly made use of the term "substitution," but so as to grasp all of its ramifications—especially when held against Levinasian thought—one must consider the seminal changes the term underwent, as it migrated from *Black Skin, White Masks* to *Wretched of the Earth*. Surely, Fanon's later troubling embrace of violence as a way of taking-the-other's-place is a far cry from the plea for transcendence in intersubjective love that framed the earlier work. In the poetic chapter on *négritude*, at the heart of *Black Skin, White Masks*, Fanon paid tribute to a non-Western conception of substitution—a magical way of trading places, typical of an organic, holistic mind-set, devoted to the powers of animism and mana, whose harmonic sounds this lyrical philosopher heard reverberate in the poetry of *négritude*. But by the time he wrote *Wretched of the Earth*, the poetic cosmos of fulfilment had been forcefully replaced by an abject state of

nature. The new logic of substitution no longer resounded with the ethical overtones this word carried in Levinas's philosophy no less than in his own early work. Though he desperately hoped to seize the lost—or never realized—universalism of ethics, Fanon could not yet occupy that safe place outside the warring arena of politics, whose undeniable realities had been forced upon the colonized. To judge Fanon from the secure position of those not immersed in that struggle seems to judge history.

One might well ask, then, whether the difference that marks *Black Skin, White Masks* and *Wretched of the Earth* can also be interpreted as the breach that separates aspiration from reality. Drawing quasi-Levinasian gestures, the very last lines of *Black Skin, White Masks* delineated a sentient ethics of touching, awakened by a longing to feel the other, letting the other reveal himself in all his mystery. Freedom was "the open dimension of all consciousness," a technique of perpetual self-interrogation— struggle proved just an intermittent phase, the passing of time. As a way of undoing the "vicious circle" of a double narcissism that riddled the relations between blacks and whites, Fanon demanded the realization of a "new humanism," a taking on of "the universality inherent in the human condition."[65] More than violent negation, humans were positive affirmation—a "yes"— and consciousness was a process of transcendence that involved love and understanding. As a psychoanalytic handbook, punctu- ated by paroxysms of revolutionary verve and poetic élan, *Black Skin, White Masks* ended with a rallying cry to *act, agir*, which found its response in *Wretched of the Earth*, the manual for revo- lutionary change Fanon realized in his Algerian phase. Thrown between a desire for activist force and a tranquil Kantian- inspired universalism, *Black Skin, White Masks*'s muted call for counterviolence still remained framed by a pacifistic poetry that yearned for the unmediated encounter with the other. In so posi- tioning his work, Fanon resolutely rejected the choice offered between sameness and difference, also voiced in Taylor's two

choices of an expanded liberalism. For the two positions, that of "color-blindness" versus the "color-conscious" embrace of the racial mark, merely amounted to two alternatives in a drama staged by white others, a neurosis out of which the black agent needed to escape, by projecting into the future the figure of a universal, human being. Such a projection, Fanon romantically hoped, might return the luster to Kant's proverbial starry sky, or, as he put it in the scansion of his characteristic poetic diction: "It is a long time since the starry sky that took away Kant's breath revealed the last of its secrets to us. And the moral law is not certain of itself."[66]

ETHICAL TRANSITIVISM

Though Fanon, rereading Lacan, crafted the term *ethical transit* to diagnose the psychological well-being of Antillean subjects, it might not altogether be implausible to use the mechanism as a way of understanding similar latent transfers that transpire in the broader ethical field. Viewed from this perspective, certain unreflective liberal scripts then can be seen to impose a psychological transitivism, according to which the reciprocating other is assumed to mimic the liberal subject's moral gestures at the imaginary level. To name but one of the better-known examples, one might consider, for instance, whether such an automatism still functions in Kohlberg's neo-Kantian psychological theory of cognitive moral development. Indeed, as Carol Gilligan's feminist critique of Kohlberg's universalist ethics of justice showed, his model of moral role-taking, which required the adoption of the other's point of view, was fraught with an unspoken, yet pernicious gender bias. In imagining the subject of moral deliberation to be male, Kohlbergian theory excluded an array of additional moral perspectives, especially the sense of self and ethics of care, often favored by women.[67] Applying it to our focus on the Habermas-Taylor dialogue, we might ask whether

such a mechanism of ethical transitivism isn't operative in Taylor's neo-Hegelian contribution and Habermas's reply. With this query in mind, it seems appropriate that we return to their exchange about multiculturalism.

In his contribution to the debate, Taylor enumerated the merits of the discourse of recognition, from Rousseau to Hegel,[68] to bolster the virtues of a communitarian liberalism that protects group rights, enabling the survival of endangered cultures—a case in point being Francophone Québec. At the same time, he remained all too conscious of the problems that stem from assimilating the authenticity of the other to the "dominant or majority identity,"[69] addressing the coercion exerted through cultural logics of imposition. Readily acknowledging the centrality of Fanon in the pluralism debates, he noted how *Wretched of the Earth* had made explicit the struggle to reverse the inculcation of identity images. Though Fanon's use of force was not adopted by all of his adherents, as Taylor stressed, "the notion that there is a struggle for a changed self-image, which takes place both within the subjugated and against the dominator, has been very widely applied."[70] Insofar as they fought for the revision of forcibly imposed identity images, feminist and multicultural identity struggles, Taylor indicated, remained indebted to Fanon's anticolonial program.[71] Yet, Taylor's main concern, in the end, lay with the campus canon debates, which bore on the need to universalize equal esteem for diverse cultures. To promote the acceptance of non-Western texts as objects worthy of study required, he advised, that all embrace the hypothesis according to which cultures intrinsically carried a "presumed worth"—a value judgment that subsequently could be put to the test through the actual study of individual cases.[72] Naturally, Taylor's proposition for such a much-needed, thorough canon reform that potentially would include all cultures indiscriminately is sound and worthy of adoption. Indeed, hesitation is not due as regards the tenets of his proposal for reform,

but rather as regards the presuppositions, or foundational premises, that would guide its future implementation. For, as laudable as his position sounds, in the course of his discussion Taylor slipped comfortably into a presumably homogeneous, undifferentiated "we," a collective subject that, as it appeared, would study the "other" ethnographically and anthropologically. Such a study would yield a fusion and expansion of interpretive horizons, he surmised, adding that this position was informed by Gadamer's hermeneutical theory of understanding, without, however, noting that this perspective, in typical Hegelian fashion, relied on the figure of the self returning to itself, charted through an expansive, grand journey to the other. Following the idealistic figure of self and other, all too familiar by now, Taylor in the end risked retracing the voyage toward the (Hegelian) certainty of self-consciousness at the expense of the other, sublating, or—phrased yet differently—translating the "other" into the homogeneity of a collective "we." For in the absence of specifications about how this collective subject was to be constituted, the gesture of hermeneutical recognition threatened to absorb, and hence to transliterate, all difference in fusion.[73] The same reservation is due to Taylor's invocation of Herder. Sliding from a discussion of "equal respect" to one of "equal worth" or "value," Taylor speculated that, in the grand course of history there lay a moral duty to recognize "our" own relatively futile cultural contribution to the vast expanse of world culture, conceived along Herderian lines. But what could it mean for Taylor to adopt Herder's perspective and to presume a final, ultimate theological "horizon from which the relative worth of different cultures might be evident?"[74] In a similar vein, how is one to understand the Hegelian span of history that once again seeps into the discussion? Applying even more pressure to the Hegelian presuppositions that upheld Taylor's argument, one might go so far as to ask whether it would truly be advisable to reconcile a secular theory of multiculturalism, governed by the

sober language of formal legal and political rights, with the kind of theodicy or Christian eschatology Hegel predicted at the end of his *Lectures on the Philosophy of History.*[75]

At least one other seminal point of critique with regard to Taylor's model emerges. Don't judgments about worth and value—for which individual cultures are to be tested—again presume an underlying (substantivist) consensus on values, a position that might reintroduce a foundationalist axiological system, no longer subject to communal debate, dialogue, let alone, dissent? On this point, I can only agree with Habermas's rejoinder in his essay "Struggles for Recognition in the Democratic Constitutional State" that the presumed, substantivist claims of excellence about a culture should not detract from, even less eclipse, the need for more primordial, procedurally (formally) defined rights to equal respect. As Habermas convincingly argued, Taylor's analysis was rooted in a false antithesis insofar as he didn't pay due consideration to the fact that bearers of individual rights were always situated intersubjectively. Thus, the problem did not lie in the contradiction between two competing sets of rights (collective versus individual ones), but in the very *actualization* of basic rights. Normative decisions enacted by the law were contingent insofar as they reflected the citizenry, which is why they would always prove to be permeated by the fiber of ethics. In effect, it is this very paradox between political recognition and ethical values—the lived mores, codes, customs of particular communities, Hegel's *Sittlichkeit*–that Habermas shows us must be thought through, thus returning us to a question asked earlier: "Whose ethics for democracy?"

Writing as a dual observer of the multiple struggles that mark the American and European scenes, Habermas noted that the life-world of a nation's citizens or their contingent horizons of experience—including the *ēthos*—defined not only a nation's patriotic self-understanding but also its legal system, resulting in what he called a *juridified ethos*. Precisely this "ethical-

political self-understanding on the part of [a] nation," as he added, was continuously altered and profoundly affected by migration and multiethnicity. Moreover, because multicultural societies are not simply multiethnic but also *multi-ethic* in constitution, as I suggested at the outset, they require that one be recognized not just as a citizen, but also as a member of a culture or, to put it in Habermas's words, an "ethical community integrated around different conceptions of the good." This can only indicate that in a postconventional multicultural, pluralist democracy, ethical integration was to be radically disengaged from political integration, meaning that even if liberal constitutional democracies are inevitably weighed down by ethical substance, they must nonetheless seek to maintain a legal neutrality "vis-a-vis communities that are ethically integrated at a subpolitical level." Or, to put the issue in different terms, so as to safeguard the pluralism of democracy, there must exist then a necessary asymmetry between the ethical and the political, an unbridgeable distance between the two, which, as signified by the hyphen in the phrase ethico-political, ought to prevent the one from collapsing into the other. The paradox Habermas's critical theory seeks to think, then, is the following: given the inevitable ethical permeation of any pluralistic democracy, how to maintain an ethical neutrality on the procedural legal level that can guarantee the coexistence of multiple ethical positions. Needless to say, Habermas himself thereby remains susceptible to Taylor's frank acknowledgment that liberalism itself is merely a "particularism masquerading as a universalism." Nor do Habermas's rationalist (Kantian) foundationalism and conception of rational discussion entirely escape ethical transitivism— if one considers the grounded charges of antifoundationalist critics, such as Mouffe, who have repeatedly noted that his regulative idea of consensus, though "conceived as infinite," still has a "clearly defined shape," so that it runs the danger in turn of imposing "a univocal model of democratic discussion."[76] That

Habermas's social theory and discourse ethics fail to secure against the possible obliteration of multiply situated differences that constitute the democratic polity is also a point that has been made, though from within the parameters of a communicative discourse ethics, by fellow Frankfurt School theorist Seyla Benhabib. In her *Situating the Self*, she has sought to amend Habermas's model by designing a "postmetaphysical interactive universalism" that no longer subscribes to a "counterfactual" ideal of consent but draws upon a context-sensitive "reversing of perspectives."[77] Thus, her proposal for an adjusted version of communicative ethics called for a historically and culturally self-conscious universalism that reflects on its situatedness, though without relinquishing its deontological, normative perspective. In her essay on the generalized and concrete other she argued against the Kantian legacy of the "generalized other," which might result in inadvertent "substitutionalist" versions of universalism, against which she held out another universalism that, no longer gender-blind, demonstrates "the will and the readiness to seek understanding with the other and to reach some reasonable agreement in an open-ended moral conversation."[78] From this standpoint, the pragmatic presuppositions of democratic discussion could "be challenged within the conversation itself," yet without abolishing or suspending them altogether, for to do so would mean to open the gates to "violence, coercion, and suppression,"[79] and to initiate the return to the "state of nature," that is, to the "struggles onto death among moral opponents" for moral recognition.[80]

CONCRETE UNIVERSALISMS

How should pluralist democracies negotiate between the ethical and the political without collapsing them? How to ensure the coexistence of a potentially infinite array of diverse ethical systems, approaches, and mores—such appear to be the persist-

ing questions at the core of the multiculturalism and pluralism debates. And, though the solutions of the interlocutors in these discussions vary, to the point of seeming irreconcilable, all appear animated by a genuine adherence to a democratic "attitude," or *democratic ethos*, as Mouffe has phrased it. The outer limit of such a democratic ethos is constituted by violence, or the use of force, its inner limit by the political recognition of difference. Indeed, it is precisely this outer line of democratic liberalism that Fanon crossed when he advocated, even embraced, violence, as he found himself in the thick of anticolonial warfare against what proved to be, in essence, a nondemocratic regime. But whereas his advocacy of violence demands to be understood within its historical context, his writings have retained an urgency that goes well beyond their time-bound parameters. Over and against conventional variants of the Hegelian dialectic, Fanon relentlessly interrogated the power dynamic in the struggle for recognition no less than the ethical transitivism that bound subjects to identity images. Laying bare the epistemic violence transported by the model of recognition, he also opened up a radically other dimension as he called attention to the frail, porous border that was rifted between an unreflective liberalism and violence. Fundamentally, he exacted that the "universal"— whether in its Kantian formalist or Hegelian substantivist meaning—be made to live up to its pretensions to indiscriminate inclusion—though he, as much as Levinas, deplorably, in the end endorsed a male-identified humanism. But while to some it would be easy to rebuke the holistic phantasm of universality that regulated Fanon's overhaul of a Manicheistic moral order, it might perhaps be more productive to engage directly with his reflections on concrete universalism. Then, it becomes evident that the fundamental question about universalism his work poses also informs the debates about multiculturalism and pluralism: must the demand for universal recognition—in its cultural, political, and legal meanings—imply the uncontested recogni-

tion (or acceptance) of universalism? With this phrasing, it appears not only that Hegel's model of recognition is still with us, but also that the old dialectic of how to mediate (negotiate) between universalism and particularism has lost none of its relevance. It is to a brief discussion of the conflictual views around "universalism" that I would like to turn in conclusion.

At the risk of unduly streamlining current controversies, one might say that critiques of the Enlightenment ideal of universality, proffered in the name of difference or pluralism, usually take two forms. Its "weaker" version targets the coercive, manipulative, and exclusionary application of the category "universal" to exclude those thought to deviate from the normative, or normalizing mean, a skewed logic historically enacted in colonialism, racism, and all forms of discrimination on the basis of gender or sexual orientation. As we saw, it is this kind of critique that Fanon promoted as he hoped to advance a concrete, not abstract, universalism. But it is also here, I believe, that one must situate Étienne Balibar's analysis of the curious bonds that connect certain strands of neoracism to the project of universalism. Less a wholesale rejection of universalism than a contestation of its imaginary manifestations, his work has warned that it may be impossible to "effectively face racism with the abstract motto of universality," since racism "has already (always already) occupied this place."[81] While it is vital for a progressive universalism to fight the primitive particularism at work in differentialist, cultural neoracism, these contestations do little to counter the rhetoric of universalism that such a neonationalist differentialist culturalism often mimics. Given that the struggle between racism and democracy transpires within the space of universalism, the hard task awaiting pluralist democrats therefore is how to "to transform universalism, not to abandon it [. . .] for this would amount to surrendering without combat."[82] Similar exigencies apply to an abstractly formulated humanism, according to Balibar, since

the theoretically infused racist theories of the last decades have demonstrated that they easily can have truck with the rhetoric of a theoretical humanism. For these reasons, a purely theoretical (strategic) humanism must likewise be replaced by a workable, concrete humanism, which in the context of post–Cold War Europe for Balibar can only mean guaranteeing an "internationalist politics of citizenship."[83]

But in the conflictual field of democratic politics, other, "stronger" antifoundationalist critiques of universalism have disputed justificatory political scripts that proscribe universalist principles. Not infrequently, Habermas's discourse ethics has been taken to task for being the chief representative of such a normative universalism, while he, for his part, has opposed the relentless search for a mendacious "will to power," concealed behind Enlightenment ideals.[84] At stake in these disputes, as we noted earlier, is liberalism's unificatory, normative starting point and the coercive force with which it might strive for collective consent about the principles, procedures, policies, or operations of the polity, at the expense of dissenting difference. On this reading, even the most hospitable or generous liberalism might still limit the playing field of those who can join the democratic discussion in the polity. For in presuming a moral, rational norm on the basis of which its emancipatory program can be justified, such variants of liberalism forget their contextual point of origin, as Mouffe has argued, together with the "unrecognized violence hidden behind appeals to 'rationality.'" Seeking to "establish a rational and universal consensus by means of free discussion,"[85] the proponents of deliberative democracy, she maintains, link politics to morality, thus overlooking that their decisions are not moral and universal but political and contingent. Liberal democracy in Mouffe's pragmatic, late Wittgensteinian model is but one of many language games that can only "be defended in a 'contextualist' manner."[86] Anything but the advocacy of real violence or a Schmittean decisionism,

her position would rely on linguistic contestation within a multiplicity of discursive practices, which does not avoid "agonistic confrontation,"[87] but allows for social struggle, confrontation, dissent, meaning that only "conflictual consensus" can ever be reached.[88] Rejecting justificatory scripts based on the "identification of the universal with the particular," Mouffe nonetheless still retains a quasi-Kantian position insofar as the universal can only ever function as a regulating horizon, but never as an attainable endpoint. Still, when it comes to the formalist/substantivist divide in political theory, Mouffe has spoken out against privileging "neutral procedures and general principles," as this would be detrimental to the democratic project itself, always entrenched as it is in "substantial ethical commitments." Notwithstanding the existing plurality of possible political language games, the main task that confronts advocates of a radical democracy is how to guarantee the construction of a democratic *ethos* that will allow for the recognition of a democratic plurality without resulting either in mere political decisionism or else in a disavowal of the power relations that inexorably suffuse any future democratic polity.

Obviously, it won't be possible to resolve these contentious political debates between foundationalist and antifoundationalist positions, nor can they, for that matter, easily be settled insofar as they concern fundamental disagreements over the distribution of consent or dissent, no less than over the admissibility of a universal, normative, moral foundation for the democratic project. Upon closer scrutiny, furthermore, positions also appear polarized over the way in which the ethical and the political relate to one another, as rendered by the hyphenated construction "ethico-political." Thus, as we noted, in his proposal for postconventional multicultural societies that integrate immigration and asylum reforms, Habermas theorized the inevitable contingency and contextuality that invariably inflect the formal procedures governing democratic

cohabitation. If for him the main dilemma appeared to be how possibly to maintain neutrality in the exercise of democratic procedures, then Mouffe's antifoundationalism, on the contrary, contested the flawed starting point of this position, doubting the attainability, no less than advisability, of such a neutral mean. All the same, such deeply embedded disagreements between factions, must not necessarily detract from the circumstance that they also come together at notable junctures. Agonistic, antifoundationalist poststructuralist accounts of pluralism and multiculturalism, for one, usually subscribe to a modicum of "universalization," that is, to the (universal) *extension* of democratic rights to willing participants of the polity, while remaining vigilant, to be sure, about the issue of *whose* rights are under discussion. Moreover, whether it is a matter of privileging moral, social, legal, or political struggles for recognition, all factions accede that such struggles cannot take the form of an enforced submission to hegemonic subject positions but that they require *nonviolent,* that is to say, discursive contestation. Finally, an extended reflection on the complex relations between the ethical and political also makes it clear that the ethical, in the sense of *ēthos*, can't refer only to Hegel's *Sittlichkeit,* or to the situated, context-bound cultural baggage of mores with which the democratic project inevitably is burdened.[89] At a more fundamental level, the ethical also betokens the place of a radical openness, a holding open of the realm of possibilities—though not necessarily in the sense Levinas had in mind when he thought of ethics as that which precedes politics, a term thus reduced to mere strategic action. Perhaps the difficulty rather lies in how to reclaim such an ethical openness *within* the political, without lapsing back into metaphysics, total indecidability, decisionism, or, simply, political disaffectedness.[90]

Leaving these questions open for further reflection, let me in closing bring up another crucial point that bears upon the recent

controversies over the shortcomings of universalist political projects. For it seems to me that the intensity with which some of these exchanges about (a Kantian) universalism have been conducted might threaten to deflect from a more worrisome current political trend, namely, the ready embrace of an unreflective globalism.[91] Doesn't Kant's utopian universal history of peacefully coexisting atomistic moral agents, who all will that the maxims governing their actions become universal law, by comparison pale, attesting as it does to a quaint, even nostalgic anti-Babelic longing for the overcoming of glossolalia? At present, its real or purported horrors seem slight compared to the more disconcerting realities of a globalized strategic, manipulative, pragmatic utilitarianism, including its perhaps most seductive phantasm, that of a corporate multiculturalism. Mapped out in Fukuyama's *End of History*, this program for a globalized liberal world order, propelled by a healthy, competitive free-market capitalism, not only transforms the other into nothing but a potential economic competitor, but also sees itself as the fulfillment of a radically misunderstood dream of "universal recognition." Equally problematic, of course, is a romanticized melancholia that remains in the thralls of an internalized or incorporated alterity, where one complacently revels in the awareness that one always already is a "stranger to oneself."[92] How to retrieve the radical alterity of otherness for a truly emancipatory pluralist politics is the challenge whose extraordinary dimensions we have perhaps only just begun to recognize.

NOTES

I wish to express my indebtedness to discussions with Isaac Julien, Ernesto Laclau, and Chantal Mouffe, which helped me further refine the argument of portions of this essay.

1. See Karl Marx, "The Eighteenth Brumaire of Louis Bonaparte," in Karl Marx and Frederick Engels, *Collected Works*, trans. Richard Dixon et al. (New York: International Publishers, 1975–), vol. 11, 103. Marx's full quote runs as follows:

"Hegel remarks somewhere that all facts and personages of great importance in world history occur, as it were, twice. He forgot to add: the first time as tragedy, the second as farce." As David Fernbach, the editor of the Penguin edition of Marx's writings points out, the figure is in all likelihood to be attributed to Engels, who made similar comments in an 1851 letter to Marx. See Karl Marx, *Surveys from Exile: Political Writings: Volume 2* (London: Penguin, 1992), 146n.

2. See Jacques Derrida, *Specters of Marx: The State of the Debt, the Work of Mourning, and the New International*, trans. Peggy Kamuf, with an introduction by Bernd Magnus and Stephen Cullenberg (New York and London: Routledge, 1994). Derrida pursues the economy of a "hauntology" in Marx's work but also the return, or perhaps persistence, of a discourse of the modern apocalypse and of the "last human" in the postmodern present.

3. Francis Fukuyama, *The End of History and the Last Man* (New York, Oxford, Singapore, and Sidney: The Free Press, 1992). On Fukuyama, see also Derrida's *Specters of Marx*, 56–68, which takes on the Christian eschatology, the gospel-like nature of Fukuyama's world-historical project.

4. See Nancy Fraser, *Justice Interruptus: Critical Reflections on the "Postsocialist" Condition* (New York and London: Routledge, 1997), especially the chapter "From Redistribution to Recognition? Dilemmas of Justice in a 'Postsocialist' Age."

5. Amy Gutmann, ed., *Multiculturalism: Examining the Politics of Recognition* (Princeton, N.J.: Princeton University Press, 1994). This book assembles contributions by Charles Taylor, K. Anthony Appiah, Jürgen Habermas, Steven C. Rockefeller, Michael Walzer, and Susan Wolf. In what follows, I will focus principally on Charles Taylor's essay, "The Politics of Recognition," and Jürgen Habermas's "Struggles for Recognition in the Democratic Constitutional State."

6. K. Anthony Appiah, "Race, Culture, Identity: Misunderstood Connections," in *Color Conscious: The Political Morality of Race*, K. Anthony Appiah and Amy Gutmann (Princeton, N.J.: Princeton University Press, 1996), 92, emphasis added. See also his "Identity, Authenticity, Survival: Multicultural Societies and Social Reproduction," in Gutmann, *Multiculturalism*, 149–63.

7. Walter Benjamin, "Critique of Violence," in Benjamin, *Reflections: Essays, Aphorisms, Autobiographical Writings*, trans. Edmund Jephcott, edited and with an introduction by Peter Demetz (New York: Schocken, 1986), 285. Benjamin comments on the "minimal program" of Kant's categorical imperative, namely, "act in such a way that at all times you use humanity both in your person and in the person of all others as an end, and never merely as a means." As he observes in a footnote: "One might, rather, doubt whether this famous

demand does not contain too little, that is, whether it is permissible to use, or allow to be used, oneself or another in any respect as means. Very good grounds for such doubt could be adduced." Benjamin, *Reflections*, 285n.

8. On the problem of imagining the other, see, for example, Elaine Scarry, "The Difficulty of Imagining Other People," in *For Love of Country: Debating the Limits of Patriotism*, Martha C. Nussbaum et al. (Boston: Beacon Press, 1996), 98–110.

9. The category of "alterity" or "otherness" (*autre*) must be demarcated from the position of the personalized other (*autrui*), insofar as the former often is held to refer to a logical category (in French, *le même et l'autre;* in German, *das Selbe und das Andere*). In his early work on the history of insanity, *Madness and Civilization*, for instance, Foucault demonstrated how this ontological dialectic grounded epistemic regimes of violence, in which order was imposed to mark off and tame uncontrollable alterity. See, furthermore, Michel Foucault, *The Order of Things: An Archeology of the Human Sciences* (New York: Vintage, 1994), xxiv and especially 326ff. For the French original, which unambiguously distinguishes *le Même* from *l'Autre*, not *autrui*, see Michel Foucault, *Les mots et les choses: Une archéologie des sciences humaines* (Paris: Gallimard, 1966), 15 and 337ff. On the philosophy of the other, see especially Michael Theunissen, *The Other: Studies in the Social Ontology of Husserl, Heidegger, Sartre, and Buber*, trans. Christopher Macann (Cambridge, Mass.: MIT Press, 1984). Paradoxically, the objectification of *autrui* into *l'autre* can be found among quite a few philosophers of otherness, certainly Levinas, whose discourse on "the feminine" elevates women to a transcendental position, stripping them of the position of actional subjecthood. The same holds for Sartre's philosophy, especially for the analysis of the existentialist subject offered in *Being and Nothingness*, which found a necessary response in de Beauvoir's *Second Sex*.

10. See Gayatri Chakravorty Spivak's "Can the Subaltern Speak?," in Cary Nelson and Lawrence Grossberg, eds., *Marxism and the Interpretation of Culture* (Urbana: University of Illinois Press, 1988).

11. See, among others, Emmanuel Levinas, *Ethics and Infinity: Conversations with Philippe Nemo*, trans. Richard A. Cohen (Pittsburgh: Duquesne University Press, 1985), 77.

12. Taylor, "The Politics of Recognition," 65.

13. Frantz Fanon, "The Negro and Recognition," in Fanon, *Black Skin, White Masks*, trans. Charles Lam Markmann (New York: Grove Weidenfeld, 1967), 210–22.

14. In many ways, this piece stands in dialogue with Homi Bhabha, who has similarly discussed the ethical impulse in Fanon's work, linking him to Levinas. See

Homi K. Bhabha, "On the Irremovable Strangeness of Being Different," in *PMLA* 113.1 (January 1998): 34–9. For other important overview readings of Fanon, see Henry Louis Gates, Jr., "Critical Fanonism," *Critical Inquiry* 17 (Spring 1991): 457–70, and Françoise Vergès, "Creole Skin, Black Mask: Fanon and Disavowal," *Critical Inquiry* 23.3 (Spring 1997): 578–95.

15. See the essay by Chantal Mouffe, "Which Ethics for Democracy?" in this volume.

16. See Seyla Benhabib, "Judgment and the Moral Foundations of Politics in Hannah Arendt's Thought," in Benhabib, *Situating the Self: Gender, Community, and Postmodernism in Contemporary Ethics* (New York: Routledge, 1992), 122–23.

17. G. W. F. Hegel, *Phenomenology of Spirit,* trans. A. V. Miller (Oxford and New York: Oxford University Press, 1977), 112.

18. See Jürgen Habermas, "On the Pragmatic, the Ethical, and the Moral Employments of Practical Reason," in Habermas, *Justification and Application: Remarks on Discourse Ethics* (Cambridge, Mass.: MIT Press, 1993); William Regh, "Translator's Introduction," *Between Facts and Norms: Contributions to a Discourse Theory of Law and Democracy,* by Jürgen Habermas (Cambridge, Mass.: MIT Press, 1996), ix–xxxvii.

19. On the need to expose such power dynamics and relations of domination in pluralistic democracy, see Chantal Mouffe's "Democracy and Pluralism: A Critique of the Rationalist Approach," *Cardozo Law Review* 16.5 (March 1995): 1533–45.

20. For a reference to Fanon's prophetism, see also Cornel West, "The New Cultural Politics of Difference," in West, *Keeping Faith: Philosophy and Race in America* (New York and London: Routledge, 1993), 13–14.

21. See David Brion Davis, *The Problem of Slavery in the Age of Revolution 1770–1823* (Ithaca, N.Y. and London: Cornell University Press, 1975), especially the epilogue "Toussaint L'Ouverture and the Phenomenology of Mind," 557–64; Orlando Patterson, "The Constituent Elements of Slavery," in Patterson, *Slavery and Social Death: A Comparative Study* (Cambridge, Mass. and London: Harvard University Press, 1982); and Paul Gilroy, "Masters, Mistresses, Slaves and the Antinomies of Modernity," in Gilroy, *The Black Atlantic: Modernity and Double Consciousness* (Cambridge, Mass.: Harvard University Press, 1993), 41–71. Gilroy, in particular, uses W.E.B. Du Bois's concept of "double consciousness," expounded in *The Souls of Black Folk,* as a point of departure for his analysis of the "Black Atlantic" as a "counterculture of modernity." Referring to "the core dynamic of racial oppression as well as the fundamental antinomy of diaspora blacks," the phrase, as Gilroy goes on to

show, acquires an inordinate historical complexity when seen within the context of Du Bois's work. For "double consciousness" brought into play "the unhappy symbiosis between three modes of thinking, being, and seeing," notably racial particularism, nationalism, and, finally, a "diasporic or hemispheric" strand that was "sometimes global and occasionally universalist." That complexity was only compounded by the fact that *The Souls of Black Folk* proved strongly influenced by the Hegelianism Du Bois encountered in Germany, as his adoption of a quasi-Hegelian philosophy of history demonstrated. See Gilroy, *The Black Atlantic*, 30, 27, 134. Within the frame of the present study, focused mainly on Fanon, it won't be possible to pursue these connections further. However, anticipating the argument of my analysis, I would like to add that Du Bois's notion of double consciousness also rewrote Hegel's parable of self-consciousness, for example, when Du Bois observed: "After the Egyptian and Indian, the Greek and Roman, the Teuton and Mongolian, the Negro is a sort of seventh son, born with a veil, and gifted with second-sight in this American world,—a world which yields him no true self-consciousness, but only lets him see himself through the revelation of the other world. It is a peculiar sensation, this double-consciousness, this sense of always looking at one's self through the eyes of others, of measuring one's soul by the tape of a world that always looks on in amused contempt and pity." W.E.B. Du Bois, *The Souls of Black Folk* (New York: Vintage, 1990), 8. Indeed, the passage seems very close to Fanon's reflections on the black Antillean's alienation from the Hegelian project of freedom in his "The Negro and Recognition," in Fanon, *Black Skin, White Masks* (see the discussion below).

22. Gilroy, "Masters, Mistresses, Slaves," 55. Gilroy's critique of conventional theories of modernity specifically calls for a consideration of the historical institution of slavery, over and against the unproblematic embrace "of such central categories of the Enlightenment project as the idea of universality, the fixity of meaning, the coherence of the subject, and, of course, the foundational ethnocentrism in which these have all tended to be anchored" (Ibid.).

23. On the difference between these ontological and existential moments, see Alexandre Kojève, *Introduction to the Reading of Hegel: Lectures on the Phenomenology of Spirit*, trans. James H. Nichols, Jr., ed. Allan Bloom (Ithaca, N.Y., and London: Cornell University Press, 1980), 51ff.

24. Hegel, *Phenomenology of Spirit*, 112. Hegel captured this process by means of the reflexive verb *"sich gegenseitig anerkennen,"* or *"Sie anerkennen sich als gegenseitig sich anerkennend."*

25. Kojève, *Introduction to the Reading of Hegel*, 11. Kojève simultaneously ascribed a biologistic predicament to the position of the serf, defining him as marked by animality, a suggestion missing from the Hegelian passage, at least

in the *Phenomenology of Spirit*. See, however, Gilroy's analysis of racist motifs in Hegelian philosophy, in Gilroy, *The Black* Atlantic, 50, 134.

26. Fukuyama, *The End of History*, 152.

27. Elaborating further on the eschatological dimensions that Derrida, in particular, has discerned in Fukuyama's project, one could perhaps say that in his presentism, or adulation of the now, one encounters the strangely distorted image of Levinas's prophetic conception of the "end of history," or eschatology. The latter, for Levinas, also became an event that no longer took place at the end of time but at every instant, outside a totalizing context, or frame. See Emmanuel Levinas, *Totality and Infinity: An Essay on Exteriority*, trans. Alphonso Lingis (Pittsburgh: Duquesne University Press, 1969), 23.

28. Fukuyama, *The End of History*, 338. The pernicious slant of Fukuyama's right-leaning universalized liberalism especially surfaces in the grand image with which his tract ends, overcoming the apocalyptic danger of multicultural difference. Willfully or un-self-consciously, he clads the conquest of American liberalism in the mythical, cinematic language of the "trek to the West," evoking a fierce battle between good cowboys and bad Indians. This troubling image not only reframes the Hegelian struggle of life and death as the American myth of the conquest of the West but also offers the latest variant of the famous train metaphor that Marx already used for the progress of history.

29. For further discussion of Habermas's Hegel interpretation in the *Philosophical Discourse of Modernity*, see also Paul Gilroy, who, in arguing for a radical, multicultural revision of modernist theory, criticizes Habermas's blindness to the imperialistic legacy in the Hegelian narrative. See Gilroy, "Masters, Mistresses, Slaves," in *The Black Atlantic*, 50ff.

30. Jürgen Habermas, *The Philosophical Discourse of Modernity: Twelve Lectures*, trans. Frederick Lawrence (Cambridge, Mass.: MIT Press, 1987), 22.

31. Axel Honneth, *The Struggle for Recognition: The Moral Grammar of Social Conflicts* (Cambridge, Mass., and London: MIT Press, 1996), 1.

32. Ibid., 59, 63.

33. My phrase here alludes to Judith Butler's *The Psychic Life of Power: Theories in Subjection* (Stanford, Calif.: Stanford University Press, 1997). See especially the chapter "Stubborn Attachment, Bodily Subjection: Rereading Hegel on the Unhappy Consciousness," 31–62.

34. The two tempos of Hegelian self-consciousness return in Lacan's famous 1949 Ziffich lecture, "The Mirror Stage as Formative of the Function of the I as Revealed in Psychoanalytic Experience." Thus, Lacan rethought the dialectic between self and alterity, cast as the process of mirror identification, while the

struggle between self and other appeared as the dialectic of social ego forma-
tion, achieved through the Oedipal triangle. Lacan maintained that this first
fictional, yet constitutive form of identification, mediated through a specular
non-self, preceded the social dialectic of identification with the other. Linking
ego psychology to a philosophico-ontological framework, he grafted his claims
about the "function of the I" onto a theory of the "ontological structure of the
human world," boldly setting out to undercut Cartesianism in general and
Sartre's assertive existentialism in particular. Starting off from comparative
psychology, namely, Köhler's *Aha-Erlebnis*, Lacan redescribed the infant's first
moment of recognition, which was directed at its mirror image and followed
by a sequence of gestures through which it playfully enacted (or externalized)
the relation between this virtual specular complex and the reality it doubled.
As he cast the mirror stage in quasi-Platonic language, Lacan observed that the
infant's "jubilant assumption" of its specular image was to be thought of, ana-
lytically speaking, as a process of identification that transformed the subject as
it assumed an external *imago*. Jacques Lacan, "The Mirror-Stage as Formative
of the Function of the I as Revealed in Psychoanalytic Experience," in Lacan,
Écrits: A Selection, trans. Alan Sheridan (New York and London: W.W. Norton
& Company, 1977), 2. Through primary identification with the alterity of the
self-image, a primordial, symbolical form of the ego came about, pointing
more particularly to the intrapsychic formation of the (narcissistic) *Ideal-Ich*.
(See also the entry *"Ideal-Ich"* in Jean Laplanche and J.B. Pontalis, *The
Language of Psycho-Analysis* [New York: W.W. Norton & Company, 1973]). As
emphasized before, central for Lacan was that the mirror stage, marked by the
dialectic between self and mirror image, preceded the "social" stage, in which
the ego objectified itself through identification with the other, no less than
through its linguistic inscription into the universalism of language, accom-
plished in the so-called symbolic phase. Pushing the moment of alienation that
structured Hegel's allegory of self and alterity to its extreme, Lacan underlined
that the presocial, psychogenetic process included a fictional component. That
is, the ego related to itself reflexively as double, automaton, phantom, specter.
Functioning as an "orthopaedic" structure, the *imago* lent the subject a pri-
mordial totality, an "armor" of an alienating identity, which it all too readily
assumed. In the subject's ascent to power, the "total form of the body" was
experienced as a *Gestalt*, which symbolized the "mental permanence of the I"
but also prefigured its "alienating destiny." This formative specular process
through which the infant set up a relation between *Innenwelt* and *Umwelt*
involved a homeomorphic identification with the double, as well as a hetero-
morphic identification with space, the spatial ensnarement in the mirror.
Eventually, the temporal dialectic of the mirror stage came to an end through a
new dialectic that would "henceforth link the *I* to socially elaborated situa-
tions." Already evident in primordial jealousy, in which affect signaled a "medi-

atization through the desire of the other," the process of social integration would eventually culminate in the Oedipal complex. (Lacan, "The Mirror Stage," 5) One must, furthermore, consider the fact that Lacan's (if only parenthetical) reference to Charlotte Bühler's account of *infantile transitivism* showed his concern with processes in which the infant mimicked not just the self as *imago*, but also another self. As we shall see, it is precisely the mimicry of the other that will inform Fanon's analysis of the alienated Antillean subject. Finally, in rejecting Freud's original topography (perception-consciousness), Lacan relied on Anna Freud's notion of denegation *(Verneinung)*, isolating it as one of the ego's major defense mechanisms, insofar as it was *"the function of méconnaissance* that [characterized] the ego in all its structures" (Ibid., 6).

35. I wish to express my indebtedness to Isaac Julien's work on Fanon, above all his film *Black Skin, White Masks*, as well as to Stuart Hall's observations about the function of the Hegelian dialectic in Fanon's thought. See, further, the essays collected in Lewis R. Gordon, T. Denean Sharpley-Whiting, and Renée T. White, eds., *Fanon: A Critical Reader* (Oxford, England, and Cambridge, Mass.: Blackwell, 1996); Vergès, "Creole Skin, Black Mask."

36. Fanon, *Black Skin, White Masks*, 61.

37. The English translation reads as follows: "This book, it is hoped, will be a mirror with a progressive infrastructure, in which it will be possible to discern the Negro on the road to disalienation." However, in the original the final phrase is: "in which the Negro could rediscover himself [*se retrouver*] on the road to disalienation." Fanon, *Black Skin, White Masks*, 184; compare the French original in Frantz Fanon, *Peau noire, masques blancs* (Paris: Éditions du Seuil, 1995), 148. Indeed, Fanon scholar Françoise Vergès highlights the mistranslation, noting that in the English version, "the *reader* discerns the Negro in the mirror that is the book, whereas in Fanon's text the book is a mirror *to the Negro."* Vergès, "Creole Skin, Black Mask," 580n.

38. Fanon, *Black Skin, White Masks*, 183. Fanon borrows the term from Dide and Guiraud's *Psychiatrie du médecin practicien* (Paris: Masson, 1922).

39. Fanon, "The Negro and Recognition," *Black Skin, White Masks*, 216.

40. The model of ethical transit, *le glissement éthique*, is accomplished in Martinique through cultural imposition of a collective, racially marked unconscious. Though Fanon here uses a nontechnical term, *glissement*, gliding or sliding, it is perhaps not far-fetched to link the mechanism to *transitivism*, as mimetic enactment of ethical gestures, discussed also in Lacan's essay on the mirror stage. See also the French original, Fanon, *Peau noire, masques blancs*, 155, 156.

41. Fanon, *Black Skin, White Masks*, 8.

42. In privileging the Kojèvian emphasis on violence, Fanon's reading concurred with Sartre's similar stress on negation in both his *Being and Nothingness* and his *Anti-Semite and Jew*, on whose insights about the "aetiology of hatred" *Black Skin, White Masks* also relied. As an interesting response to the so-called submerged violence of Sartrean existentialism, one must also read Lacan's essay on the mirror stage. In it, Lacan suggested that the death drive, the destructive instincts, and aggression, resurfaced in existentialism. More so, Sartre's philosophy plainly reinscribed itself in the *constitutive misrecognitions of the ego*, as it venerated the illusions of autonomy, authenticity, freedom, and the real. Showing itself to remain mired in, or fixated on, the stage of "primary narcissism," existentialism glorified modes of action that bordered on negating aggression or destructivity, an "existential negativity," resulting in a "consciousness of the other that can be satisfied only by Hegelian murder" (Lacan, "The Mirror Stage," 6). In other words, Sartre's theory of self-consciousness bobbed on misrecognition. For a similar assessment of Lacan's forceful critique of the existentialist paradigm in its relation to Fanon's work, see Vergès, "Creole Skin, Black Mask," 589. Clearly, in advancing his theory of misrecognition, Lacan also proposed a "dialectic of knowledge," in keeping with the tradition of ideology critique, which seeks to unmask the distortions of the historical subject's flawed gaze. For analyses of the dynamics between dialectics, ideology, and *misrecognition*, see also Slavoj Žižek, "Introduction: The Specter of Ideology," and Louis Althusser, "Ideology and Ideological State Apparatuses (Notes towards an Investigation)," especially his notes on mirror duplication in Žižek, *Mapping Ideology* (London and New York: Verso, 1994), 1–33, 134–35.

43. Fanon, *Black Skin, White Masks*, 218.

44. Ibid., 220n.

45. Fanon invokes Kierkegaard's concept of anguish in *Black Skin, White Masks*, 221.

46. Important, here, is Fanon's critique of Sartrean existentialism, in the chapter "L'expérience vécue du Noir" (translated in English as "The Fact of Blackness"), where he took on Sartre for turning *négritude* into a negative, transitory term, an intermediary passage on the way to the universal needs of the proletariat. Indeed, in his "Black Orpheus," Sartre defended a Marxist humanism, stating that race was merely particular, class universal. *Négritude* was a passing negative moment without value in itself, since the end goal was a universal synthesis, a society without races, to which *négritude* was not a final cause or end but simply a means, no different in status than the instrumental violence that inhered in the Hegelian dialectic. Going further, he even stripped black consciousness of affirmative power, rendering it as a lack

(manque). Taking a resolute turn, at this point, *against* Sartre's universal (quite unlike other essays would do), Fanon condemned the philosopher's reduction of black consciousness to such a lack and, even worse, to a self-absorbed opacity or immediacy. Again and again, he took aim at Sartre's demand for a true "universal," stating that barely has the Negro's blindfold been taken off, or he was forced to embrace the universal, when in fact he would like to savor the rewards *of négritude*. See Fanon, *Black Skin, White Masks*, 132ff, and Jean-Paul Sartre, "Black Orpheus," in Sartre, *"What is Literature?" and Other Essays* (Cambridge, Mass.: Harvard University Press, 1988), 291–330.

47. Fanon, *Black Skin, White Masks*, 222.

48. Frantz Fanon, *The Wretched of the Earth*, trans. Constance Farrington, preface by Jean-Paul Sartre (New York: Grove Press, 1963), 36, 37.

49. Ibid., 39.

50. Ibid., 45.

51. Ibid., 61.

52. Ibid., 41.

53. Ibid.

54. Ibid., 93.

55. Ibid., 88.

56. Ibid., 80.

57. Ibid., 94.

58. Sartre, "Preface," in Fanon, *Wretched of the Earth*, 20.

59. Ibid., 17.

60. Ibid. In his 1961 preface, Sartre made it clear that "liberal hypocrisy" avowed its allegiance to a humanism that "claimed to be universal," while in the overseas colonies it applied a *numerus clausus* as to who could qualify as a member of the human race, as to who could be cataloged under the rubric "human" (14–15). According to the existentialist philosopher, Fanon's tract on violence was the first since Engels (excepting the fascist Sorel) to have brought "the processes of history into the clear light of day" (14). To explicate the point, Sartre had recourse to the logic of specularity at the core of the Hegelian dialectic of consciousness, in which two warring individuals looked each other in the eye. In like manner, the dehumanizing effects of colonial violence, with its affirmation of subjugation and servitude, needed to be countered by the insurrectionary force of revolutionary socialism. Succumbing to the vicious

circle of violence, Sartre avowed that the singed "marks of violence" and traumatic wounds could no longer be effaced by "gentleness," only by violence (21). Yet, he quickly did away with the possible suspicion that the countercolonial rebellion would end in mere acts of savagery or "primitivism." Rather, violence was the only (creative, spontaneous) means available to thrust out colonialism, to cure the colonial neurosis, and lay claim to humanism: "[Fanon] shows clearly that this irrepressible violence is neither sound nor fury, nor the resurrection of savage instincts, nor even the effect of resentment: it is man recreating himself" (21). As he looked in the mirror held up to him as a European, Sartre saw the "striptease" of Enlightenment ideals, which were idle chatter when judged from the reality of racism (26). In racist humanism, he concluded, "the European has only been able to become a man through creating slaves and monsters. [...] In the notion of the human race we found an abstract assumption of universality which served as cover for the most realistic practices" (26).

61. See Hannah Arendt, *On Violence* (San Diego, New York and London: Harcourt Brace Jovanovich, 1970); for a critique of Arendt's Eurocentrism, see also my "On the Politics of Pure Means: Benjamin, Arendt, Foucault," in *Critique of Violence: Between Poststructuralism and Critical Theory* (London and New York: Routledge, 2000).

62. Levinas, *Ethics and Infinity,* 98.

63. As Levinas noted: "It is extremely important to know if society in the current sense of the term is the result of a limitation of the principle that men are predators of one another, or if to the contrary it results from the limitation of the principle that men are *for* one another. Does the social, with its institutions, universal forms and laws, result from limiting the consequences of the war between men, or from limiting the infinity which opens in the ethical relationship of man to man?" (Levinas, *Ethics and Infinity,* 80).

64. Emmanuel Levinas, "Substitution," in Levinas, *The Levinas Reader,* ed. Seán Hand (Oxford, England, and Cambridge, Mass.: Blackwell, 1989), 115.

65. Fanon, *Black Skin, White Masks,* 8, 10.

66. Ibid., 227. The French original reads: "Depuis longtemps, le ciel étoilé qui laissait Kant pantelant nous a livré ses secrets. Et la loi morale doute d'elle-même" (Fanon, *Peau noire,* 184), and alludes to Kant's famous stellar figure in the second *Critique.*

67. Carol Gilligan, *In a Different Voice: Psychological Theory and Women's Development* (Cambridge, Mass.: Harvard University Press, 1982). See also Seyla Benhabib, "The Generalized and the Concrete Other: The Kohlberg-Gilligan Controversy and Moral Theory," and "The Debate over Women and

Moral Theory Revisited," in Benhabib, *Situating the Self*, 148–202. It should be stressed that the critical positions Fanon occupied, whether in his capacity as a psychiatrist or political activist, labored under a phallocentric model of subjecthood. That he himself, therefore, was susceptible of the very same ethical transitivism is clear from several of his writings, for example, from the chapter, "The Woman of Color and the White Man," which *Black Skin, White Masks* dedicated to Mayotte Capécia's *Je suis Martiniquaise*, and from "Algeria Unveiled" (in Frantz Fanon, *A Dying Colonialism*, trans. Haakon Chevalier [New York: Grove, 1965]). For a critique of Fanon's "construction of a Creole masculinity and femininity," see Vergès, "Creole Skin, Black Mask;" for other feminist critiques of Fanon, including "Algeria Unveiled," see also Diane Fuss, *Identification Papers* (New York: Routledge, 1995) and Madhu Dubey, "The 'True Lie' of the Nation: Fanon and Feminism," in *differences* 10.2 (Summer 1998): 1–29.

68. In fact, in "The Politics of Recognition," Taylor identifies Rousseau early on as "one of the points of origin of the modern discourse of authenticity," later on as "one of the originators of the discourse of recognition," while pointing to the obliteration of differential positions that might follow from Rousseau's "general will." Taylor, "The Politics of Recognition," 35, 44, 48.

69. Ibid., 38 and 38n.

70. Ibid., 65.

71. Ibid., 66.

72. Ibid., 66–67.

73. It seems justified, in this context, to refer to the logic of forcible substitution that often informs conventional philosophies of translation. For an excellent account of how the idealistic trajectory of the self through the other has grounded theories and practices of translation, from Luther via Herder to Schleiermacher, and beyond, see Antoine Berman, *The Experience of the Foreign: Culture and Translation in Romantic Germany* (Albany, N.Y.: State University of New York, 1992). For an alternative model of multicultural translation that emphasizes how cultural difference—also, or especially, at the nonverbal corporeal level—resists being recuperated by the discursive norm, see Homi K. Bhabha, *The Location of Culture* (London and New York: Routledge, 1994).

74. Taylor, "The Politics of Recognition," 73.

75. G. W. F. Hegel, *Vorlesungen über die Philosophie der Geschichte* (Frankfurt a.M.: Suhrkamp, 1986), 540.

76. Mouffe, "Democracy and Pluralism," 1545.

77. Benhabib, *Situating the Self,* 8, 9.

78. Ibid., 9.

79. As Benhabib explains, "One thus avoids the charge of circularity: by allowing that the presuppositions of the moral conversation can be challenged within the conversation itself, they are placed within the purview of questioning. But insofar as they are pragmatic rules necessary to keep the moral conversation going, we can only bracket them in order to challenge but we cannot suspend them altogether." Benhabib's comments are made in the context of an attempt to overcome the charge of *petitio principii,* often directed at Habermas's universal pragmatics. As agonistic critics might argue, in turn, such a proposal does not solve the circularity, for it still presupposes that all participants univocally submit to the collective moral conversation, structured around universal respect and egalitarian reciprocity. (Seyla Benhabib, "Afterword: Communicative Ethics and Current Controversies in Practical Philosophy," in Seyla Benhabib and Fred Dallmayr, *The Communicative Ethics Controversy* [Cambridge, Mass., and London: MIT Press, 1990], 340.)

80. Ibid., 340.

81. Using a dialectical model, Balibar contends that "universalism and racism are indeed (determinate) contraries, and this is why each of them has the other one inside itself—or is bound to affect the other *from the inside.*" See Étienne Balibar, "Racism as Universalism," in Balibar, *Masses, Classes, Ideas: Studies on Politics and Philosophy before and after Marx,* trans. James Swenson (New York and London: Routledge, 1994),198.

82. Ibid., 204.

83. See Étienne Balibar, "Racism and Nationalism," in Étienne Balibar and Immanuel Wallerstein, *Race, Nation, Class: Ambiguous Identities* (London and New York: Verso, 1991), 64.

84. Habermas, *Philosophical Discourse of Modernity,* 414n.

85. Chantal Mouffe, "Decision, Deliberation, and Democratic Ethos," in *Philosophy Today* 41.1 (Spring 1997): 26.

86. Ibid., 28.

87. Ibid., 26.

88. As Mouffe puts it: ". . . while a pluralist democracy certainly requires a certain amount of consensus on the political principles that need to be shared by *all its members,* it is clear that those principles can only exist through competing interpretations that are bound to be in conflict. In other words, we will always be dealing with a 'conflictual consensus' and this explains why a pluralist

democracy needs to allow dissent on the interpretation of its constitutive principles" (Mouffe, "Decision, Deliberation, and Democratic Ethos," 27).

89. In this section, I further elaborate on Ernesto Laclau's suggestive observations about the ethical in his "Identity and Hegemony: The Role of Universality in the Constitution of Political Logics," forthcoming in Judith Butler, Ernesto Laclau, and Slavoj Žižek, *Universality, Hegemony, Contingency* (London: Verso, 2000). As he notes: "If the moment of the ethical is the moment of radical investment [. . .], two important conclusions follow. The first, that only that aspect of a decision which is not predetermined by an existing normative framework is, properly speaking, ethical. The second, that any normative order is nothing but the sedimented form of an initial ethical event. This explains why I reject two polarly opposed approaches which tend to universalize the conditions of the decision. The first are the different variants of a universalistic ethics which attempt to reintroduce some normative constant in the ethical moment and to subordinate the decision to such a constant, however minimal it could be (Rawls, Habermas, etc.). The second is pure decisionism, the notion of the decision as an original *fiat* which, because it has no *aprioristic* limits, is conceived as having no limits at all. So what are those limits which are other than aprioristic? The answer is the ensemble of sedimented practices constituting the normative framework of a certain society. This framework can experience deep dislocations requiring drastic recompositions, but it never disappears to the point of requiring an act of *total* refoundation. There are no places for Licurguses of the social order."

90. See also Judith Butler's comments on universalism, especially when she states that there is the need for "the continuing revision and elaboration of historical standards of universality proper to the futural movement of democracy itself." Formulated in a utopian way this means the "futural anticipation of a universality that has not yet arrived" (Judith Butler, "Universality in Culture," in Nussbaum, *For Love of Country*, 49).

91. Clearly, the process of globalization itself is extraordinarily intricate and polyvalent, as are the many uses to which the term has been put, whose opposite ends are defined, on the one hand, by a productive "cultural" globalization that emphasizes the increasing importance of so-called minority cultures on a global scale, and, on the other, by the suffocation of Third World economies and markets under the crushing weight of a normalized Western economy. For a lengthier discussion of these two contrasting uses of the term, see also my "Christo's Wrapped Reichstag: Globalized Art in a National Context," in *Germanic Review* 73.4 (Fall 1998): 350–67.

92. See Friedrich Nietzsche, *On the Genealogy of Morals and Ecce Homo*, trans. Walter Kaufman (New York: Vintage, 1989), 15.

On Cultural Choice

Homi K. Bhabha

One of the striking changes wrought by living in a multicultural society, and writing about it, is the way it alters our relation to the concept of culture. For much of our lives we consider culture to be a handmaiden to history: a mirror, or a screen, to social reality. Culture is the symbolic realm through which we enact a range of imaginative aspirations that may subvert our mundane lives or exercise alternatives that supplement the leaden prose of the world. We may choose between cultural options, but we do not, strictly speaking, "choose" our culture, because it is the representational medium through which we know, or make, our choices in the first place. It is hardly surprising, then, that a strange

self-consciousness comes upon us when our commitment to cultural rights in a multicultural society requires us to reflect upon the "right" to cultural choice.

The right to a culture, it is frequently argued, turns on the ethical and political freedom of "choice": the freedom to choose a cultural affiliation, the right to be free to constitute or preserve a culture, or indeed to oppose it by exercising the moral "right of exit." There are, of course, many social limitations to cultural choice—poverty, illiteracy, gender, economic hardship, patriarchal authority—but, for the moment, I want to examine what is entailed at the ethical and enunciative level by the concept of cultural choice. The act of choosing is formative of the image of "selfhood" that plays a normative role in liberal thinking, and influences what it means to be a social agent. But cultural "choice" is not a one-shot affair, Will Kymlicka tells us in *Multicultural Citizenship,* his influential work on cultural rights that has significantly shaped the discussion on group rights and liberal principles. "What is distinctive to the liberal state," he writes, "concerns the forming and revising of peoples' conception of the good, rather than the pursuit of those conceptions *once chosen.*"[1]

The liberal conception of the good requires that the originary, first act of choosing has to be supplemented by a second deliberative choice, a kind of doubling the stakes of choice, if you will. It is worth noticing that this liberal notion of choice is grounded in an iterative or supplementary logic: deliberative cultural choice only "knows" its freedom retroactively, once the revisionary choice has been made. So the freedom attributed to choice, within the liberal discourse, and to the autonomous individual subject that subtends it, is realized in a time-lag that exists *in-between* the supplementary sequence of choices. The deliberative act of choosing, so crucial to establishing the autonomy and punctuality of the free liberal subject, strangely

becomes a belated (*nachträglich*), retroactive inscription of individualism. Such a disturbance in the "time" in which the liberal subject is constituted as an agent of free choice complicates our understanding of culture as a medium of ethical, aesthetic, and political judgment. Acts of judgment that deliberate on the good life, or the good citizen, become particularly difficult when the cultural norms by which we orientate ourselves, and the codes by which we signify value, are themselves rendered indeterminate and contingent.

This leaves us with some compelling questions. Could the *nachträglich* temporality of choice have wider implications for the multicultural condition and the liberal conception of a common good? How does this temporality play out in the transnational context of migration in which societies are passing through a process of cultural and normative *translation* that, in the words of Walter Benjamin, represents "a continua [*sic*] of transformation not abstract areas of identity and similarity"[2]?

Recent writings on the ethics of migration and multiculturalism have had to deal with these conundrums of cultural "choice." For example, Teresa Sullivan poses these questions in her essay "Immigration and the Ethics of Choice" from the perspective of a political demographer with an interest in the ethics of migration.

> What does it mean to be a good immigrant? . . . Is the good immigrant the one who shares his material success with his comrades at home, or the one who invests in her own country? . . . Is the good immigrant the one who brings up assimilated children, or the one who preserves a bit of the culture of his homeland? Does the good immigrant imply obeying the laws of the host country, even its immigration laws?[3]

She then suggests that there are no clear answers or guidelines because the "social role of immigrant does not carry with it a lot

of normative expectations and several contradictory expectations are possible."[4] It is a feature of multicultural societies that there is, around the issue of cultural choice, an intensification of normative underspecificity and an indeterminacy in social and moral codes. In a similar vein to Sullivan's argument, Rainer Bauböck, the Viennese political theorist, extends Charles Taylor's notion of the politics of recognition to suggest that multicultural "objects of choice include the additional options of multiple membership and toleration of syncretic and hybrid practices."[5] More significant than the diversity of objects, according to Bauböck, are the disjunct temporalities—successive, cumulative, or continuous—that constitute social codes whose erratic signification of cultural norms further unsettle the grounds of deliberation and choice.

Bhiku Parekh further extends this line of thought to encompass issues of social theory and social policy with which he has been involved both as an academic and as an active participant in the formation of public policy on Asian migration in Britain. Parekh suggests that multicultural societies display a growing gap between "the so-called core and fundamental values" and "the structured realities of organized public life,"[6] such that the public sphere increasingly becomes located in an *intermediate* realm of operative public values. The pressure of incommensurate cultural choices applies itself to civic relations that are acted out in this operative sphere where dialogue can be fragile and overdetermined: "each [operational value] limits and [only] partly defines the contents of the others. They are embodied in institutions and practices that cannot be neatly catalogued or summarized. They are of varying degrees of generality, interpenetrate each other, and cannot be easily individuated."[7] The transformation of operative values depends upon interactions and interlocutions that "cause considerable moral and social disorientation"[8] between core and structure, norm and practice, rendering a multicultural existence irredeemably estranging to

self and other, host and stranger. All three of these writers ultimately ask what the prospects are for dialogues of tolerance across such landscapes of estrangement.

Clifford Geertz's Tanner lecture, "The Uses of Diversity," attempts to make an elegant response to this very issue. Geertz tries to transform the traditional concept of culture-as-self-containedness by taking on the responsibility of engaging with "strangeness" as constitutive of the very moment of cultural identification and ethical enunciation. Geertz asks us "to refocus our attention . . . and make us visible to ourselves by representing us and everyone else as cast into the midst of a world full of *irremovable strangeness* we can't keep clear of."[9] Such cultural strangeness cannot be contained or regulated in a binary representation of cultural difference. The problem is not, Geertz warns us, "the distant tribe enfolded upon itself in *coherent* difference,"[10] but a disjunctive, anxious terrain of "sudden faults and dangerous passages"[11] that produce moral asymmetries within the boundary of a "we." Such strangenesses are more oblique and shaded, less easily set off as anomalies than they are "scrambled together in ill defined expanses, social spaces whose edges are unfixed, irregular, and difficult to locate."[12] In Geertz's splendid summation: *"Foreignness does not start at the water's edge but at the skin's."* [13]

Too true. But what are we to make of the *amniotic* structure of cultural spacing—a watery skin if ever there was one? How are we to grasp a "difference" that is at once liminal and fluid? We have to account for a temporal movement that erases the enfoldedness of cultural containment and signifies an interstitial connectedness (not one cultural category or community opposed to another). When moral dilemmas that arise from the experience of cultural diversity are represented in spatial metaphors—ill-defined expanses, social spaces whose edges are unlocatable, uneven terrains, dangerous passages, clefts and contours—their "irremovable strangeness" tends to become normalized into

"coherent difference" and the ethical challenge is resolved as an epistemological issue. The language of spatialization provides an excellent *description* of the moral asymmetries that inhabit the "we" that lives out the multicultural condition, but Geertz ends by somewhat eliding the "irremovable strangeness" upon which he centers his interpretation of cultural difference in our time. Having so productively led us away from the ethnographic notion of epistemic cultural identities as symbolized in "the distant tribe enfolded upon itself in *coherent* difference,"[14] he returns to a description of our times that seeks—even if it does not find—the comfort of an enfolded form of cultural comparativism. From an Archimedian anthropological perch he writes that "the world is coming at each of its local points to look more like a Kuwaiti bazaar than like an English gentleman's club,"[15] instancing what are, to my mind—perhaps because I have never been in either of them—the polar cases. Geertz's landscape of difference finally requires the binary juxtaposition of bazaar and club to express the skeined asymmetries of "ethical" multiculturalism, even as he persuades us that we must learn to live with—within—an asymmetrical "We."

In contrast, the legal philosopher Joseph Raz advances a notion of "affirmative multiculturalism . . . without territorial separation"[16] to explore the impact of such asymmetries in the context of culturally and ethnically plural societies. Having begun this essay by opening up the question of cultural choosing as an interstitial, time-lagged process, I find it interesting to encounter a similar problematic of cultural choice in Raz's theory of "value pluralism": cultural practices, in affirmative multicultural societies, do not constitute successive or cumulative options "as if they come one by one,"[17] adding up to a whole integrated context. Multicultural ethical choice is articulated through "the core options that give meanings to our lives, [in the form of] dense webs of complex actions and interactions . . . the density of their details defy[ing] explicit learning or comprehen-

sive articulation."[18] The temporality of such cultural representation is neither synchronous, consensual, nor successive: social practices are "conglomerations of interlocking practices that constitute the life options." Effecting a choice in this context, Raz continues to make it impossible for the subject "to consider and decide deliberately . . . a lot has to be done, so to speak automatically. But to fit into a pattern, that automatic aspect of behavior [call it ideology, interpellation, subjectification, discourse] has to be guided, to be channeled into a coherent, meaningful whole."[19]

Raz's discussion of value pluralism is rent by a kind of discursive or enunciative split at the point at which it gives an account of what is involved in the process of cultural choice. One form of the conflict of choice, Raz argues, is endemic to value pluralism and consensual in nature. It maintains the moral mastery of the self and conforms to the mundane reality "that two values are incompatible if they cannot be realized or pursued to the fullest degree in the same life. . . . What one loses is different from what one gains . . . faced with valuable options . . . one simply chooses one way of life rather than another, both being good and not susceptible to the comparison of degree."[20] But "affirmative multiculturalism" can bring no such closure and composure to the subject of cultural choice. Its subjectivity is performatively constituted in the very tension that makes knowledges of cultural difference dense, conglomerative, and nondeliberative. What emerges is an agonistic and ambivalent subject of a double, decentered multicultural choice:

> Tension is an inevitable concomitant of accepting the truth of value—pluralism [in the context of affirmative multiculturalism]. And it is a tension without stability, without a definite resting point of reconciliation of the two perspectives, the one recognizing the validity of competing values and the other hostile to them. There is no point of equilibrium, no

> single balance which is correct and could prevail to bring
> the two perspectives together, one is forever moving from
> one to the one to the other, from time to time.[21]

My emphasis on the double and displaced nature of cultural "choice" attempts to unsettle the validation of the autonomic subject, as well as the divisions and distances through which it maintains its apodictic authority in matters of cultural judgment and identification. To reconstitute the question of choice, and relearn the language of freedom, requires that we not merely rethink the ends of freedom, but focus on the "middle"— culture as a media of in-betweenness. The structure of "double-and-displaced" choice is a narrative of the subject, discursive or practical, that occupies the space in-between making the initial choice and then effecting its iterative, revisionary double. Geertz describes such a cultural "strangeness" in the asymmetries that constitute cultures in-between and betwixt; Raz expresses another kind of estrangement in the tension and the torsion of value pluralism, its loss of a "single" balance, and its opening up of a double location of cultural value that emerges in the interstice between one perspective and another, and moves from one time to another.

The subject can no longer be imagined as a form of personhood that is prior to the cultural performance, standing apart from the social process, constituted as "consciousness" outside the material and signifying practices of texts, languages, institutions, political regulations, communal registrations, and psychic representations. The subject is not simply what you start with, as an origin, nor where you end, as a closure. The subject is a strategy of authorization and differentiation that produces an anteriority before the beginning, and a futurity beyond the end, where the present is the time of decision and choice, at once deliberate and disjunctive, at once survival and sovereignty. Or to put it in Hannah Arendt's words:

> Most action and speech is concerned with the in-between . . .
> which for all its intangibility is no less real than the world of
> things we visibly have in common. . . . Although everybody
> started his life by inserting himself into the human world
> through action and speech, nobody is the author or pro-
> ducer of his own life-story. In other words, the stories, the
> results of action and speech reveal an agent, but this agent is
> not an author or producer. Somebody began it and is its sub-
> ject in the twofold sense of the word, namely actor and suf-
> ferer, but nobody is its author.[22]

Arendt's more general speculations on authorship and agency
—the subject in the two-fold sense of the word —has a specific
resonance for the "in-between" that reveals itself in the tense
timbres that sound in the dialogues of culture's "difference." The
subject of multiculturalism is riven by a tension between the
politics of recognition and what I will call the poetics of identifi-
cation. The furor between ethnocentric "essentialists" and those
who are labeled postmodern "performance" theorists should not
be understood as a disagreement centered on the question of the
necessity of "identity": Is an identitarian "essence" crucial for
social agency, or is agency more effective when its seen as a dis-
cursive effect, a social and linguistic practice? This wasting
argument about *who or what* "is" the subject ignores a far more
significant contemporary question about *where* the "subject" of
difference lies: Is the moment of differentiation internal to the
history of a culture and integral to its communal existence? Or,
are cultural differences to be read as borderline, liminal
"effects," signs of identification produced in those translational
movements in which minorities negotiate their rights and repre-
sentations?

"Recognition" claims that the cultural respect sought by
minorities represents an ontological right. The right of recogni-
tion is founded on the assumption that a culture may lose its

social status or its political autonomy but it can still preserve the sovereignty of its "self-presence," its potential for human freedom and self-representation. According to this view, a culture's quiddity, its singular "difference" that needs to be protected and propagated, is already "in place" within the normative, naturalizing structures of a culture's most enlightened self-understanding. The "value" of a culture may indeed be distorted by dissent within the community, or discredited in cross or intercultural relations, but to set that to rights requires a mode of interpretation committed to authenticating and authorizing that culture's presence by illuminating its indigenous genius or its universal resonance.

The poetics of identification strives to represent the process through which intercultural relations *in-between* class, gender, generation, race, religion, or region are articulated as hybrid identifications. As it lays no claim to an originary self-presence, a poetics of identification has no access to a moral or mimetic measure of cultural authenticity. What would it mean, then, to represent a minority in terms of an intersective or interstitial cultural presence—how would cultural differences come to be signified in the passage between cultural particularities? From the perspective of such questions of identification, a culture can only know itself when it "works through" those shards that unsettle any easy sense of solidarity or community: the inequalities of power, the anomalies of authority, and the incommensurable choices that afflict the "common" good. Such articulations of cultural difference—whether they are affiliative or antagonistic—can only be achieved by acknowledging the fact that judgments across cultures reveal not only the discontinuities between cultural systems but display the contingent and arbitrary frameworks of value *within any one cultural system*. A poetics of identification seeks to make a connection between cultures at this level of "internal contingency" so that linkages are not based on an ontological right to "self-presence."

Linkages are instead ethical projects that acknowledge the need to take responsibility for those subjects of alienation and antagonism, those elements of perverse particularity that striate the social surface and indelibly mark, even marginalize, its self-presence with an "irremovable strangeness." Unlike the notion of recognition, which assumes that cultural value is, indeed, *in place*, requiring only just conditions of representation and recognition, a poetics of identification puts *in play* the question of the location of cultural difference, its modes of representation, and *who* or *what* might be authorized to be its signifying subjects. Take the following example: the "difference" of gender as articulated in and through the dialectic of class division. Taking into account the racial economy of labor would require a productive *mis-recognition* of each mode of minority identification—gender, class, race—as they come to signify an emergent, hybrid identification—"black socialist feminism." For the poetics of identification, the process of constructing a collectivity, or a solidarity, of political causes—gender, class, race—requires that each sign of identity be made to confront the contingent and multicausal identifications that constitute agency in complex, democratic societies.

What we might describe as a minoritarian mutuality (rather than coevality) attempts to avoid the particularism of identity politics, for the poetics of identification suggests that one identifies with individual or group differences in a "second person" relation. In other words, the *I of self-presence or self-interest* is relocated or conjugated through the locution of a *You*, which is a "voice" that comes from the borderline of the other's difference, and guards against cultural exceptionalism or exclusion. Such a double and disjunctive identification of the *I* and the *You* engenders a form of cultural membership that may be worked into a contingent form of community. Contingency, in this sense, is neither a postmodern deferral of "identity" *tout court* nor that Pollyanna pluralism that celebrates "multiple

identities." What is at stake in the agonistic and ambivalent splitting of the minoritarian subject—I/You—is the emergence of a spectral or virtual "third" position that mediates the relation of self to other and facilitates what Arendt describes as the subject in the "two-fold" sense of the word. The subject as a two-fold process—the I as a part of, but not equivalent to, the You—exceeds the first- or second-person perspective. Such a process of doubling, or self-distanciation, has to be read as the slippage between "persons" *within* the same subject of utterance. When the "I" addresses itself *as if* it were a "You," or vice versa, there ensues an effacement or displacement of any notion of social enunciation as a direct expression of one's cultural self-presence or one's unmediated selfhood. Speaking of oneself *as* an other, in the two-fold movement of the subject, demands a moment of objectification—a relation of thirdness—in which I and You can only relate to each other through a circuit that passes through the wider circle of collective social and cultural forces. The third "person" involved in the relay of the I/You is a recognition of the intersubjective realm as the signature of sociality; it constitutes social agents, aligns them in relation to each other, makes possible the two-fold relationship of I/You, but cannot itself be personified in the speech-act.

Multicultural contingency is a *temporality* of cultural representation and judgment that expresses the tension between recognition and identification. As Raz warns us, there is no point of equilibrium, no single balance. We cannot simply "choose" between an ontological self-presence and an ethical mutuality, for the temporal displacement between the *I* and the *You* within any act of cultural identification is also the territory in which the other's difference installs itself as an ethical proximity. Furthermore, the ethicality of this minority movement, between distance and proximity—or distance *as* proximity—lies in our willingness to accept that, in different times and places, we may be the subjects and the objects, the actors and

the sufferers, of our culture and another's. This is an ethical gesture that Emmanuel Levinas locates deep in the heart of cultural meaning itself: "Cultural meaning is taken to occupy an exceptional place between the objective and the subjective—the cultural activity disclosing being; the one that works the disclosure, the subject, invested by being its *servant and guardian*."[23]

It has been the burden of this essay that we are, as Arendt named us, subjects in the two-fold sense of the word, and that we must learn both to survive and aspire to that condition of subjectivity. As we move between recognition and a poetics of identification, from the one to the other, from time to time, we have to learn another kind of balance that requires us to be at once inside and outside the minority group; somewhere in-between self-respect and the criticism of the "other." Minorities[24] are often offered only the most disciplinary and normalized spaces of representation—the stereotype, the statistic, the survey, the report, the statute, the documentary, to say nothing of being the objects of virulent forms of hate speech. I would suggest that the tendentious, self-critical joke—"a rebellion against. . . authority, a liberation from its pressure"[25]—might be a strategy of cultural resistance and agency committed to a community's survival.

Read as a minority speech-act, the joke circulates around a doubly articulated subject: the negatively marked subject, singled out, at first, as a figure of fun or abuse, is turned through the joke-act into an inclusive, yet agonistic, form of self-critical identification for which the community takes responsibility. At one level, the subject of the jest (*sujet d'enonce*) is the object viewed from an alienating, foreign perspective. Such an extrinsic glance, like the carceral colonial gaze, shares a strategic desire to "destructure" the minority culture in a way that echoes Frantz Fanon's description of the colonizers' practice of "cultural mummification . . . [that] testifies against its members. . . .

It allows no cultural confrontation. There is on the one hand a culture in which qualities of dynamism, growth, and depth can be recognized. As against this we find characteristics, curiosities, things, but never a structure."[26] Working within and against the jesting subject is the differently disposed subject of the joke-work (*sujet d'enonciation*)—less a "person" than an "anonymous" enunciative process or position, involved in the circulation of puns, proverbs, jokes, the common knowledge of popular life. The aim of the subject of the joke-work is to revivify the mummified, imprisoned image of the minority culture by recasting the sign of identity "singled" out for brutal fun into a relational signifying system of cultural identification. This is how Freud describes the particular labor of the tendentious, self-critical joke-work:

> The intended rebellious criticism is directed against the subject himself, or to put it more cautiously, against someone in whom the subject has a share—a collective person, that is (the subject's own nation for instance). The occurrence of self-criticism as a determinant may explain how it is that a number of the most apt jokes . . . have grown up on the soil of Jewish popular life. The jokes made about Jews by foreigners are for the most part brutal comic stories in which a joke is made unnecessary by the fact that Jews are regarded by foreigners as comic figures. The Jewish jokes which originate from Jews admit this too; but they know their real faults as well as the connection between them and their good qualities, and the share which the subject has in the person found fault with creates the subjective determinant . . . of the joke-work"[27] (156–57).

Self-irony as a minority gesture does not consist in "balancing" the extrinsic and intrinsic view in some proposed zero-sum game of cultural equity played out between universalism and relativism; nor does it lie in the binary confrontation of cultural

insiders and outsiders—Self and Other—each straining to achieve a more holistic or authentic identity at the expense of the other. Through the very performance of the self-critical joke-work there *emerges* a structure of identification—what Freud calls "the subjective determination of the joke-work"— that provides a way for minority communities to confront and regulate the abuse that comes from "outside" or the criticisms that emerge from within the community itself. These negative perceptions are different both in kind and quality, but the "self-critical" posture allows them to be represented without a defensive drawing of the boundaries around ethnicity, customary experience, social victimage, or other forms of cultural essentialism or historical exceptionalism. In fact, the performative act of "sharing in"—"the *share* which the subject has *in* the person found fault with"; "someone *in whom the subject has a share*—a collective person, that is [the subject's own nation, for instance]"[28]—is a mode of communal identification where cultural affiliation results from an ambivalence that afflicts the authority, and authorization, of those limits that establish the location and locution of cultural boundaries. *To share in* is to participate communally, to associate in fellowship; *to have a share in* assumes, at the same time, a contradictory process of division, partialization, and separation. The affect of the joke-work, its structure of feeling and phrasing, arises from the interleaved dissemblings of the joke-work, caught in the interstices between these double subjects of "sharing."

Sharing in the "collective person"—nation, group, community—becomes an iterative act of communal membership where self-recognition—the *I*—is conjugated through double-identification as the *You*. To establish its own cultural presence, self-recognition has to turn upon an encounter with alterity prior to affirming the affiliative bond which, like "joking as a *play* with one's words and thoughts is to begin without a person as an object . . . as though the self did not feel certain in its

judgment on the point."[29] Unlike the death-dealing mummifying gaze of the racist and its fixated images of otherness, the self-critical community, poised on the knife-edge of ambivalence, discerns the transformative moment of "difference" moving restlessly in-between culture's antagonistic aspect and its agonistic self-apprehension. To have a *share in* the collective person is to resist both the homogeneity and horizontality of communal experience.

There can be no synchronous entry of social difference into the communal habitus. To represent one's interests as a group or a community, to have a share within the wider social circle, demands the iterative practice of the self-critical joke-work. Its affiliative articulation—making connections between the community's real faults and its good qualities—is a highly mediated, tendentious process that emerges from the ambivalence generated by the double "subject" of the jest, and remains unavailable to a transcendent, Archimedian perspective. For the formation of the self-critical community is predicated on the repetition of the instance of cultural alterity that is neither disavowed nor suppressed but worked around—just like the starting point of the self-critical joke, which is, at first, a play without a person as its object. Such a process of rearticulation or transvaluation makes the self-critical community the ground for a complex and productive "cultural confrontation" (no cultural simplification for the victimized, warns Fanon). The value in belonging to a community, or signifying a sense of collective solidarity, does not lie in cultivating some deep structure of cultural authenticity conserved in the homogeneous empty time of Tradition. A productive cultural confrontation lies in the ability to negotiate the ambivalent liminalities of a culture, its perceptual and experiential boundaries. A community's "real fault," its internal contradictions, or a "singled out" subject of difference, becomes the passageway through which a "negation" turns into the basis for a negotiated share in a collective person. Such a passageway

must be kept open for a range of border-crossings and cross-border identifications so that, in that iterative process, the community may be re-membered.

In the performance of the joke, timing is all; jokes can be repeated again and again, because although each time the punch line comes in at the same point in the story line, it occurs at a different moment of utterance, within a changed trajectory of telling and timing. The cultural text of the joke, the knowledge of intimate recollection held in common by the community—an element of which is at first alienated, singled-out, in order then to be re-membered—may be recognizable, but it is its renegotiation that enables it to function as an effective sign of cultural identification. Such collective identification depends for its efficacy on the temporality of enunciation, the contingent "time" in which cultural "faults" and "virtues" are translated and rearranged to accommodate emergent, hybrid subjects and values. This is why the self-critical community resists the regulative and rebarbative function of an orthodox Tradition that polices jesters and banishes poets.

In all seriousness, the tendentious joke-work raises an issue fundamental to the performance of "truth" as an ethical and social practice.

> The more serious substance of the joke is the problem of what determines the truth. . . . Is it the truth if we describe things as they are without troubling to consider how our hearer will understand what we say? Or is this only jesuitical truth, and does not genuine truth consist in taking the hearer into account and giving him a faithful picture of our own knowledge? . . . What [such jokes attack] is not a person or an institution but the certainty of our knowledge itself, one of our speculative possessions.[30]

Laying aside the validity of the distinction between jesuitical truth and genuine truth, the "uncertainty" that the joke casts on

the production of knowledge goes beyond mimetic or epistemological paradoxes. It attaches to the very mode of *address* of modern thought which, as Foucault once pointed out, "is itself an action—a perilous act."[31] For Freud, the action of the joke is its relentless drive toward the "third person," who is neither the joker nor the person who is the object of the joke, but an "outside person" whose reaction makes evident the pleasure or success of the joke "as though the self did not feel certain in its judgment on that point."[32] In light of my concern with the self-critical minority, the uncertainty or indeterminacy of modern knowledge becomes an *act* of cultural survival and historical renewal. To take the hearer into account is to share *in* the making of a "collective person"—nation, community, group—from the ambivalent movement that circulates in-between first and third persons. To be the first person is to be the witness, the victim, the actor, bound to the event and perhaps blinded by it. To be the third person—the "outside person"—is to be the hearer, the overseer, the assessor, in an interstitial yet evidentiary position. But the first person who shares the experience feels a deep uncertainty in its judgment, and the third person who has a share *in* the experience has the freedom to speculate with what is only partial, piecemeal, fragmented.

The ironic wisdom of the joke-work lies in its emphasis on the two-fold nature of the subject. The play between first and third persons, or the relay between the *I* and *You*, makes us alive to the fact that it is by accepting our irremovable strangeness that we learn to live with one another. It is my hope that the example of survival and solidarity enunciated in the self-critical joke will allow the memory-work of our multicultural future to be carried out somewhere between tears and laughter.

NOTES

1. Will Kymlicka, *Multicultural Citizenship* (Oxford: Clarendon Press, 1995), 82.

2. Walter Benjamin, *One Way Street and Other Writings,* trans. Edmund Jephcott and Kingsley Shorter (London: Verso, 1985), 117.

3. Teresa A. Sullivan, "Immigration and the Ethics of Choice," in *International Migration Review,* Vol. 30, no. 1 (Spring 1996): 98.

4. Ibid., 98.

5. Rainer Bauböck, "Cultural Minority Rights for Immigration," in *International Migration Review,* Vol. 30, no. 1 (Spring 1996): 209.

6. Bhiku Parekh, "Minority Practices and Principles of Toleration," in *International Migration Review,* Vol. 30, no. 1 (Spring 1996): 251.

7. Ibid., 261.

8. Ibid., 266.

9. Clifford Geertz, "The Uses of Diversity," in *Michigan Quarterly Review,* Vol. XXV, Number 1 (Winter 1986): 121.

10. Ibid., 117.

11. Ibid., 119.

12. Ibid., 121.

13. Ibid., 112.

14, Ibid,. 119.

15. Ibid,. 121

16. Joseph Raz, *Ethics in the Public Domain: Essays in the Morality of Law and Politics* (Oxford: Clarendon Press, 1994), 172–74.

17. Ibid., 177.

18. Ibid., 177.

19. Ibid., 176–77.

20. Ibid., 180.

21. Ibid., 180.

22. Hannah Arendt, *The Human Condition* (Chicago: The University of Chicago Press, 1958), 182–84.

23. Emmanuel Levinas, *Collected Philosophical Papers,* trans. Alphonso Lingis (Dordrecht: Martinus Nijhoff Publishers, 1987), 82.

24. An earlier version of this argument appeared elsewhere as a part of the fore-

word to *Modernity and the Jew,* ed. Bryan Cheyette and Laura Marcus (Stanford: Stanford University Press, 1998).

25. Sigmund Freud, *Jokes and Their Relation to the Unconscious,* trans. and ed. James Strachey, ed. Angela Richards (New York: Pelican, 1976), 149.

26. Frantz Fanon, *Towards the African Revolution,* trans. Haakon Chevalier (New York: Pelican, 1970), 44–45.

27. Freud, op. cit., 156–57.

28. Ibid. My emphasis.

29. Ibid., 196–97.

30. Ibid., 161.

31. Michel Foucault, *The Order of Things: An Archeology of the Human Sciences* (London: Tavistock Publications Limited, 1970), 328.

32. Freud, op. cit., 196.

Atttitude, Its Rhetoric

Doris Sommer

*e*ducated readers naturally feel entitled to know what they're reading, to know it, often, with the conspiratorial intimacy of a potential partner. Even when we remember that literature participates in the asymmetries of power, it rarely occurs to us that readers, friendly and eager as we are to please, may be the targets of a text, not its coconspirators. My advice is to be careful. Otherwise we'll continue to mistake the incompetence that distinguishes us as particular readers for a challenging horizon that we can and should overcome. Some texts mean to sting readers, to stop those of us bent on intimacy and to direct us toward a different engagement, one that makes respectful distance a reading requirement. The slap

of refusal from unyielding books can slow readers down, detain them at the boundary between contact and conquest, before they press particularist writing to surrender cultural difference for the sake of universal meaning. The very familiarity of universalism as measure of literary worth, while its codependent term *particularism* still sounds strange to contemporary criticism,[1] shows how one-sided interpretation has been, even when we read "minority" texts. If learning makes the distance between writers and readers seem superficial or circumstantial, mere interference on the way to understanding, particularist writing puts circumstance to work, resurfacing the stretch with fresh stop signs.

Those signs can go unnoticed because they have no rhetorical names. Until now rhetoric has assumed a cultural continuity between orator and audience, between writer and reader.[2] John Guillory reminds us that professional reading depends on noticing signs of literary convention. We critics and teachers are trained to recognize the rhetorical work in a work of art; and this makes us wary and reflective about the "lay" pleasures of a text.[3] I want to add that wariness should include self-reflexivity about our own training in rhetorical conventions, because training has stopped at an extraordinarily limited vocabulary, a hopelessly myopic lens that cannot read particularist performances. "Competent" reading, as we have practiced it, squints at the range of tropes and language games that demand attention to degrees of literary uncooperativeness.

Naming some figures of cultural discontinuity is my purpose here, to contribute toward a rhetoric of particularism that will appreciate artful maneuvers for marking discursive distances. I'd like to frame this discipline-specific exercise as a response to colleagues who have turned to ethics in order to reflect on a range of cultural and political analyses. My possibly exorbitant hope is that attention to the most basic features of literariness can again be useful as well as pleasing. Artfulness, perceived

through conventions, is literary criticism's evidence of an artist, an agent.[4] Perceptible choices, readable tropes, evidence of grooming, these leave traces of intention and agency [like the purposefully imperfect transvestism of hairy chests under evening gowns that Baudrillard prefers over acts that pass for the real thing].[5] Visible brushstrokes produce the kind of esthetic effect that I would like to call "good-enough beauty."[6] It is a beauty that keeps a distance from paradigms to operate in the margin for esthetic "error" that opens up when contingency interferes with intentionality.[7]

Winnicott endorsed mothers who nurture but don't smother children. Mothers who preserve a measure of their own independence demonstrate their externality from children, and construct a distance in the relationship, a necessary distance for love to flow between mother and child. *An Essay on Exteriority,* Levinas's sometimes overlooked subtitle for *Totality and Infinity,* underlines distance as the imperative condition for ethics.[8] Ontologies of the self colonize externality, he complained; they send philosophical speculation into concentric and totalizing circles around the knowing subject who overwhelms the external body and therefore misses any opportunity for ethics, or for love. Love is "a relationship with what forever slips away."[9] The good-enough (in mothers, in lovers, artists, and subjects of civil society) is attractive, but mercifully underwhelming. It elicits responses and leaves room to respond. Good-enough beauty is seductive enough to engage us, but not overpowering in ways that would beam us into another, ecstatic, dimension where boundaries blur between text and readers. Artfulness decenters the subject differently. With its visible traces of before and after, its loose ends and stray hairs, the makeover revels in its intentionality. The effort shows. If we overlook the effort, either by magnanimously misconstruing the performance as a universally discernible object of admiration, or by fixing it into an essential representation of a culture foreign to us, we will demur from

engaging with the performer. That is why the flash of immutable perfection, through the romantic symbol, filled Walter Benjamin with fear and disdain for irrational and irresponsible esthetics.[10] Artfulness should incite entanglement, precisely because the artist calls attention to his or her talent for tangling. Are we concerned that noticing the rhetorical ploys will neutralize them? Do we fear that interpreting unfamiliar gestures of control will upset the strategy? Literary seductions surely survive interpretation in nonexotic writers; the pleasure of reading stays even when professional readers stop to reflect on it. Resourceful interlocutors are not so fragile as to fear the very engagements they invite. The point is that their invitations are conditional, attentive to the conditions of unequal exchange. They elicit esteem. Unlike respect, which is universally conferred by moral imperative, esteem is earned to varying degrees, in the situatedness of ethical encounters.[11] And, in the situatedness of generally asymmetrical relationships, entanglement is not friendly. Irreducible alterity makes political parity practically unthinkable; and procedural justice in the "public sphere" cannot avoid normative impositions.[12]

Particularist writing invites these admissions, between the flattery and seductions that keep us engaged. Antagonism, to put it simply, is built into the asymmetries between texts and readers; it hopes to get a hearing long enough to win some ground in the struggle for rights and resources. The operative esthetic for antagonistic, or politely offputting, postures includes a set of conventions for reminding powerful interlocutors of the inequalities they would rather forget. And the name for these literary and locutionary conventions is what we popularly call "attitude." Attitude performs the differential between histories of readers and texts that come together at some moments and syncopate at others.

Meaning can skip a beat, break communication so that words are no longer bridges; they don't *pontificate,* Maurice Blanchot

would say;[13] instead strategic words can suddenly freeze and
thaw in a *syncope,* a term that Catherine Clément takes from
musical notation (and from its medical meaning of "apparent
death") to name a political or philosophical interruption of pre-
dictability. Disencounters are not only a nuisance to universal
understanding; they are also enabling signs for reading the his-
torical and cultural embeddedness of texts and of readers.
Differently situated and consequently limited understanding is
news only to those who mistake their particular situatedness for
a universal setting. Well-meaning readers who hope to over-
come limits through empathy and learning aren't harmless
when they violate difference. Without difference, writer and
reader are ultimately redundant. One will do. Today's literary
criticism is hardly scandalized by the reduction as readers dis-
appear authors, despite the clamor of some texts against the
author's dismissal by self-authorized critics. The reduction
cheats those readers too. It robs them of the aesthetic particu-
larity, the distinctive charm or bite, of some books. The formal
experiments and aesthetic thrill of particularism's seductive and
defensive tousle with universalism are lost on readers who don't
get them because they don't expect them. To compound the loss,
they will also miss opportunities for extraliterary confrontations
in a public sphere. Can difficult dialogues follow from an educa-
tion that conflates conflict into collaboration? Learning to read
for historically constituted difference, that is, learning to toler-
ate attitude, is a civic obligation. Otherwise we cannot hope to
hear citizens whom we should not presume to know.

Particularist writing interrupts intimacy with unfriendly
noises and identifies itself through announcements of limited
intimacy and access, through gaps in communication that tell a
reader where to stop. Toni Morrison describes them as
"absences so stressed, so ornate, so planned they call attention
to themselves; arrest us with intentionality and purpose."
Paradoxically, the arrested reader gains access that a more

strident approach would have missed, access to "the question of cultural (or racial) distinction." Disruption performs the discontinuity that opens the space between particular histories, like a *slap* that interrupts an *embrace,* in Morrison's analogy between music and the rhythm of her writing.[14] It syncopates communication and heightens the pleasure of the next embrace with the poignancy of dependence and the thrill of an anticipated sting. In other words, the undisputed but underanalyzed "pleasure of reading" is often a specifically masochistic pleasure. We are more likely to enjoy a rebuff than to admit the antagonism of the gesture.

Absences can, of course, incite the fill-in work that keeps a reader self-important, if limits are misread as the difficulty, ambiguity, or complexity that demands interpretive labor and rewards readers with proof of their own competence. But if we let them, absences can also fissure comprehension (which still means grasping, seizure) to release readers from the exorbitant (and unethical) but usually unspoken assumption that we should know Others enough to speak for them. Released and relieved from that obligation, we may wonder at the persistence of our desire to overtake otherness. Noticing the aggressive desire will be the point, before we rush to redirect energy. Stopping short is a step in the syncopated rhythm of engagement offered by particularist books. That's the way *El hablador* (*The Storyteller*) begins, with a start, a shock, a double take. "I came to Firenze to forget Peru and the Peruvians for a while, and behold, the damned country forced itself upon me this morning in the most unexpected way."[15] Before the narrator identifies himself as a writer named Mario Vargas Llosa, before he has any attributes, subjectivity, background, or future, he responds to Peru. The character is constituted by responding to the Other, in this syncopated moment of choosing to leave and being taken aback.

This Levinasian parable shows that one doesn't freely "turn to ethics," despite the recent rush that many suspect to be an evac-

uation from politics.[16] Instead one is turned, hailed, interpellated by a command to attention, as I have been hailed by books that refuse to play conspiratorial games with the reader. To follow Levinas, willfully *taking* the turn, locating oneself as the subject of activity, vitiates any claim to ethical conduct. Ethics means demoting the self to serve the Other, to be the hostage object of the Other subject. It means facing up to the Other's demands and leaving ontology behind, because theorizing the world in function of the self cannot escape "egolotry." But I am skeptical about categorical commands that cannot respond to particular seductions and that conflate precritical respect with differentially earned esteem. The hostage is suspiciously hard at work, flattening uneven gestures into equal-opportunity stimuli for self-limitation. The requirement assumes privilege, not debt; it suggests what Jewish mystics called *tzimtzum* to describe God's loving self-diminishment in order to make room for creation.[17]

It is dangerous not to notice differences, and unethical to demur entirely from exchanges that may contaminate difference. Cultural relativists can claim a freedom from the controlling behavior of colonizers, a freedom that amounts to irresponsibility when it refuses to respond to seductions and demands. Perhaps they will overread the signs of difference to fix them into evidence of exoticism, incomprehensible and untouchable. And colonizers who decline to know the Other surely suspect that knowing more would compromise their colonial control. Yet literary studies proceed as if readerly control were not a political concern. The concern, of course, is that literature can incite a desire to control the subject who has written and the subjects represented. A frustrated incitation to interpret, a lure to contemplate difficulties along with prohibitions against explaining them away, these can confront readers with their own desire to burn away difference. Obstacles to that desire can become signposts of a measure of autonomy. Obstacles enable something different from control; they summon the kinds of interpretive labor

that accept the burden of difference instead of wishing it away. Until now, the challenges of literary criticism to the congealed practices of language have been more hermeneutical than ethical, more goads to achieving masterful propositions than opportunities to detour from heady approaches.

Once we register the damage wreaked by propositional reductions, Wittgenstein sighed, "We feel as if we had to repair a torn spider's web with our fingers."[18] With this helpless image he haunts us with the delicate contingency of meanings. This is an ethical warning; it is about doing damage, after all. Worry should be part of interpretive work, if we learn to read the performances of strategic distance written into some ethnically marked literature. A variety of rhetorical moves can hold presumptively unmarked readers at arm's length, or joke at their pretense of mastery, in order to propose something different from knowledge. Philosophers have called it acknowledgment. Others invoke respect. I want to call it availability for feeling esteem, a specifically aesthetic appreciation for artfulness and agency that might expand perceptions of an active citizenry.

The essays I have written over the last years are invitations to develop an unlikely program of training in the modesty and tolerance for limitations that enable engagements between discontinuous histories. These are premodern postures that postmodern negotiations will need to revive. I call the program unlikely, even if sensitive leads have already shown how to tread with one step in and one step out of competence.[19] In our enlightened traditions learning still assumes a substantive object or a self-authorizing method, not a vulnerable comportment. We learn something. But particularist books require postures that resist the epistemological desire that drives readers toward data, postures that hold back the impulse to overrun oppositions that allegedly get in the way of understanding. Oppositions are features of understanding; they need time and space to do the productive work of distinguishing between Self

and Other so that these can be interlocutors (not avatars). Amassing data or dismissing them, either way we have wanted to share so much of what the author has Said that we can pretend to assume whatever he or she assumes. This Whitmanian rush of easy intimacy wants no dialogue, is deaf to the Saying, and stays lonely; it imagines democracy to be a unitary spirit of the people, something to celebrate. The lessons in listening for surprises, in pausing before they are neutralized, the training to stretch our expectations of difference and to tolerate silence, these may be universal markers of serious literature,[20] but they are particularly provocative today in some ethnically colored authors and in culturally self-conscious white ones. The problem, as I have been saying, is that our culturally relativist habits of reading don't prepare us for rhetorical surprises. Universalizing readers don't often expect particularist language games to stray beyond demonstrations of sincerity and authenticity. My observations are not about subalterns who vent anger undetected by the masters, as James Scott describes them;[21] nor are they about a different set of yet unnamed, ethnically inflected tropes that exclude standard readers from insider jokes, as Homi Bhabha is developing them. (Think, for example, of Roberto Fernández's Mrs. Olsen who says "Thanks!" for the boniato, while she pushes her Cuban neighbor toward the door. "For nothing," answers Barbarita.)[22] The tropes of obstruction are meant to be noticed by outsiders. They are stop signs. Universalists who mistake their setting for the universe need obstacles to notice the boundaries, perhaps to stumble, and then to step more carefully.

Strategic interference in communication, to put it bluntly, can be a necessary condition for ethical behavior. Neither the more nor the less powerful party behaves responsibly by discounting the difference between them. Nevertheless, defenders of "coercion-free" linguistic action, in the line of Hannah Arendt, refuse this concession to disruption, to what she called a form of

"violence." Arendt's *Human Condition* hoped to rehabilitate politics from all forms of disruptive interference, and "to establish intersubjective relationships free from violence."[23] But the absolute distinction between violence and politics that she assumes is too rigid, according to Jürgen Habermas, who otherwise sustains her dedication to communicative ethics; it takes an outmoded Aristotelian (linguistic) notion of praxis as the entire "practical" realm, and then reduces politics to that narrow activity: "Arendt pays the price of screening all *strategic elements* out of politics as '*violence,*' severing politics from its ties to the economic and social environment in which it is embedded via the administrative system, and being incapable of coming to grips with appearances of *structural violence.*"[24]

To recognize some pertinent disruptions in communication, it will help to invent provisional names for the recurring tropes. These will include: (1) *required bilingualism,* (2) *syncopation,* or the *interruptus,* (3) *the torn web,* (4) *saturation,* (5) *white-out,* (6) *flaunted secrets,* and (7) *the hundred gates* (what the Hebrew concept of multiple precautions calls *meá shearim*).

I'll barely mention an example each, since I've developed them at length elsewhere, and invite you to recover other instances.[25] Starting with the trope of *(1) incompetent monolingualism,* consider *The Ballad of Gregorio Cortez.* The film's dramatic center is a bilingual scene of shooting the sheriff. Played without subtitles, it leads monolingual viewers to misconstrue explanations until a long-delayed translation produces a gasp of embarrassment. It was the Law's presumption of competence (which implicates the credulous viewer) that precipitated the violence.[26] *(2) Syncopation,* or the *interruptus,* is a trope that frustrates expectations (for example, that a talking cure will help) when a trauma victim wisely refuses to satisfy impertinent curiosity. Remember Sethe as she circles the kitchen, and the issue, after Paul D *(3) tears the web* with his demand that she confess her damaging story in *Beloved:* "she could never close in, pin it down for anybody who

had to ask. If they didn't get it right off—she could never explain."[27] "The Good Soldier Schweik" is a master of *(4) saturation,* a trope that overwhelms the genre of confession and that wears out his interrogators with so much detail that it is impossible to tell what piece of his tedious report matters.[28] Jesusa Palancares does the same, before she shuts the door on readers who insist on taking her life. ("Fuck off, now. Let me sleep.")[29] *(5) White-out* refers to the doubt that colored narrators inflict on white competitors who defer to, or defend against, Black informants. Cirilo Villaverde's abolitionist novel, *Cecilia Valdés,* dramatizes the deafness of privileged Cubans when the novel delays the articulate slaves who are willing to tell the incestuous story that the white narrator and his mulatta heroine refuse to put together.[30] And Julio Cortázar's "The Pursuer" has Charlie Parker dismiss whatever his French biographer knows ("And furthermore, cool doesn't mean, even by accident ever, what you've written")[31] in order to make the white man nervous, to wrest control over his own life from the scholar who presumes to take it down. Their mutual demand for recognition conjures the Hegelian tension between master and slave; but it also confronts any pretense of dialectical resolution. Nothing is resolved until one of them dies. The opportunities for deconstructing the differences between them are warnings, for Parker, of his fragile autonomy. In order to live, artist and critic had locked each other into a performance of insoluble codependence.[32]

(6) Flaunted secrets names a border trope, between self and other, to limit intimacy whether or not information is withheld. Offering information belongs to more than one language game, in the rhythm of slap and embrace that wrests esteem from desire. Consider this passage from Frederic Douglass's *Narrative:*

> I deeply regret the necessity that impels me to suppress any thing of importance connected with my experience in slavery. It would afford me great pleasure indeed, as well as

materially add to the interest of my narrative, were I at liberty to gratify a curiosity, which I know exists in the minds of many, by an accurate statement of all the facts pertaining to my most fortunate escape. But I must deprive myself of this pleasure, and the curious of the gratification. . . .[33]

It was Rigoberta Menchu's 1983 *testimonio* that first taught me how attention-getting reluctance can be.[34] Courteous but uncompromising, she guarded secrets in each of the short ethnographic and autobiographical chapters. Finally, I sensed that her wordy silence on issues that might not have otherwise concerned me was delivering a redundant message: "You don't own me." Ten years later, now a Nobel Peace Prize laureate speaking on indigenous rights at Harvard University, Rigoberta again flaunted secrecy as a signature of her performance style: In the question period, the first query came from a student who introduced himself as Lebanese, perhaps to invite a solidarity between one misunderstood foreigner and another. He asked if Rigoberta would translate her opening words, spoken in an incomprehensible language for us, presumably in Maya Quiché. "No," was her simple answer. "They're untranslatable." "Do they have any meaning?" pressed the student. "Profound meaning," she assured him, but untranslatable. But once her secrecy syncopated the exchange, and preserved her externality from sympathetic listeners, the conversation survived this "apparent death." Rigoberta spoke again, elaborating on her greeting, explaining the formulae that honor each listener individually, by relation to her and to others. These were Maya Quiché formulae, and through them she was performing the cultural expertise that helped to legitimate her leadership in indigenous rights. Interrupting translation was evidently, and effectively, a gesture that safeguarded the privilege of her expertise; it demands recognition, in the way that quotes in Latin might shore up the claim of expertise by a theologian.

Emmanuel Levinas knew that externality depends on the *interruptus* that secrecy performs: "The real must not only be determined in its historical objectivity, but also from interior intentions, from the secrecy that interrupts the continuity of historical time. Only starting from this secrecy is the pluralism of society possible."[35] In other words, only by underlining the available spaces for exit is the exercise of voice properly esteemed. And Jean-François Lyotard explains that "The suspension of interlocution imposes a silence and that silence is good. It does not undermine the right to speak. It teaches the value of that right."[36]

Secrets perform the paradox of being constructed by the subject and of somehow preexisting that construction; they participate in the unspoken contract that both acknowledges the constructedness, and agrees not to interpret away those border "objects." Transitional tropes of secrecy, then, can link the outer and inner worlds visibly, audibly, so that the distance is both perceptible and negotiable. Readers who press Rigoberta for the narrow authenticity of truth-telling (and there have been many) miss the point and override the person.[37]

With these tropes, and no doubt others still to be named, writers can maneuver texts into unanticipated passes that make even bullish readers stop to ponder the move. The performances can wrest control from readers who may be enchanted by the surprising turns and feel disoriented, dependent, even relieved from the anxiety of needing to know it all. Then the hard work of interpretation can begin; it will attend to what cannot or should not be explained away, because culturally differentiated limits on interpretation can be the very information that should fuel contemporary rhetorical analyses. Reading for historically constituted and asymmetrical particularism in texts—and in our own situated responses—is the urgent task on our multicultural agenda. Otherwise, "minority" texts will continue to be celebrated or denigrated in universalist (essentialist) terms, instead of making a difference.

A power adjustment will be preliminary to possible interpretations and political dialogues. Because, if critics don't break the universalist habit of thinking that they should know more and interpret better than the particularist authors they target, dialogue may turn out to be a posthumous challenge with a dead author. Without telling limits, can an ethnically marked, "minority," or unconventionally gendered writer hope really to engage an authoritative reader? In writers whom postcolonial theory calls subaltern, agency or "subject-effect" is felt mostly in the performance of boundaries. Without them, the imperial I would take in more space. And thanks to those boundaries, the I avoids lonely monologues because the You is stubbornly present.

I call the prologue to *Proceed with Caution* (1999), on the rhetoric of particularism an *Advertencia*/Warning, inspired by one such colonial subject. He is the first mestizo chronicler of Peru, known by the oxymoronic name of El Inca Garcilaso de la Vega, an excessive and unstable mix of indigenous royalty and Spanish nobility. In masterful Spanish, Garcilaso performed wonders with prefaces. His magic was to multiply the conventional first move, adding one prologue after another to keep readers at the threshold. Distance is the redundant message of the trope of *(7) a hundred gates;* after the prologue-dedication "To the Most Serene Princess" follows a "Preface to the Reader" that discounts Spanish historians because they know so little about Peru. Then, still holding back—so that the stance itself is a message of control—Garcilaso adds his *Advertencias* about the general language of the Indians that Spaniards will never master, despite some laudable exertions by Jesuits. Now *advertencia* is the standard term for preliminary advice to the reader, although here it is pluralized to multiply the barriers. But the popular English translation neutralizes the word into "notes" ("notices" would be better), perhaps associating it with "advertize," a term of open and welcoming information. In Spanish, though, the association is

more legal than commercial, more cautionary than welcoming. *Advertencias* are warnings.

If one stops to think about it, the rhetorical restraints and barbs at aggressive appropriations are all plausible. But literary criticism has seldom stopped to think about the ravages of facile intimacies; it has not paused to hear the invitations to tangle, issued between the wariness and refusal that amounts to "attitude." Particularist literature would logically try to occupy a central importance while holding off universalists who would claim coauthorship. But our culture of criticism takes the underdeveloped practices of "reader response" theory as basic and unobjectionable. The "strategies of containment" that claim our attention here would defend cultural difference as a value in itself.[38] It is the *differend*, the stubborn residue that survives in the margins of normalizing discourses. Acknowledging that residue is the condition of possibility for democratizing confrontations because it admits the asymmetry of power. Difference safeguards particularist identities against seamless assimilation, a word that rhymes with neutralization and sometimes also with physical annihilation.

Is inhospitality toward readers, or our demotion, surprising? Then it merits a pause long enough to learn new expectations. Mistrust is a productive feature of some literary seductions and other social engagements, but we have too often and blithely wished away the persistent signs. Educated readers usually expect to enter into collaborative language games with a range of writers, as if asymmetrical relationships flattened out on the smooth surface of print culture. But particularists can counter those expectations with less flattering and more promising games. Instead of offering stories that become ours by dint of effort, they invite us to play variations on follow-the-leader. Perhaps we can learn to step differently, to respect distances and explore the socially and intellectually enabling possibilities of acknowledging our own limits.[39]

More steps should follow from listening for attitude, but it would miss my point about cautious engagement to predict what those steps will be. Instead, I want to stay at the first stage as an exercise in stamina for reading the reluctance that we have rushed to overcome. The intention is—of course and paradoxically—to refine readerly competence, not to dismiss it. The improvement will be substantial. It will be to notice the tropes of particularism as invitations to engage, to delay, and possibly to redirect the hermeneutical impulse to cross barriers and fuse horizons. If we manage to include among our reading requirements the anticipation of strategic refusals, because differences don't reduce to moments in a universal history of understanding, this will be no minor adjustment, but a halting and more promising approach.

NOTES

1. Particularism is a word I borrow from historians to name cultural embeddedness in experience and circumstance. It was also a favorite term of New Critics, but for them it meant inimitable originality available for universal appreciation. See Allen Tate and Stephen Knapp's recent book on the universalist particular.

2. See, for example, Richard A. Lanham's useful *Handlist of Rhetorical Terms*, 2nd ed. (Berkeley: University of California Press, 1993).

3. John Guillory, "The Ethical Practise of Modernity: The Example of Reading," in this collection.

4. This is what Homi Bhabha implies in his focus on creative choices in the performance of heterodox identities. When static notions of "cultural respect" detain the creative movement to fix it, when those notions overlook the decisions made between voice and exit, they paradoxically discount the agent of volatile performances and demote active subjects into untouchable objects of reverence. See Homi Bhabha, "On Cultural Choice," in this collection.

5. Baudrillard, *Seductions*.

6. I offer this in the Winnecottian spirit that Barbara Johnson invokes in her essay "Using People," in this collection.

7. See Alan Singer, "Beautiful Errors: Aesthetics and the Art of Contextualization," *boundary 2* 25:1 [*Thinking through Art: Aesthetic Agency and Global Modernity;* a special issue coedited by Daniel T. O'Hara and Alan Singer] (Spring 1998): 7–34. This critique of both classical perfectionism and of avant-garde estheticism (in its untranslatability) targets the assumptions of universalism in favor of contextualization.

8. Emmanuel Levinas, *Totality and Infinity: An Essay on Exteriority,* trans. Alphonso Lingis (Pittsburgh: Duquesne University Press, 1969).

9. Emmanuel Levinas, *Le Temps et l'Autre,* 78.

10. Walter Benjamin, *Ursprung des deutschen Trauerspiels.* The English translation, *The Origin of German Tragic Drama,* is by John Osborne (London: NLB, 1977). "Allegory and Trauerspiel" is on 159–90. See also Beatrice Hanssen, *Walter Benjamin's Other History: Of Stones, Animals, Human Beings, and Angels* (Berkeley: University of California Press, 1998).

11. Nancy Fraser, "Recognition without Ethics?" in this collection.

12. Chantal Mouffe, "Which Ethics for Democracy?" in this collection.

13. Maurice Blanchot, "Interruptions," trans. Rosmarie Waldrop and Paul Auster, 43–53.

14. Toni Morrison, "Unspeakable Things Unspoken."

15. Mario Vargas Llosa, *The Storyteller,* trans. Helen Lane (London and Boston: Faber and Faber, 1989); *El hablador* (Barcelona: Seix Barral, 1987), 3.

16. See Marjorie Garber, Beatrice Hanssen, and Rebecca L Walkowitz, "Introduction" in this collection.

17. Given the human capacity for violence, self-effacement is the condition for relationship which begins with "After you, sir!." No doubt intended as a variation of the selfless "Here I am" in Abraham's exemplary dedication to God, Levinas's "After you" assumes that the speaker could claim priority, but chooses not to. See Levinas, *Ethics and Infinity,* 88.

 This choice is like the liberal's self-constraint on reading "fragile" minority literature, advocated by Peter J. Rabinowitz. See his "'Betraying the Sender': The Rhetoric and Ethics of Fragile Texts," *Narrative* 2:3 (October 1994): 254–67, where he worries that his reading of Nella Larsen's *Passing* has "tampered with a finely wrought text in such a way as to damage it" (202). He understood the book's secret (that it was about lesbianism passing for heterosexuals), and divulged it. Thanks to Irene Kacandes for this article.

18. Ludwig Wittenstein, *Philosophical Investigations,* 106.

19. See, for examples, Henry Louis Gates on *The Signifying Monkey,* and Stanley E. Fish, *Surprised by Sin: The Reader in Paradise Lost* (Berkeley: University of California Press, 1971; orig. Macmillan, 1967) on Milton's victimization of readers.

20. This is the gambit that Sacvan Bercovitch theorizes in "Games of Chess: A Model of Literary and Cultural Studies" in *Centuries' Ends, Narrative Means,* ed. Robert Newman (Stanford, Calif.: Stanford University Press, 1996), 15–57.

21. James C. Scott, *Domination and the Arts of Resistance: The Hidden Transcript* (New Haven, Conn.: Yale University Press). His earlier work had attended to rebellious activities, but this one focuses on speech acts as if they merely contained trouble, without causing it. See his *The Moral Economy of the Peasant: Rebellion and Subsistence in Southeast Asia* (New Haven, Conn.: Yale University Press, 1976); and his *Weapons of the Weak: Everyday Forms of Peasant Resistance* (New Haven, Conn.: Yale University Press, 1985).

 My criticism coincides with Sherry B. Ortner's general objection to ethnographies that demote or dismiss the resistance they target. See her "Resistance and the Problem of Ethnographic Refusal," *Comparative Studies in Society and History* 37:1 (January 1995): 173–93.

22. Roberto G. Fernández, *Raining Backwards* (Houston: Arte Publico Press, 1997), 86.

23. I am grateful to Beatrice Hanssen for this quote and for her argument in "The Politics of Pure Means: Benjamin, Arendt, Foucault," in *Violence, Identity, and Self-Determination,* ed. Hent de Vries and Samuel Weber (Stanford, Calif.: Stanford University Press, 1997), 236–52. See Jürgen Habermas, "Hannah Arendt: On the Concept of Power," in *Philosophical-Political Profiles* (Cambridge, Mass.: MIT Press, 1983), 173.

24. Habermas, *Profiles,* 179.

25. *Proceed with Caution, When Engaged by Minority Writing in the Americas* (Cambridge: Harvard University Press, 1999).

26. See Doris Sommer, "Cortez in the Courts: The Traps of Translation from Newsprint to Film," in *Media Spectacles,* ed. Marjorie Garber, Jann Matlock, and Rebecca L. Walkowitz (New York: Routledge, 1993).

27. Toni Morrison, *Beloved* (New York: New American Library, 1988), 163.

28. I thank Kim Sheppele for this association; the variable spelling Schweig and Schweik is part of the point of Czechoslovakian mongrelization of several languages.

29. "Taking A Life: Hot Pursuit and Cold Rewards in a Mexican Testimonial

Novel," *Signs*, 20/4 (Summer 1995): 913–40.

30. Doris Sommer, "Who Can Tell?: Filling in the Blanks for Villaverde," *ALH* 1994 6:2, 213–33.

31. Julio Cortázar, "The Pursuer," "The Pursuer," trans. Paul Blackburn, in Cortázar, *Blow-Up and Other Stories* (New York: Collier Books), 161–220. The quotation is from 208. The Spanish original is "El perseguidor," in Cortázar, *Las armas secretas* (Bueno Aires: Sudamericana, 1959), 149–313 [300].

32. See Doris Sommer, "Grammar Trouble: Cortázar's Critique of Competence," *Diacritics*, 25:1 (Spring 1995): 21–45.

33. Frederick Douglass, "Narrative of the Life of Frederick Douglass," in *The Classic Slave Narratives*, edited and with an introduction by Henry Louis Gates, Jr. (New York: Mentor, Penguin Books, 1987), 243–331. The quotation is from 315.

34. Rigoberta Menchú, *I Rigoberta Menchú: An Indian Woman in Guatemala*, edited and with an introduction by Elisabeth Burgos-Debray, trans. Ann Wright (London: Verso Editions, 1984), 1. Originally published as *Me llamo Rigoberta Menchú y así me nació la conciencia* (Barcelona: Ed. Argos Vergara, 1983).

35. Levinas, *Totality and Infinity*, 57–58.

36. Jean-François Lyotard, "The Other's Rights," in *On Human Rights: The Oxford Amnesty Lectures 1993*, ed. Stephen Shute and Susan Hurley (New York: HarperCollins, 1993), 136–47. The quotation is from 142.

37. David Stoll is the most ardent crusader for authenticity among Rigoberta's readers. He summarizes his book about her *testimonio*, forthcoming from Westview Press, in "Life Story as Mythopoesis," *Anthropology Newsletter*, (April 1998): 9–11. After paragraphs of quibbling over details, over the difference between fact and myth (the way that historians quibble with details of Bartolomé de las Casas's version of the *Destruction of the Indies*), Stoll writes: "Rigoberta was not known to most fellow Mayas until the left began to publicize her as a Nobel candidate in 1991. But many warmed to the idea that one of their own was being honored internationally, as a symbol for what so many had suffered. Her story also had broad appeal to the many ladinos who have had similar experiences with the Guatemalan state. If poetic truth is good enough for you, this is the part of her story that is all too true" (9).

38. Strategies of containment is a term from Fredric Jameson's *The Political Unconscious*, where it refers to neutralizations of political energy. Here I use the term to name defenses of political difference.

39. The challenges are legible and audible from so many directions that the focus

here on literature from the Americas, mostly Spanish America, shows the limits of my own circumstances and interests. Like Sander Gilman's *Jewish Self-Hatred*, this book could have followed many different leads from literary traditions that others know better than I. Gilman's focus on Jews is almost fortuitous, autobiographical, he says, since any "marginalized" culture produces self-hatred to the extent that minorities participate simultaneously in a majoritarian culture that hates them. During my own childhood in Brooklyn, we had a bad name for Jews who were so embarrassed by ethnicity that they chose not to claim it. They were "white Jews," troubled and untrustworthy. Whatever utopian or democratizing ideals may have tempted us all toward assimilation, "whitening" was, to many of us, a hasty price for a distant prize. So instead, like Garcilaso and like the Jewish philosopher of love whom he chose to translate, we preferred to weave back and forth, glad to fit into universal culture when we could, but loathe to give up the anchor of a "native" condition.

My "mosaic" New York sometimes showed volatile cultural conditions that demanded acknowledgment and negotiation. Years later, I circle back to the first step, listening for the limits of culturally embedded positions.

Cosmopolitan Ethics
The Home and the World

Rebecca L. Walkowitz

osmopolitan ethics has returned. An ideal invented by the Cynics and the Stoics and pursued in the Enlightenment, it is serving widely today as a model of international affiliation. The contemporary philosophers and cultural theorists who elaborate this model often disagree about its applications, but they share in their differences, if not a singular "ethics," a rhetoric of ethical urgency. Recent cosmopolitanisms seek to establish principles of interpretation and encounter in the context of cultural diversity and political conflict, yet these principles are often formulated within and

through the interactions they serve to manage. Indeed, theorists regularly invoke works of literature and other cultural artifacts to exemplify ethical paradigms, even as these paradigms seek to make visible, if not suspect, such acts of exemplarity. It is this relation among ethics, literature, and cosmopolitanism that I wish to consider.

For Martha Nussbaum, an advocate of Kantian cosmopolitanism, the "universal values of justice and right" define a common and primary "allegiance" to "the worldwide community of human beings." This allegiance is formed in the imagined uniformity of "values" and the exclusion of "morally irrelevant" particularisms, such as religion or country of origin. Cosmopolitanism thus cultivates, writes Nussbaum, the eagerness "to understand humanity in all its strange guises."[1] Critics of Nussbaum's program, many of whom offer their own versions of cosmopolitanism, reject just this kind of even collectivity and comfortable "understanding" as the presumptive universalism of universalism, the notion that Western humanism will be found, intact, in the cultures it subsumes.[2] Instead, Bruce Robbins suggests, cosmopolitanism might register its own pluralities in the multiple attachments and particularisms that form its "actual" existence in the world.[3]

As the singular "cosmopolitanism" of Kantian philosophy becomes the plural "cosmopolitanisms" of multicultural variety, "ethics" and its normative demands are often set aside but rarely abandoned. Even those accounts of cosmopolitanism that reject the language of universalism, as Amanda Anderson has argued, may find their way back to its imperatives all the same. Such accounts, Anderson writes, articulate "intellectual programs" that are in fact "ethical ideals for the cultivation of character and for negotiating the experience of otherness."[4] These ideals, on all sides, are figured as an ethics of imagination.

Elaine Scarry has noted that the Kantian allegiance to a worldwide community, and the values it is meant to maintain,

depends on the cosmopolitan's ability to imagine other people, those far away whose injury one must conceive as one's own.[5] This is the "understanding" that Nussbaum seeks to promote. In the alternative vision, however, a cosmopolitan perspective is defined by its recognition of the differences it cannot assimilate and the distances it cannot, entirely, cross. Where "ethics" is invoked, cosmopolitan practices typically demand one of two scenarios: an imagined association between cosmopolitans and the culture they situate elsewhere, or a refusal to transgress, perhaps a refusal to imagine at all. Either way, these practices generate theories of affiliation that are also theories of reading: they evaluate and deploy acts of description, interpretation, appropriation, and exclusion—the acts that make affiliation possible.

Doris Sommer proposes a practice of reading that recognizes the particularism of particularist objects, the way that some texts, she posits, distinguish themselves by the readers they will not admit, by their resistance to universal interpretation. In this view, the distance between text and reader is either conquered or, as Sommer has put it, "esteemed."[6] Whereas Sommer turns to "particularist" texts to record an anti-universalist resistance, Martha Nussbaum locates her argument for universalism in literature she associates with worldwide allegiance. Nussbaum transforms an international narrative into a theory of idealized internationalism. She chooses for her example *The Home and the World*, a novel published in 1919 by Rabindranath Tagore and later produced as a film, directed by Satyajit Ray, in 1984. Although one character in the story does describe an allegiance to universal "Right" that takes priority over the "worship" of "country," the text allegorizes and thus unsettles the distinctive locations that its title proposes.[7]

I want to address this allegory and its unsettling effect to suggest that the particularism or universalism of individual works of literature, their placement in the world and relation to their readers, may be the contested subject rather than the confirmed

context of their narratives. Ray's film and Tagore's novel, positioned by Nussbaum as texts promoting universalism, are suggestive also about the kind of particularist affirmation that Sommer advances. Because *The Home and the World* examines the allegiances—patriotic and cosmopolitan—it might help to forge, it demonstrates the undernoticed inventions of local, as well as international, uniformity. Rather than finding a proper, ethical relation to the foreign or familiar cultures that texts are thought to represent, we might notice how this kind of localizing, placing, and situating is what literature may narrativize and disorient. One thinks in this respect of novels by contemporary writers such as Salman Rushdie or Kazuo Ishiguro, whose narratives defamiliarize the conventional languages and settings we associate with "English" texts. These kinds of works resist ethical readings based either on distance or proximity by revising the positions that characters and readers think themselves to inhabit. Similarly, Satyajit Ray's film of *The Home and the World*, with Bengali dialogue and English subtitles, repeats in its opening scene, in a scene of translation, the disparate conditions of its cosmopolitan narrative. It is to this text that I wish to turn in order to offer, by way of my own example, the ethical fictions that make a cosmopolitan ethics—universal or particularist— difficult to apply.[8]

Ray's film situates its Bengali narrative, set in colonial India, with an untranslated reading of English poetry. That this is strange may be lost on English-speaking viewers who fail to notice in a moment of comfort that a "foreign" language within a "foreign" soundtrack has made them right at home. In this initial scene, there is no single position of inside or outside: for the viewer who understands English, the foreignness of the poem may be missed; for the viewer who lacks English, the poem is unavailable but its exclusions are all the better known. An extended credit sequence and a two-minute voice-over precede this episode, but the English reading initiates conversation and

establishes the stories the film will tell.

The subject of the reading is a Jacobean madrigal, intoned with reverence and deliberate care by the educated patriarch, Nikhil. Nikhil addresses the madrigal to his wife, Bimala, who does not read, speak, or understand English. The poem is not identified in the film, though its reading immediately follows Bimala's description—she is the film's narrator—of her husband's "Western education." The poem, it would seem, is what this education facilitates:

> *Love not me for comely grace,*
> *For my pleasing eye or face,*
> *Nor for any outward part,*
> *No, nor for my constant heart,*
> *For those may fail, or turn to ill,*
> *So thou and I shall sever:*
> *Keep therefore a true woman's eye,*
> *And love me still, but know not why—*
> *So hast thou the same reason still*
> *To dote upon me ever!*[9]

The text is unremarkable, one might say, both because Bimala, in her linguistic ignorance, cannot engage with it and because it, as a poetic object, does not command much engagement.[10] "Love me not for comely grace" is an artifact of "English tradition," synonymous in Ray's film with the content of a "Western education." Nikhil would distinguish between his "country" and the "Right" that is "far greater than" his home, but his "home," as his reading habits suggest, is a place already Anglicized, seen through a "Western" education that everywhere inflects the cosmopolitan position he represents. Where particularist boundaries are least asserted, in Nikhil's philosophy and in his poem, they are nevertheless rendered in the specificities of universal affiliation.

The Englishness of Nikhil's poem is affirmed in *The Home and*

the World by its quotation in a Bengali context, where it is most distinguished by the cultural contrast its oration affords. Like, for instance, the very-English "afternoon tea" Virginia Woolf imagines in a South American resort,[11] the madrigal is peculiarly, emphatically localized by its "foreign" invocation. For Bimala, listening to words she cannot understand, and for viewers, watching her listen, the English poem registers only as "English poem." It is, in a sense, an empty signifier, marking the exchange—the fact that exchange cannot take place—between Nikhil and his wife.

The poem is a lesson in ignorance: what Bimala and viewers learn is a difference in English understanding, that some have it and some do not. Even assuming, as I do, that some of the film's audience does indeed "have it," whether or not they also speak Bengali, the fact that a "foreign" reading has taken place is confirmed by Nikhil's immediate question to Bimala: "Did you understand?" I take this question rhetorically, as Nikhil wanting her to recognize that she is missing something, that she does not know English and should want to learn it. I also take the question literally, as Nikhil wanting her to appreciate the affect of his love even though she cannot grasp the content, where "Did you understand?" is not a question about the specific words at all. These meanings seem to pull in opposite directions—at once toward the poem and away from it—and they reflect the incongruity of Nikhil's instruction, which associates the values of English knowledge with the imperatives of immutable, ethical ignorance. The obligation of indiscriminate affiliation is articulated through the privilege of cultivated taste.

Nikhil's poem itself affects a conflicted cosmopolitanism. His recitation, in its English fluency, implies the necessity of knowledge and reading, but the text advocates, despite its itemization of particulars, a Platonic love based on intellectual distance and relinquished curiosity. In this sense, the differences that Nikhil's cosmopolitanism would approach and seek to understand do

not, in a significant way, *count* as differences, since they are separate from and secondary to the structure of allegiance that finds them. Where a particularist ethics does not cross boundaries, a universalist ethics may ignore what it finds there. Thus, it is not that "comely grace" and "constant heart" should be overlooked by "a true woman's eye," they should be irrelevant to it. The poem does not say, "it does not matter"; rather, it says, "do not consider." "Love me still but know not why" suggests, importantly, not a higher or worthier object of love in lieu of grace, eyes, face, part, or heart, but that which will not, or cannot, be specified, a something neither "outward" nor inward, a something that is closest, in many ways, to nothing. Nikhil would teach Bimala to appreciate English poetry for herself, or at least for him, but she best follows the poem's lesson—love without reading, devotion without question, allegiance without particularism—when she seeks not to understand it. The poem's cosmopolitanism is very particular, indeed.

The self-styled cosmopolitanism of *The Home and the World* ultimately depends on the uneasy encounter between one invented place and another, between public and private, between a conventional England and an invented "Motherland." What Edward Said calls the "specific situation" of a work, its particular location in the world, is thus difficult to describe here, since it is precisely that—the home, the world, the situation—which the narrative most seeks to explore, in its plots of rising nationalism, modernization, and ethnic conflict.[12] Moreover, the perceived content of the narrative is inseparable from the cultural contexts that have directed its reading, first as a novel and later as a film. Aijaz Ahmad argues this point, and illustrates it, when he remarks that any given work by Tagore is "patently canonical and hegemonizing inside the Indian cultural context" but taught in the West "as a marginal, non-canonical text, counterposed against 'Europe.'"[13] In the West, where he was the first person of color to win the Nobel Prize, an "Indian"

from within the British Empire, Tagore is exceptional;[14] in Bengal, where his family made its fortune in early trade with the East India Company, where he supported British rule into the 1920s, Tagore seems rather continuous with the "Europe" he is said to infiltrate.[15] His very name, "Tagore," contains in its origins an appropriation or adaptation that takes the form of translation: the novelist's ancestor, called "Thakur" ("holy lord") by Bengalis as a term of respect, became "Mister Tagore" in the mouths of English merchants unable to pronounce the vernacular honorific.[16] Tagore, one might say, records a difference between East and West he is otherwise thought to transcend.

Perhaps because his plots seem "international" rather than "particular," some readers have included Tagore in the tradition of English literature. Whether or not these readers are right in this presumption, or even in their sense of what constitutes a genuinely "particular" perspective, the contested locations of Tagore's writing point toward the variable conditions of localized narrative. Tagore's biographers note that a Macmillan edition of his work published in 1936 gives no indication whatsoever that its English writings are translated from Bengali texts; moreover, in 1984, a book on T. S. Eliot claimed the American-born poet as "the sixth Briton" to win the Nobel Prize for Literature, after Kipling, Tagore, Yeats, Shaw, and Galsworthy.[17] Tagore's texts exist, in their reputation and circulation, somewhere between England and Bengal; it is the English accessibility of his Bengali writing, its diverse cultural idioms and literal translation, that has made Tagore "marginal, non-canonical," and, indeed, cosmopolitan.

The resistance to universalism in the uneven languages and locations of texts may be a resistance, also, to particularism. Approaching the home and the world, readers may find it difficult to legislate an enduring, ethical relation to objects whose cultural distance is irregular, unmeasured, or changeable—as changeable, say, as the writer's migration, the reader's mobility,

a nation's reorganization or dissolution, the text's translation and circulation. When it comes to cultural difference, theorists of ethical reading often assume both its fact and its definitive estrangement. In the recognition of particularism, whether they seek to overcome or to respect it, readers may fail to account for an object's intervention in, and transformation of, the proximity it is thought to lack. Only by coming to terms with this intervention can we assess the principles of affiliation that literature may be said to demonstrate.

NOTES

1. Martha C. Nussbaum, "Patriotism and Cosmopolitanism," in Martha C. Nussbaum with Respondents, *For Love of Country: Debating the Limits of Patriotism*, ed. Joshua Cohen (Boston: Beacon Press, 1996), 4–9.

2. See Bruce Robbins, "Cosmopolitanism and Boredom," *Radical Philosophy* 85 (September/October 1997): 28, and Judith Butler, "Universality in Culture," in Nussbaum and Respondents, *For Love of Country*, 51–52. Not all of the critics of this model, it should be said, offer an alternative cosmopolitanism in its place. For critiques of "cosmopolitanism" and its antinationalist sentiments, see other respondents in *For Love of Country*; Timothy Brennan, *At Home in the World: Cosmopolitanism Now* (Cambridge, Mass., and London: Harvard University Press, 1997); and Pheng Cheah, "Introduction Part II: The Cosmopolitical Today," in *Cosmopolitics: Thinking and Feeling the Nation*, ed. Pheng Cheah and Bruce Robbins (Minneapolis and London: University of Minnesota Press, 1998).

3. Bruce Robbins differentiates new work represented in his volume by describing its subject as "actually existing cosmopolitanisms." See Bruce Robbins, "Introduction Part I: Actually Existing Cosmopolitanisms," in Cheah and Robbins, *Cosmopolitics*, 2–3.

4. Amanda Anderson, "The Divided Legacies of Modernity," in Cheah and Robbins, *Cosmopolitics*, 269–75.

5. Elaine Scarry, "The Difficulty of Imagining Other People," in Nussbaum and Respondents, *For Love of Country*, 99.

6. Doris Sommer, "Attitude, Its Rhetoric," in this volume.

7. Nussbaum, "Patriotism and Cosmopolitanism," 3. Rabindranath Tagore, *The*

Home and the World, trans. Surendranath Tagore, translation revised by Rabindranath Tagore (New York: Macmillan, 1919), 20.

8. J. Hillis Miller has argued, much as I might here, that "storytelling" and "narration" are inseparable from the topic of "ethics." For Miller, however, this is a justification for literature that maintains "ethics" as a consistent category, whereas I argue here for its inclusion in the repertoire of local fictions. J. Hillis Miller, *The Ethics of Reading* (New York: Columbia University Press, 1987), 5–11.

9. *The Home and the World*, dir. Satyajit Ray: Bengali, with English subtitles, 1984.

10. The madrigal, as a genre, is a ditty of sorts, little composed in England after the mid-seventeenth century, though popular as "revival" since the eighteenth century. One prominent reviewer has mistaken this poem for the work of John Milton, but the author is in fact the rather more anonymous John Wilbye, whose madrigals were widely available in the early twentieth century, when the film's story takes place. The poem was first printed in John Wilbye, *The Second Set of Madrigals to 3.4.5. and 6. Parts* (London: 1609). It was later included in Palgrave's *Golden Treasury*, reprinted at least twenty-two times in the nineteenth century alone. See "Introduction" by Allan Abbot in Francis Turner Palgrave, *The Golden Treasury* (New York: Charles E. Merrill, 1911), 159. For the "mistaken reviewer," see Ian Buruma, "The Last Bengali Renaissance Man," *The New York Review of Books* (November 19, 1987): 14.

11. See Virginia Woolf, *The Voyage Out* (London: Harcourt Brace, 1920), 121.

12. Edward Said has argued that texts are distinguished by their "specific situation" in the world. For Said, this "situation" is something more internal than "context" but not equivalent to "the textual object itself." Edward Said, "The World, the Text, and the Critic," in *The World, the Text, and the Critic* (Cambridge, Mass.: Harvard University Press, 1983), 39.

13. Aijaz Ahmad, *In Theory* (London and New York: Verso, 1992), 197.

14. I take these details about Tagore's Nobel Prize from Krishna Dutta and Andrew Robinson, *Rabindranath Tagore: The Myriad-Minded Man* (London: Bloomsbury, 1995), 187 and passim.

15. For discussion of Tagore's family background, see Dutta and Robinson, *Rabindranath Tagore*, 18–19.

16. Dutta and Robinson, *Rabindranath Tagore*, 18.

17. Dutta and Robinsion, *Rabindranath Tagore*, 5–6.

Contributors

HOMI K. BHABHA holds the Chester D. Tripp Distinguished Service chair in the Humanities at the University of Chicago and is Visiting Professor in the Humanities at University College, London. Author of *The Location of Culture* (Routledge, 1994) and editor of the essay collection *Nation and Narration* (Routledge, 1990), Bhabha has recently finished a book on "The Quasi-Colonial," which is forthcoming from Harvard University Press. He is currently at work on *A Measure of Dwelling*, a theory of vernacular cosmopolitanism.

LAWRENCE BUELL is John P. Marquand Professor of English at Harvard University, author of *The Environmental Imagination* and other books and articles about the literature and culture of the United States, and coordinator of the special 1999 *PMLA* issue on the ethical turn in literary studies.

JUDITH BUTLER is Maxine Elliot Professor in the Departments of Rhetoric and Comparative Literature at the University of California, Berkeley. She is the author of *Subjects of Desire: Hegelian Reflections in Twentieth-Century France* (1987), *Gender Trouble: Feminim and the Subversion of Identity* (Routledge, 1990), *Bodies That Matter: On the Discursive Limits of "Sex"* (Routledge, 1993), *The Psychic Life of Power: Theories of Subjection* (1997), *Excitable Speech* (Routledge, 1997), as well as numerous articles and contributions on philosophy, feminist and queer theory. Her most recent work on Antigone and the politics of kinship is entitled *Antigone's Claim: Kinship Between Life and Death* (forthcoming 2000)

NANCY FRASER is Henry A. and Louise Loeb Professor of Politics and Philosophy at the Graduate Faculty of the New School for Social Research and coeditor of the journal *Constellations*. Her books include *Justice Interruptus: Critical Reflections on the "Postsocialist" Condition* (Routledge, 1997) and *Unruly Practices: Power, Discourse, and Gender in Contemporary Social Theory* (1989). In 2000, she will publish *Adding Insult to Injury: Social Justice and the Politics of Recognition* and *Redistribution or Recognition? A Political-Philosophical Exchange*, coauthored with Axel Honneth.

MARJORIE GARBER is William R. Kenan, Jr. Professor of English and Director of the Humanities Center at Harvard University. She is the author of numerous books and essays on topics in literature, cultural criticism, and theory. Her books published by Routledge include *Vested Interests, Shakespeare's Ghost Writers,* and *Symptoms of Culture.*

JOHN GUILLORY is Professor of English at New York University and the author of *Cultural Capital: The Problem of Literary Canon Formation.* He is currently writing on the history

of literary study as a discipline and its relation to the growth of the professional-managerial class in the United States.

BEATRICE HANSSEN was trained in comparative literature at the Humanities Center, Johns Hopkins University, and is Associate Professor of German at Harvard University, where she also teaches in the Literature Program and Comparative Literature. She publishes in the fields of aesthetics, critical theory, literature, and philosophy, and is the author of *Walter Benjamin's Other History: Of Stones, Animals, Human Beings, and Angels* (1998) and of *Critique of Violence: Between Poststructuralism and Critical Theory* (Routledge, 2000). She is also coeditor of the series *Walter Benjamin Studies*.

BARBARA JOHNSON teaches in the English and Comparative Literature Departments at Harvard, where she is the Fredric Wertham Professor of Law and Psychiatry in Society. She is author of *The Critical Difference, A World of Difference,* and *The Feminist Difference.* The essay in this volume is part of a project titled *Persons & Things.*

PERRI KLASS, M.D., is a pediatrician who serves as Medical Director of Reach Out and Read at Boston Medical Center, where she is Assistant Professor of Pediatrics. Her most recent books include *Other Women's Children,* a novel, and *Baby Doctor: A Pediatrician's Training,* a collection of essays. Her short stories have won five O. Henry Awards and have been widely anthologized, and her essays and journalism have appeared in *The New York Times Magazine, Parenting, Discover, Esquire, Amerian Health,* and many other newspapers and magazines.

CHANTAL MOUFFE is a Senior Research Fellow at the Centre for Study of Democracy at the University of Westminster. She is the author of, among other works, *The Return of the Political,*

Hegemony and Socialist Strategy (with Ernesto Laclau), *Dimensions of Radical Democracy, Gramsci and Marxist Theory,* and *Deconstruction and Pragmatism.*

DORIS SOMMER teaches literature of the Americas at Harvard University. She is the author of *Foundational Fictions: The National Romances of Latin America* (1991) and the forthcoming *Proceed with Caution, When Engaged by Minority Writing in the Americas.* Her current focus is on developing an "esthetics of bilingualism."

REBECCA L. WALKOWITZ, is Assistant Professor of English at the University of Wisconsin—Madison. She is writing a book about styles of cosmopolitanism and twentieth-century fiction and she is an editor of four previous volumes in the CultureWork Series, published by Routledge. Her essay on Kazuo Ishiguro and the aesthetics of treason is forthcoming in *ELH.*

Index